PAINTING WATERFOWL
with J. D. Sprankle

Painting Waterfowl

with J. D. SPRANKLE

Step-by-Step Full-Color
Instruction for 13 Projects

CURTIS J. BADGER
and
JAMES D. SPRANKLE

Stackpole Books

Published by
STACKPOLE BOOKS
Cameron and Kelker Streets
P.O. Box 1831
Harrisburg, PA 17105

Printed in the United States of America

10 9 8 7 6 5 4 3 2

First edition

Library of Congress Cataloging-in-Publication Data

Badger, Curtis J.
 Painting waterfowl with J. D. Sprankle/Curtis J. Badger
and James D. Sprankle. – 1st ed.
 p. cm.
 ISBN 0-8117-1884-0 : $49.95
 1. Decoys (Hunting) – Painting. 2. Acrylic
painting – Technique.
I. Sprankle, James D. II. Title.
ND1535.B3 1991
731.4′62 – dc20 91 – 6820
 CIP
 Rev.

Contents

Introduction

Painting a carved bird is not like painting on canvas. When you're painting a scene with oils or watercolors the world you create is made entirely of color. Color creates form, mass, texture, highlight, and shadow. The painting process begins and ends with the colors you mix on your palette.

Painting a carved bird, on the other hand, is the final step in a fairly lengthy procedure in which each step is related to and builds upon the other. Form and texture begin with the act of carving and are amplified during painting. Highlights and shadows are created with paints, but their placement is often determined during the carving process.

Painting a carved bird is concerned with sculpture as much as with color. It brings together two disciplines, using one to complement the other. Painting should be considered when the carving is begun, never as an afterthought as a separate and final step. Painting should emphasize the textures created by skillful use of stones and burning tools. It should amplify the highlights and shadows that the artist began by carving tufts of feathers, feather splits, and the other subtle imperfections that give life to a wooden bird.

Acrylic paints seem to have been created for just this purpose. They are applied in thin washes of color, which are absorbed into the fine feather textures of the carving. As more washes are applied the color takes on depth and dimension without obscuring the detail beneath it.

Jim Sprankle has been using acrylics for more than twenty years and has become one of America's finest practitioners. The painting sessions illustrated in this book provide ample evidence of his mastery of the medium, but they also are intended to help you apply his methods to your own work.

The techniques Jim uses in these sessions were developed through teaching workshops and seminars across the United States, Canada, and England. Jim has won hundreds of awards in wildfowl art competitions, and he also is one of America's foremost teachers. The summer seminars he holds at his studio on Maryland's Eastern Shore fill quickly, drawing students from around the world, and his carving and painting video productions have helped many beginning artists rapidly increase their skill levels.

In most of the sessions illustrated in this book Jim will be painting a cast study bird made from his original carvings. Cast birds are excellent for painting practice because they provide the painter with a textured bird ready for its first wash of color. If you are unsatisfied with the way the painting is progressing, you can cover the paint with a coat of gesso and begin again. Painting a cast bird allows you to develop your

techniques and skills prior to committing them to a carved bird, which requires many hours of meticulous sculpting and texturing.

It is important to keep in mind that this book provides an in-depth examination of the painting methods of one artist. It should be intended as a starting point for you, a means of conquering some of the technical challenges of painting that can slow your development as an artist. Once these techniques are mastered, use them to express your own thoughts, feelings, and vision.

In studying an artist's technique it is important to understand him as a person. Therefore this book will begin with a personal look at Jim Sprankle and then will move to a consideration of the Sprankle method.

1

Jim Sprankle:
In Pursuit of Excellence

At 6:30 A.M. the alarm clock goes off and Jim Sprankle pulls on a pair of jeans and a blue work shirt and goes downstairs to take Jet, his black Labrador, for a walk. At 7:30 he has cereal and a banana, scans the morning paper, and at exactly 8:00 he walks across his back yard to his studio and begins work, which today means painting a green-winged teal drake.

At 9:00 Jim takes a ten-minute break and brews a cup of Earl Grey tea. The tan breast of the teal has been painted, and Jim is ready to mix some burnt sienna and black and add the breast spots. He works until noon, returns to the house for lunch, and is back in his studio at exactly 1:00. There is a Coca Cola break at three, and then more work until 6:00, at which time Jim breaks for a shower, one Coors Lite, and dinner. At 7:30 he is back in the studio, and by quitting time at 9:30 the teal is more than halfway completed. The breast, wings, back, and rump are done. Tomorrow he will begin the time-consuming job of vermiculating the sidepockets.

Jim Sprankle enjoys the routine, the precise schedule that marks each working day at his Maryland studio overlooking Eastern Bay and, in the distance, the

Chesapeake Bay. On days when Jim is not flying off to attend a wildfowl art exhibition or to teach a seminar, he abides by his schedule. When he travels, he is at the mercy of time tables beyond his control: airline schedules, exhibition dates, student seminars. At home he is in charge of his life and he enjoys his informal disciplines; he enjoys the precision of the day's routine, its comfortable exactness.

Jim Sprankle's art is very much like his life. It is precise, exact, disciplined, punctuated by scrupulous attention to detail. Nothing is ambiguous, wasted, or unexplained.

Some thirty years ago Jim was a pretty good baseball player. At eighteen, just graduating from high school in Lafayette, Indiana, he signed a contract with the Brooklyn Dodgers and took home twenty-five thousand dollars as a signing bonus. That was big money in 1952.

Jim grew up playing the game, pitching his way through a succession of small towns and cities, living every young man's dream. It was a life of golden promise. Dusty buses and cheap hotels were the price of admission to Ebbetts Field—the land of the gods

of Brooklyn—where toiled such immortals as Duke Snider, Carl Furillo, Don Newcombe, and Pee Wee Reese.

Sprankle followed the grail for eleven years, chasing his future from Seattle to Cedar Rapids to Binghamton, until at age twenty-nine, having at last tasted the wine, he left the dream to the more innocent vision of younger men.

There is still something of the baseball player in Sprankle, some subtle quality that goes beyond the physical ability to throw a ball past a hitter standing sixty feet six inches away. Sprankle's discipline, dedication, precision, and daily routine might have begun when he signed that Dodger contract, deciding that his fate in life depended upon his willingness to wrench the maximum from his abilities.

"Jim Sprankle is a unique guy," says Ken "Hawk" Harrelson, the Chicago White Sox broadcaster and former major leaguer who played with Jim at Binghamton in the Eastern League. "I was nineteen or so when I met him and Jim was in his upper twenties, one of the

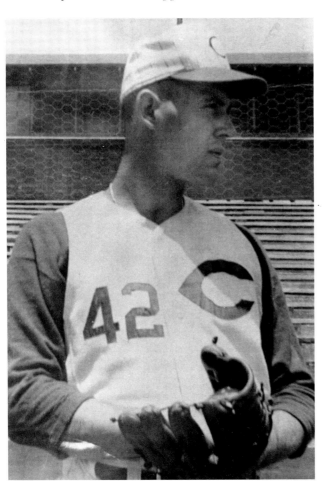

Jim Sprankle as a pitcher with the Cincinnati Redlegs.

older players on the club. I had more respect for him than anyone on the ball club. He had tremendous self-discipline. If he saw someone go out and run twenty wind sprints, Jim would run twenty-three. He was relentless."

Harrelson says Jim was a finesse pitcher. He didn't have an overpowering fastball, but he had a great curve and changeup, a repertoire that requires precision, attention to detail, and mastery of the fine points. One too many hanging curveballs and you're on the Greyhound back to Lafayette. Jim Sprankle's baseball career, then, was a proper prelude to wildfowl art, which, like baseball, requires mastery of countless small tasks.

Sprankle prefers not to talk about his baseball career. He notes simply that he spent eleven years in the Dodgers and Cincinnati Redlegs organizations. In his home there are a few mementos: a display of autographed baseballs, a bench made of Louisville Slugger bats.

Sprankle prefers to live his life chapter by chapter, and the baseball chapter is closed. Finis. No name-dropping baseball anecdotes to color his conversation. Instead, Sprankle talks about birds and art, his passions for the past twenty-two years. He lives on an eighteen-acre waterfront spread on Kent Island, just a few miles east of the Chesapeake Bay Bridge. His studio is a few yards behind the beachline, and in winter he can sit in his shop and watch the Canada geese gather by the thousands. An attached aviary contains more than twenty species of waterfowl, including canvasbacks, wood ducks, redheads, blacks, and pintails, all willing models for Sprankle's latest wood-sculpting projects.

"I was living in Binghamton, New York, and came down here for the first time fourteen years ago to the Easton Waterfowl Festival, and I just couldn't believe the atmosphere—the geese and waterfowl that were all around—and I decided, boy, I'm going to live here one day."

So ten years ago Sprankle moved from Binghamton, the last stop in his baseball career, to Annapolis, and then to this current waterfowl retreat on Kent Island. He has been sculpting waterfowl for more than twenty years and professionally for about fourteen years.

"When I stopped playing baseball, I went to work for a bank in Binghamton doing public relations and business development. Then I owned a refrigeration and restaurant supply business for six years," he says.

"I had always been interested in birds—I had been a taxidermist since I was sixteen—and I became involved in woodcarving in the 1960s while I was in business in New York. I used to come down to Tangier Island to go hunting, and I started learning about Chesapeake decoy makers such as Steve and Lem Ward. Then I found out about the Ward Foundation's World Championship Carving Competition, which really piqued my interest."

Following his baseball career, Sprankle was essentially a businessman who carved birds as a hobby. And then a serious illness forced another turning point in his life, closing an old chapter and opening a new one. "After six years in the restaurant business I had a serious cancer operation, and I decided that for the rest of my life I was going to do something I really enjoyed. The doctor said I had a kind of lymphoma that's hard to pin down. He said I might live for a year or I might live for a hundred. So fourteen years ago I decided to devote the rest of my life to bird carving, even though I knew it would be a risky way to make a living. Back then there wasn't the market for carvings that exists now, and I never dreamed that bird carvings would ever bring the kind of prices they're bringing today. Looking back on it I have no doubt that I made the right decision. I have no regrets at all."

In the past fourteen years Sprankle has become one of America's leading waterfowl sculptors. He and his wife, Patty, run a successful mail order carving supply business, his books and videos on wildfowl carving are selling well, and there is a lengthy waiting list for the summer workshops he holds at his bayfront studio.

Jim Sprankle grew up in Indiana, on the Wabash and Tippecanoe rivers. His grandfather, a German immigrant, was a talented cabinetmaker, and Sprankle learned from him a respect for wood and woodworking tools. An interest in ornithology led to a high school career in taxidermy, which provided valuable background in avian anatomy and bone structure. These interests would later be focused in the art of sculpting waterfowl from wood.

"Anything that would fly fascinated me when I was growing up. At an early age ducks caught my fancy. An older kid who was a friend of mine went to Purdue University and studied waterfowl biology and he would bring me ducks to mount every weekend. I just couldn't wait for him to get home so I could see what he brought me. I'd stay up half the night mounting

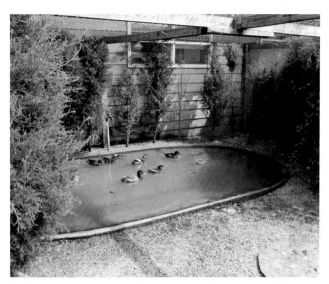

Jim's aviary is an invaluable source of reference material.

ducks. I think doing that triggered this desire to carve. It started with gunning decoys because I wanted to make something that was better than the store-bought ones, then it progressed to something more expressive."

In his twenty-two years of carving Sprankle has specialized in lifelike waterfowl, and his aviary has enabled him to study every nuance of behavior and attitude. He does not carve songbirds. "I have totally immersed myself in waterfowl," he says. "I would love to be able to do songbirds like Bob Guge, Larry Barth, or Ernie Muehlmatt, but you can't do all things well. I decided that if I were going to make a niche for myself I would have to home in on one thing, so I've concentrated on waterfowl."

The process of carving begins with research. Sprankle uses his aviary, close-up photos of birds, and mounted birds and study skins. Not only are his carvings exacting in detail, they also convey much about the attitude and personality of the bird. "I think people are becoming very educated about what can happen structurally—attitudes and anatomy and so forth. So to do any major carving you have to have good references. The first year after I had my aviary put in I won eight blue ribbons for different species at one show, and they were all carved from photographs taken in the aviary. I can't say enough about the value of that aviary in helping me do things accurately. The criterion in our business, whether you like it or not, is accuracy. The aviary certainly helps put you on track. All of my carvings in the past twelve years have been derived from something I've seen in that aviary. The

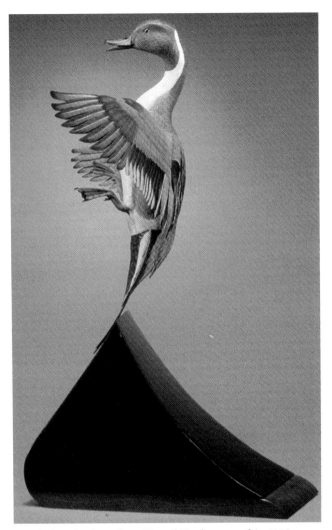

Startled Sprig: American Pintail Drake, *carved in 1989.*

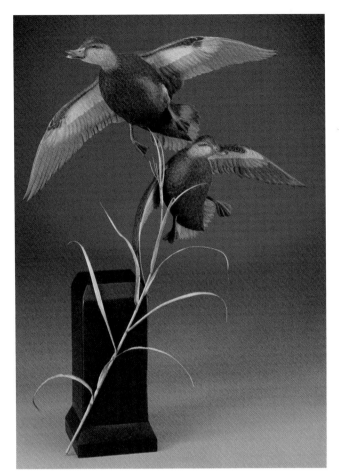

Hasty Departure: Eastern Shore Black Ducks, *carved in 1988.*

challenge for me is to do a creative piece, to work out first of all the composition, then the engineering. That's what I love about carving. The challenge keeps you crisp and eager."

Sprankle has built his career on carving individual birds – extremely realistic, expressive, highly detailed decoys. But in recent years his carvings have become more complicated, more sculptural. Often he will include several birds in one carving. A work entitled *Red River Rockets*, depicting three flying green-winged teal, finished third in the 1990 Ward World Championship. The carving is a study in motion, with the birds frozen in flight. "This is the direction I'm heading in now, doing the more complicated, creative pieces instead of single birds," he says. "The challenge is to keep it clean, to have a lot happening in the carving but to keep the composition simple and uncluttered. I have no desire to do the plastic water, the elaborate

habitats. For me, the cleaner the composition, the better the piece will work."

The teal, as do most of Sprankle's carvings, will become a part of the wildfowl art collection of an American collector. All of his pieces are sold before he completes them, at prices ranging from thirty-five hundred to thirty-five thousand dollars. Wildfowl carving is an art, but there is also a business side, and Sprankle believes that those who are successful must master both elements. "Being from Indiana, in the conservative Midwest, I was taught that you don't spend two dollars until you have at least two or three. When I first went to work for the bank in 1962, after baseball, they told me I could buy a television with an employee loan on a time-payment plan. I had no idea what they were talking about. I guess I've been lucky in that I've always had a demand for my carvings, and I think it goes back to marketing – you market what you do and you market yourself. All carvers do it, and we all seem to do it in a different manner."

Sprankle no longer takes orders for carvings. If you want a Jim Sprankle wood sculpture, your name goes into a book and you begin the wait. Obviously, at prices that run into five figures, his carvings are purchased by serious collectors. Noncollectors often are both impressed and perplexed by the prices that top carvings fetch these days. "When you go to a show, people come up and the questions are, What kind of wood is it made of? What kind of paint? How much is it? And how long did it take you? And their little computers are running to see whether they make more or less an hour than you do. So I don't even discuss how long it takes. I think that's a stupid thing to even talk about. Nobody should know that. Nobody should know whether it takes two hours or two days. People don't take into account all the time it takes prior to the actual carving, the hours you'll sit out there and watch the birds or photograph them or try to visualize the piece. Larry Barth will sit and sketch for days, then do a clay model before he even begins carving."

So goes this uncomfortable dichotomy between business and art. Some people are able to appreciate a beautiful carving or painting for what it is; others need to evaluate it on a time-and-materials basis, as if the value of Beethoven's Ninth Symphony could be measured by determining how much the composer was paid per hour.

Artists are frustrated by this attitude; Sprankle, perhaps, more than others. Here is a man who began his adult life by being paid for his talent, his promise. At seventeen he could throw a baseball past the best hitters in America. Today he can give life to a block of

The artist at work in his studio in Chester, Maryland.

basswood using the magical alchemy of art to transform wood and pigment into an eloquent statement about wild birds. Gifts such as these are rare. They transcend the profit-and-loss statement.

2

The Painting Process:
The Sprankle Method

The objective in waterfowl painting is to add the element of color to the sculptural process of bird carving. Painting should not be considered separate and distinct from carving—it should be part of the carving process, one of many steps required to create a wooden bird with beauty and realism.

Painting a three-dimensional object that already has mass, texture, highlights, and shadows is different than painting on canvas. In the following sessions we will examine painting especially as it pertains to decorative carved birds, using a method developed over more than twenty-two years by one of America's leading wildfowl artists and teachers. We will discuss the particular properties of acrylic paints that make them ideal for painting textured birds, and we will explain techniques, tools, and methods of achieving a great deal of realism in painting. Subsequent chapters will discuss in detail painting various species of birds.

In the Beginning: Being Prepared

Jim Sprankle's approach to waterfowl art can be described as disciplined, precise, prepared, and organ-

ized. It is a routine that began with a career in sports, continued through the business world, and is equally applicable to the creation of wooden birds.

When Jim was twenty-five and pitching for the Dodgers, he wouldn't think of going to the mound without memorizing "the book" on the hitters he would face. He knew which ones couldn't hit the curve ball, and which righthanders would pull the ball into the leftfield seats if you pitched them high and in.

In business he didn't meet a client without learning all he could about the client's needs and wants. And in the more free-wheeling world of art he still won't carve and paint a pintail drake until he learns everything he can about that particular bird.

The Sprankle method of painting begins here: with preparation and discipline to the point of obsession. He refuses to begin a project until he is confident that he has prepared himself as well as he can. And during the process he refuses to take shortcuts, to settle for anything less than the best he can possibly do.

In his painting studio is a collection of taxidermy specimens, a double window looking out to his aviary,

and a massive file cabinet packed with photographs, magazine articles, and his own copious notes on birds. He keeps a painting journal on each of his projects, and when the project ends, the journal is filed along with other notes on that particular bird. In the twenty-two years that he has kept his file he has seen his painting technique evolve as his skills have developed, and as he has discovered new methods and approaches to wildfowl art. It's all there in black and white – and often in color. In addition to his written notes Jim frequently has little dabs of color in the margins that represent the exact mix he happens to be referring to in the text.

"No matter how well you know birds, an extensive library of reference material is essential if you are to capture a certain species accurately," says Jim. If he has a question about a particular painting project, with his attached aviary he can simply look out the window and observe the live birds. Sometimes he will tether a bird, bring it into his studio, and observe it up close while he paints. "When you're doing demanding work, such as the vermiculation on a pintail drake or the subtle color shifts on the scapulars and tertials of a gadwall, you need all the help you can get. When you're doing realistic birds, you can't afford to guess. You have to know for sure. So I bring a bird in, and I'll look at it up close. If there's a little violet iridescence on that feather grouping, I'll see it, and when I paint the bird I'll have it right."

Most professional wildfowl artists keep aviaries because they allow them not only to study the color and anatomy of a bird but also to examine their habits and attitudes. The best of the old-time decoy makers spent a lot of time hunting and watching waterfowl, and they knew how to capture the essence of a bird with a minimum of detail. In contemporary carving it is no less important to be able to capture the essence, and then to carry it even further. You do this the way the old timers did: by watching live birds as frequently and as closely as you can. Unless you happen to live on a wildlife refuge, an aviary is nearly a necessity.

If you decide to install an aviary, Jim warns, be sure to check with federal and state game agencies to complete the necessary permits.

Mounted taxidermy specimens also provide good reference material. Jim, a former taxidermist, has a vast collection of mounted birds and study skins. These are invaluable for matching colors and for duplicating fine detail and subtle color shifts. Although color quickly fades from the tissues of a water-

fowl at death, the feather detail will remain for many years in a well-preserved specimen.

Photos and videotapes also make good reference material, although they are perhaps better suited to the carving process than to the very tedious process of painting. Photos and videos are fine for studying attitude and behavior, but they often do not pick up the subtle nuances of color and detail. If you are handy with a camera, you can often get good photos by visiting aviaries at zoos. In many cases you will be able to use a moderate telephoto lens to get useful close-up photos of birds.

With notes, photos, taxidermy mounts, live birds, and any other reference material he can muster close at hand, Jim pours a cup of Earl Grey tea and begins the painting process. Usually, his first step is to clean his glass palette, even though he cleaned it the previous night when he quit for the evening and it looks good enough to serve up a platter of scrambled eggs. He sprays the glass with Windex, dries it with a soft, white paper towel, then folds a few more towels together and places the glass over them on his work table. The glass is ideal for mixing paints, and the white towels beneath it provide a neutral surface for mixing colors.

Jim attaches a wooden keel to the carved bird to serve as a handle, so he will touch the painting surface as little as possible.

His brushes are arranged in front of him in a plastic container. They have a cleaned-and-pressed look, like a uniform hanging on a locker door before the opening-day game. The cleaned-and-pressed uniform analogy can be taken literally because Jim does clean and press his brushes, especially the flattened, fan-shaped ones he calls his feather-flicking brushes. He trains them, he says, and he keeps his first-string brushes close at hand when he has to paint subtle little feather edges. The first-string brushes are the ones with the perfect fan shape. After each use he flattens the bristles with his palette knife, and after a few months the brush begins to acquire the appropriate attitude.

The second-string feather-flicking brushes are in training. Each day for weeks now they have gotten the palette-knife treatment, but they have not yet made the varsity. Jim doesn't worry, though. He's a patient man.

So the palette is clean, fresh mixing water has been poured, the brushes stand at attention like little soldiers, the Earl Grey is brewing, and Jim has surrounded himself with all the appropriate reference

material that he can find. He tunes in a public radio station in Washington and prepares to paint.

It's almost a process of meditation, this little ritual of sorting out details. It's a kind of artist's mantra, a hymn that prepares the soul as well as the body. Yes, he needs brushes close at hand, and he needs a clean palette on which to mix his paints, but he needs the process itself as much as he needs the products it creates.

Once he starts, Jim is all business. He begins by spraying a carved bird with Deft Spray Stain, Salem maple in color. He'll spray it three or four times, enough to provide a uniform painting surface with no glossy or flat spots. (About five minutes of drying time between coats is usually sufficient.) The lacquer seals the pores of the wood, providing a proper base for the transparent acrylic paints.

In the following chapters Jim will be referring fairly consistently to several terms you might not be familiar with: color-to-water blending, painting white on white, black on black, feather flicking, building up washes, and so forth. Before we begin the actual demonstrations of painting specific birds we'll talk a little about the different techniques. It would be a good idea to practice them on a cast study bird before painting a bird that you laboriously carved.

Jim always begins painting a carving by sealing the wood, then applying a base color of tinted gesso. When painting one of his molded study birds, as he does in several of the demonstrations in this book, a wood sealer is not needed so he will go directly to the application of the base color.

All the base colors discussed in this book contain gesso: a thick, water-based, chalky medium that serves as the undercoat for subsequent applications of acrylic paints. In most cases the gesso is tinted with an acrylic color, and that mix will serve as the base color for a fairly large area of the bird, such as the sides, head, or back.

Using the gesso is important for two reasons. Always keep in mind (we'll remind you often) that acrylics are transparent, so the undercoat must be of a uniform color. Gesso also provides a nicely textured surface on which to blend paints.

Jim always applies sufficient coats of gesso to get a uniform painting surface, one that has no thin spots and gives the same texture over the entire surface. Usually it takes about three coats, and each coat is

allowed to air dry. When applying acrylic paints Jim speeds up the drying process with a hair dryer, but because gesso is rather thick and chalky, application of heat could cause the medium to shrink, creating pinholes or tiny stress lines.

"The gesso is always applied in the direction of the carved feather flow of the bird," Jim says. "If you paint across grain, the gesso will obscure all those delicate little barbs and quills that you have worked so hard to carve. Paint in the direction of the texture and the gesso will sink into the crevices, coating them but not filling them."

Using Acrylics

Acrylics are applied in thin transparent washes, a technique that leaves something to be desired when painting a smooth surface but one that works perfectly on a bird that has been textured with grinding tools and a burning pen.

"Contemporary, highly textured bird carvings seem to have been created for acrylic paints—and vice versa," Jim says. "A thin wash of acrylics will settle into the texture of the wood, giving it depth and definition. The beauty of acrylics is that you can build up color through three, four, or more washes, and in the end you get a great deal of depth and value. You can capture iridescence and subtle nuances of color that you couldn't with a less transparent medium."

Jim has used acrylics for more than twenty-two years and has developed a fairly specialized repertoire of techniques, which he preaches to the unconverted at seminars in the United States, Canada, and England. "Think thin," Jim writes on the chalkboard of his classroom. "Thin is in." This has nothing to do with saturated fats and cholesterol. Jim is talking about acrylic paint: that thin, watery stuff that looks like something you mixed with water and food coloring in third grade art class. He brushes a little watery paint on the breast of a pintail drake. It's flat, transparent, anemic looking, certainly not something you would use to paint such a colorful, elegant bird.

But he puts on a second wash, then a third, and by golly that watery stuff is beginning to look like it might have a little richness and character after all. "Acrylics should be applied in thin washes," says Jim. "They must be applied in thin washes—that's what they're made for. Acrylics are great for painting carved

birds; it's just that you have to work with them, not against them."

The thin washes that at first look so dull and hopeless build a richness that has depth and dimension. Jim puts one color on top of another, adds some pearl essence powder, which provides iridescence. Pretty soon the class is sold.

"Once you learn the properties of acrylics, you can do some amazing things," he says. "In doing a green speculum, for example, I first paint it with a coat of yellow, then I put green over the yellow, keeping it thinner in the center. After about three applications of green I'll add some green pearl essence, then come back with a thin wash of black to darken the entire area. The method produces a brilliant green speculum that has subtle iridescence, a nice central highlight, and dark edges. It's the best method I've found for painting on wood. The trick is to take advantage of the transparent qualities of the paint, to make them work for you."

JO SONYA	EQUIVALENT
carbon black	Mars black
titanium white	same
Payne's gray	Grumbacher gray
nimbus gray	
smoked pearl	
phthalo blue	same
cobalt blue	same
ultramarine blue	same
phthalo green	same
yellow light	cadmium yellow medium
yellow oxide	yellow ochre
Norwegian orange	cadmium orange
naphtha red light	Grumbacher red
red earth	
burgundy	
dioxazine purple	Grumbacher purple
burnt umber	same
raw umber	same
burnt sienna	same
raw sienna	same

[Equivalents for pearl essence powders are interference powders, iridescent powders, and bronzing powders.]

Building Color with Washes

Ducks are soft, supple, feathery little birds. But often when you look at a painted wooden bird, it looks about as soft and feathery as the side of a barn. That's because it's painted with the same technique a painter uses on a barn. That is, if it's a mainly white bird, like a bufflehead, you get out the white paint and put on enough coats to cover the wood.

That technique is fine if all you want is something that looks like a white wooden bird. But if you want a white wooden bird that looks more like feathers than wood, you need to learn to build color through washes. Or, in the case of the bufflehead, you need to learn to paint white on white. The bird is white, yes, but to create the illusion of softness and depth you have to consider the different values of white.

For example, Jim first paints the white area of the bufflehead a very light gray. He then adds pure white feather edges, which stand out like a sore thumb and look very unrealistic. But he adds a thin wash of white to the entire area, then another, then another, and pretty soon, as the color builds, the white feather edges and the gray background become almost the same value. If you look closely for the feather marks, you can still see them, but the overall impression is one of subtle softness. The feathers are there but the effect is muted, just as on the real bird, and the wooden bird doesn't look like wood any longer.

Jim uses a similar technique to paint black on black, creating a dark area that holds extraordinary texture and softness.

Building colors through washes gives the illusion of depth; the surface of the bird is no longer an impenetrable flat plane but instead takes on infinite dimension. The visual barrier is gone and the viewer gains accessibility. "It's a matter of playing with the senses," says Jim. "By building up color you can make a hard surface appear soft. You can give depth to an impenetrable object."

"Thin is in," Jim says to himself as he paints. "Don't sin, paint thin." He mixes colors on the glass palette with the palette knife, then he dips his brush in clean water, swirls it around in the paint, adds some more water, swirls it, and finally puts a weak-looking wash of color on a carved bird. "You don't change the color by thinning it," he says. "The color is the same, it's just thinner. You have to put on more coats. You'll never get in trouble by using thin washes. If you put it on too

thick, you'll get streaks, opaque chalky areas, or a value that's too dark. When that happens you've got major problems. You might as well start over. Put the washes on thin and build the color gradually to the value you want."

Building color also enables the artist to do other things, such as adding those yellow highlights to the speculum. On birds such as the wood duck and the bufflehead drake, which have subtle color shifts along their faces, you can duplicate that very elusive shift from blue to green to purple by applying washes. A thin wash of burnt umber over the wing feathers settles into the carved barbs and quills, enhancing shadows and adding definition.

Building color with washes really is what acrylics are all about. That's how they work. That acrylics are used in thin washes is not a limiting factor, it's a great advantage, especially when you're putting the paint on a carved bird.

For the major color values used in the following sessions Jim has prepared a color chart showing the exact percentages of paints mixed. He has also created a bar graph that illustrates the effect of subsequent washes of the same color. This tool will be invaluable to you in learning to mix paints and in understanding the importance of building color values with washes.

Blending Color to Water

If you read this book through to the end, you just might get tired of hearing this phrase, but it's a vital technique. Jim uses it numerous times on every bird he paints here, and you will not be allowed to pass go and collect two hundred dollars until you learn it.

Blending color to water is perhaps the most important and useful technique of the Sprankle painting method. The good news is that it's easy to learn. Basically, it means dampening with clear water the area around which you will apply paint. Then you blend the paint into the water to create a subtle, soft edge.

Remember, ducks are soft. We want feathers that look billowy, not like a concrete pad at high noon. We want details that have soft transitions, not hard edges. That's what blending color to water is all about.

Consider our example, once again, of painting the speculum of a green-winged teal drake. Jim first paints the entire speculum yellow. After the yellow dries he

dampens the center of it, then applies green paint around the margins of the water, blending the color into the water. He repeats the process, then repeats it again. The result is a green speculum that gradually fades to yellow at its center. The effect is a little garish, so Jim applies green to the entire speculum, this time not dampening the center. Because acrylics are transparent, the yellow highlight still shows through, but now it's more subtle. He might even add a final thin wash of carbon black to darken it more.

"The technique is not difficult, but you need to practice it often," says Jim. "I use two brushes. The sizes depend on the size of the area that I'm painting. Usually I'll use a slightly larger brush to put on the water than the one I use for the paint. I dampen the area with water, then blend the color into the water. It's that simple. The key is how well you can carry off the mechanics of the process, so it pays to practice. The mistake most people make is to put on too much water; then, when the color merges with it you have a real mess, with paint running all over the place. All you need to do is dampen the surface to be blended into. You don't want your brush loaded with water. Just wet it, blot it, and dampen the area."

Feather Flicking

Among Jim's army of paint brushes the feather flickers are the elite troops – highly trained, disciplined, specialists in a very demanding painting technique that is intended to complement and emphasize carved details. The feather-flicking brushes are of different sizes but all share the similar, well-disciplined shape of a fan. Jim encourages this by using a palette knife to lightly flatten the damp bristles after each use. In time the brushes become perfectly trained for their special job: flicking feathers.

Carved feather details – quills, barbs, feather groupings – are put on during the carving process. Jim uses a high-speed grinder with a wide range of tiny stones and bits to create intricate feather outlines, quills, and other details. Then he adds individual feather barbs with a burning pen, which is sort of a cross between a soldering iron and a carving knife. The burning pen has a sharp blade that is heated to varying temperatures by a rheostat. While the blade cuts, the heat cauterizes waste wood, providing a fine, clean line. Burning pens are ideal for cutting in feather barbs; a

tool with a sharp point can cut one hundred lines per inch or more.

Once these intricate details are carved, they are not simply painted over as you would our proverbial barn. The feathers of most ducks vary in color and design from the base to the tip. Typically, each feather has a light-colored edge, then a darker central area, followed by an even darker base. Jim begins painting feathers by first painting the light-colored edges, which he does with the feather-flicking brushes.

He mixes the color, carefully checks its value against a live bird or taxidermy mount, then brings out a feather-flicking brush of the appropriate size. If he's flicking the tiny feather edges on the crown of the head, he will use a small brush such as a size 2 Raphael #8404. For broader areas, such as the breast of a bufflehead, he will use the same model brush in a larger size, probably a size 6.

The feather-flicking brushes have fan-shaped bristles that generally match the contours of the feather edges. The idea is to add paint to the brush, then very lightly flick the bristles along the feather edges, leaving an irregular line of color.

It's important, first, to select a brush that comes close to matching the size and shape of the feather edge, and, second, to apply just enough paint to the brush to transfer color. If the brush is too wet, the paint will run. If the brush is too dry, the line will not be bold enough.

It pays to practice. Try the technique on a molded bird or surplus carving. After a few minutes, you should get the feel for the proper amount of paint to use, and also you should get accustomed to the light flicking action that transfers paint.

Jim lightly applies paint to the brush, flicks a few trial feathers on a piece of paper, and when he's certain the brush is ready he begins flicking feathers on the bird. The brush leaves just an irregular outline of color, one along the edge of each carved feather.

The goal is to make the feather edges slightly irregular. On a real bird they're not uniform, and neither should they be on a carved bird. Some are larger than others, some have little splits and tears, and some have subtle color differences. Ducks that spend a lot of time in tannin-stained swamps of the South tend to have a definite raw sienna bias on the lower breast and sidepockets.

"The technique is ideal because it is by nature as irregular as the feather edges on a real bird," says Jim.

"All flicks are not created equal. The last thing you want when painting a carved bird is a uniform, stamped-out look. You don't get that with the feather-flicking technique."

Flicking also is much faster than the alternative of using a small brush to painstakingly paint each little barb of each little feather. You could make a career of that. The Sprankle method is to flick an entire feather edge with one careful swipe. Once all are applied, he touches them up slightly with a small lining brush, such as a size 2 Raphael #8220. With the small brush Jim carefully extends some of the light-colored lines, making the marks even more irregular, more random, and more lifelike.

Later he will add black paint to create shadows along the edges of the feathers where he carved feather splits. Ducks are highly active birds – they fly at great speeds, swim, dive, fight with each other, mate with each other, and sometimes elude predators, including man, by the narrowest of margins – and this busy lifestyle takes its toll on a bird's plumage. A carved bird should not look like it just spent the morning at the beauty parlor. Real birds have imperfections such as broken and split feathers, and carved birds should too.

The Sprankle feather-flicking method works in concert with other techniques. For example, after flicking on feather edges Jim will usually paint each feather using the color-to-water blending method, which works like this: The feathers get an overall base color when the first coat of acrylics is applied, then the lighter edges are flicked on. Then Jim darkens the base of each feather with a darker value of the base color, which usually is created by adding carbon black to the original mix.

The darker base is blended onto the feather with the color-to-water method. First, Jim dampens the area around which the darker color will be applied; then with another brush he applies the paint, blending it to the dampened area. The technique creates a very gradual transition between the dark base and the medium value of the central portion of the feather. It's one of those unobtrusive techniques that's effective but doesn't call attention to itself. You have to look closely to see where it was employed.

Once the feather edges have been flicked and the bases darkened, Jim usually applies a wash or two of color (frequently burnt umber) over the entire area, bringing the values even closer together, making the

techniques even more subtle and adding richness and depth.

Brushing Up

Jim's contingent of brushes is not large, but in keeping with his penchant for organization and discipline each brush has its own very specialized role. The brushes listed here have joined the Sprankle army after years of testing and use. Your selections probably will be different because as you develop your own painting style, your needs will vary. This is a good starting point, however, because it defines brushes according to six fairly specialized roles. After painting a few birds you might find other brands, styles, and sizes that perform better for you. That's okay, because this list reflects only one artist's technique, style, and prejudices.

Waterfowl Anatomy

As Jim explains his painting method in the following chapters dealing with specific birds he often will refer to feather groupings and to particular parts of waterfowl anatomy. It would be a good idea to familiarize yourself with at least the basic terms listed on this diagram, especially the location of the tertials, scapulars, primaries, and other feather groups on the wings. These are referred to often during the painting process.

BRUSH MAKE	SIZE	USE
Raphael #8408	1,2	vermiculation
Strathmore-Kolinsky #585	2	vermiculation
Raphael #8240	2,4,6 filbert-type brush	blending
Raphael #8722	2,4,6 filbert-type brush	blending
Raphael #8220	1,2	lining brush
Raphael #8404	2,6	feather flicking or feather edging
Liquitex #511	6	feather flicking or feather edging
Raphael #8250	1″	washes
Raphael #8792	¾″	washes
Raphael #355	18	gesso
Raphael #359	20	gesso

Airbrushes

Badger #HD 150		airbrush
Paasche #AB		airbrush

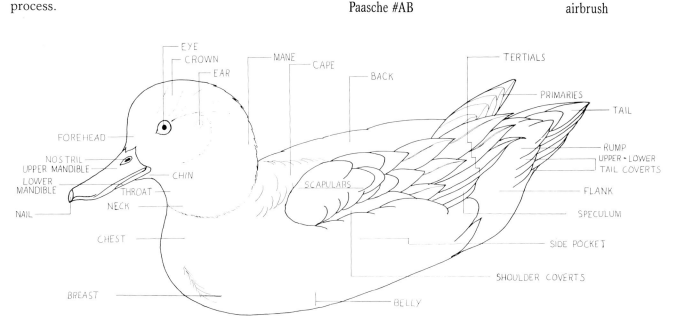

3

The Green-winged Teal Drake

Three important techniques are shown in this section: color-to-water blending, feather flicking, and vermiculation. All are important in creating a teal that will be a faithful rendition of a real bird.

Color-to-water blending is one of Jim's first steps in creating a soft edge along the breast, and he also uses it in building subtle color shifts on the head. Feather flicking gives depth and realism to the breast, and vermiculation covers the sidepockets of this bird. Neither technique is especially difficult to master, but some practice is called for.

The base coat Jim uses on the teal has a grayish color visible between the lines of vermiculation along the sidepockets. It is a mix of white gesso, nimbus gray, raw umber, and Payne's gray. Check your reference material to get an accurate read of this color. By using this mix as the overall color base, the vermiculation can later be added in one step without having to change the color of the bird.

MATERIALS & COLORS

Hyplar matte medium-varnish
Testors model paint:
brown for eye, black for pupil
gesso

nimbus gray
Payne's gray
raw umber
burnt umber
raw sienna
Hyplar burnt sienna
carbon black
Mars black
pine green
phthalo green
Hooker's green
yellow oxide
yellow ochre
cadmium yellow
yellow light
Hyplar ultramarine blue
titanium white
iridescent white
green pearl essence powder
white pearl essence powder
blue pearl essence powder

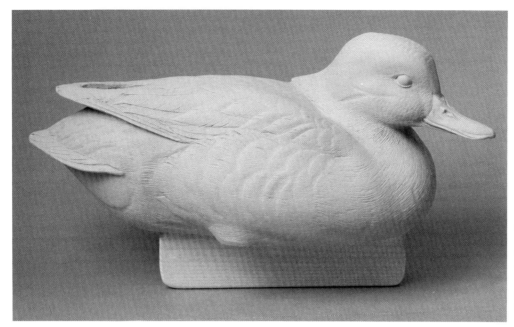

The base coat is applied directly to the molded study bird. The base color consists of a mix of 50% white gesso, 30% nimbus gray, 10% raw umber, and 10% Payne's gray (see color chart). This is the color of the teal under the black vermiculation.

The base color is a mix of 50% gesso, 30% nimbus gray, 10% raw umber, and 10% Payne's gray.

The base coat is applied with a stiff brush such as a size 18 Raphael #355 and is worked into the texture in the direction of the flow of the feathers. Painting against the feather flow will create a buildup of gesso that will obliterate feather texture if allowed to dry. Apply enough coats to obtain a smooth, uniform surface. Jim has put three coats on this teal.

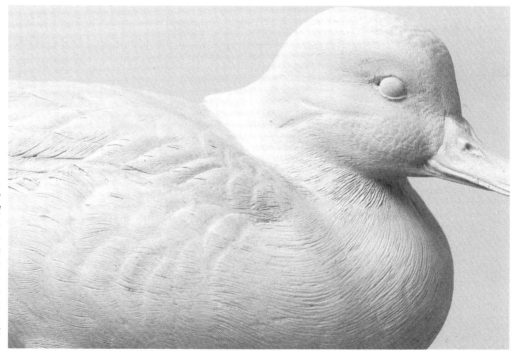

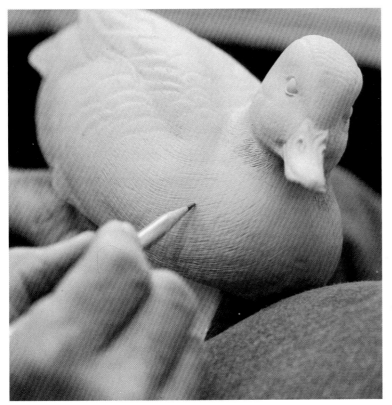

With a soft lead pencil Jim lightly marks the outline of the breast. He uses a taxidermy specimen as a guide in determining the dimensions of this area.

The base color of the breast is a mix of 50% titanium white, 30% raw sienna, 10% burnt umber, and 10% burnt sienna.

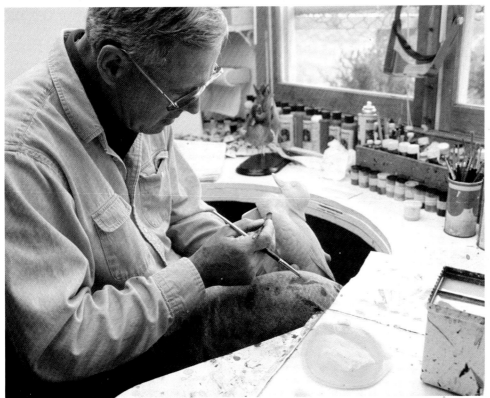

The breast color is applied in a series of very thin washes with a technique Jim calls color-to-water blending. Here he dampens the outline of the breast area with water. When he applies the color, it will be blended into the water, producing a soft edge. The color mix is 50% titanium white, 30% raw sienna, 10% burnt sienna, and 10% burnt umber (see color chart). Jim mixes the paints to match the cream breast color of the taxidermy specimen used as reference.

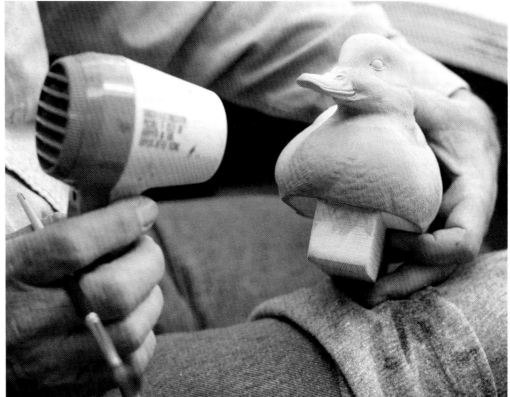

The color is applied in three or four washes, and Jim dries each coat with a hair dryer between applications. The key is to apply the paint in thin, even washes. Paint must be mixed thoroughly to avoid streaks and unevenness. Stir paint with the palette knife or brush between washes to prevent colors separating.

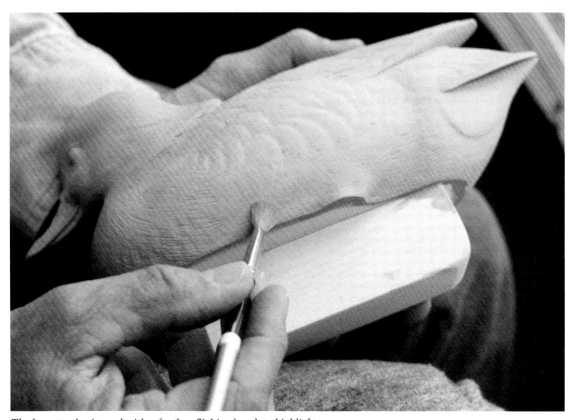

The breast color is used with a feather-flicking brush to highlight feather edges along the extreme lower portion of the sidepockets.

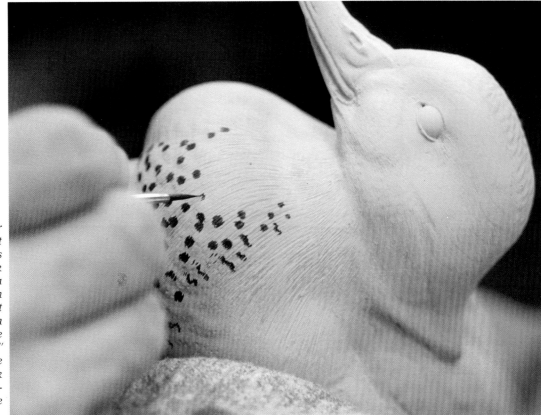

With the breast color applied, Jim's next step is to paint a series of random black spots. The color is a mix of 50% carbon black and 50% burnt umber. "Mix enough of this color to do the vermiculation also," Jim advises. "The color of the black spots and the vermiculation should be the same value."

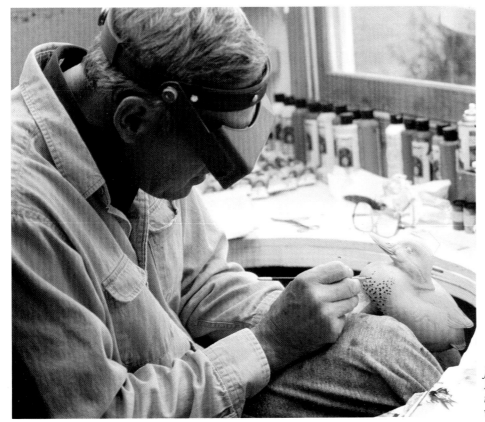

Jim applies the paint with a size 1 Raphael #8408 brush. The magnifying eyepiece helps when doing fine work such as this.

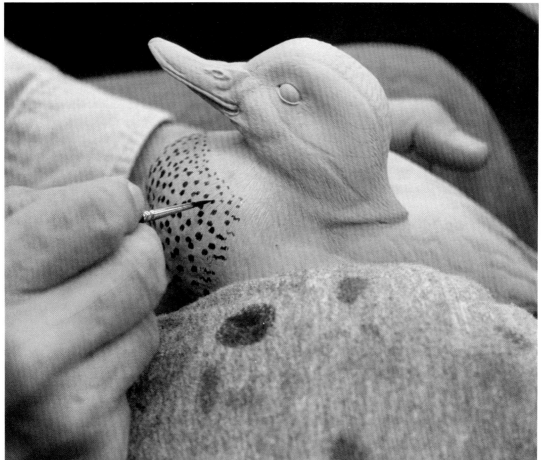

These spots should be applied at random, and they should not be symmetrical. Sharp photos, taxidermy mounts, or live birds are invaluable guides in capturing the design and shape of these spots, which become slightly elongated on the sides of the breast where they meet the vermiculated sidepockets.

As an alternative to using the small brush to apply the spots, Jim adds the paint mixture to the airbrush and sprays a few spots. Either method works well.

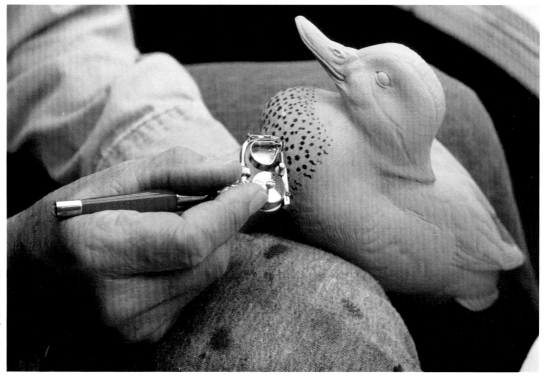

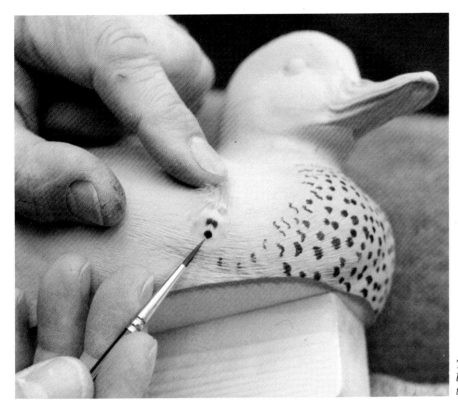

The single feather was removed from the breast of Jim's taxidermy specimen. Note the color and shape of the spots.

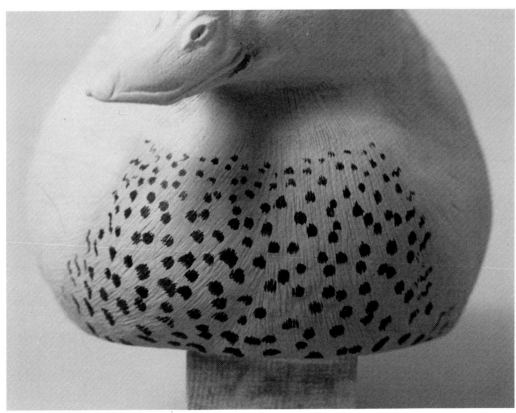

The breast has been painted with the cream base color, the black spots have been added, but the area still lacks depth and texture. Jim's next step will be to add some feathers to the breast.

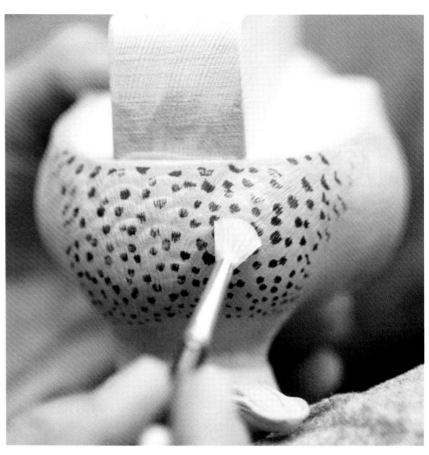

For the feather color, start with the base color of the bird and add a little iridescent white and titanium white until you can see a slight glitter in your paint mix. The paint is applied to the edges of the carved feathers with a size 6 feather-flicking brush.

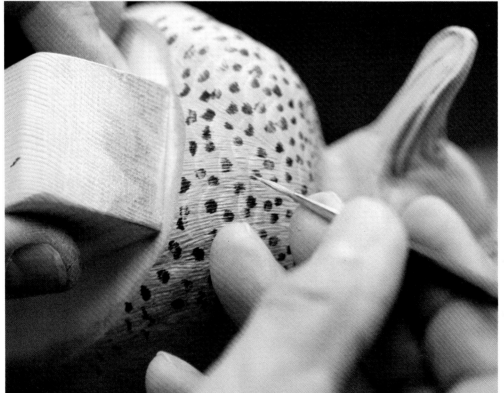

Next, Jim uses the size 1 Raphael #8408 or size 2 #8220 brush to extend the white feather lines through some of the black spots. He will also randomly darken about a dozen of the spots with another application of the black mix. This prevents the spots from appearing too uniform.

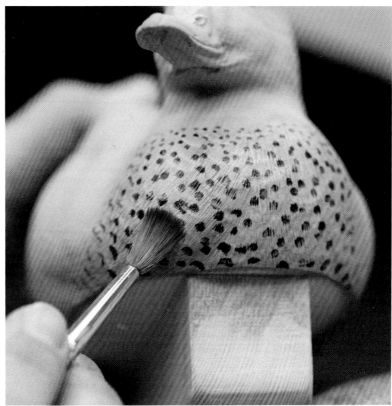

A very thin wash of burnt umber slightly darkens the breast, bringing the values closer together. The burnt umber is absorbed into the texture lines, giving the breast definition. The final step will be to apply a wash of matte medium-varnish to the breast to give it a waxy look.

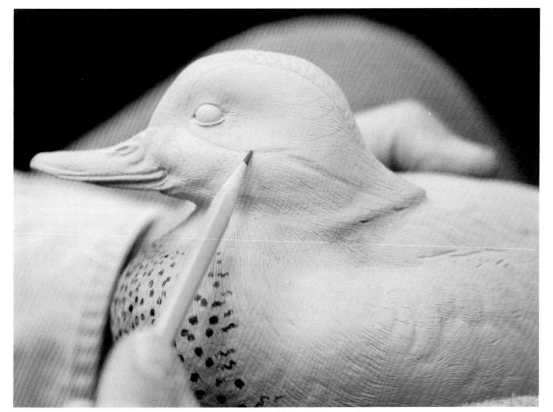

Jim begins painting the head by lightly outlining the green area with a pencil.

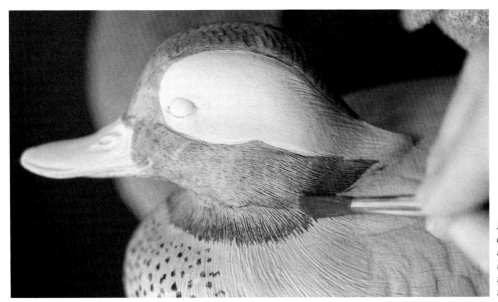

He first paints the crown, cheek, and neck with a mix of 75% burnt sienna and 25% burnt umber (see color chart). He usually uses three or four washes to build up the color.

 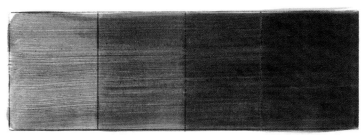

The brown color of the head is a mix of 75% burnt sienna and 25% burnt umber.

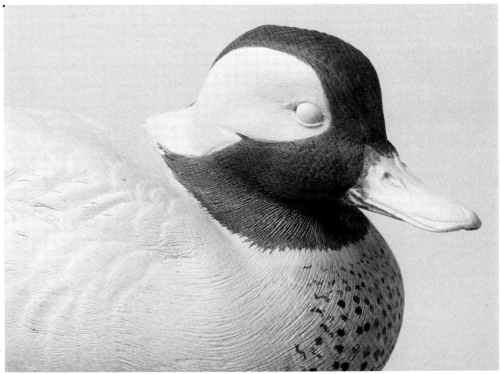

The head with three washes of color has the correct value.

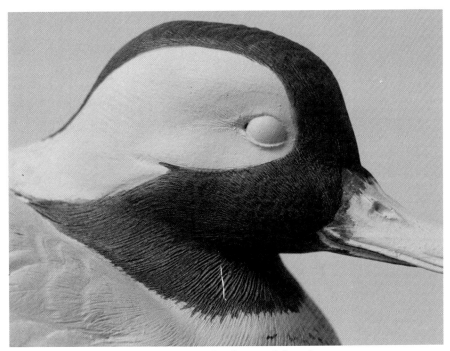

Jim has used a size 1 Raphael #8408 brush to redefine the feather edges and to pull the color down into the breast area.

The sides of the head are painted with a combination of 50% pine green, 40% phthalo green, and 10% carbon black (see color chart), again applied in thin washes. "Mix twice as much paint as you think you'll need so you won't run out," Jim advises. A small amount of green pearl essence is added to the third wash.

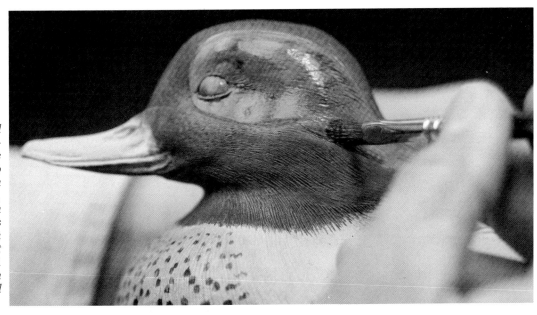

The green inset of the head is painted with a base mix of 50% pine green, 40% phthalo green, and 10% carbon black.

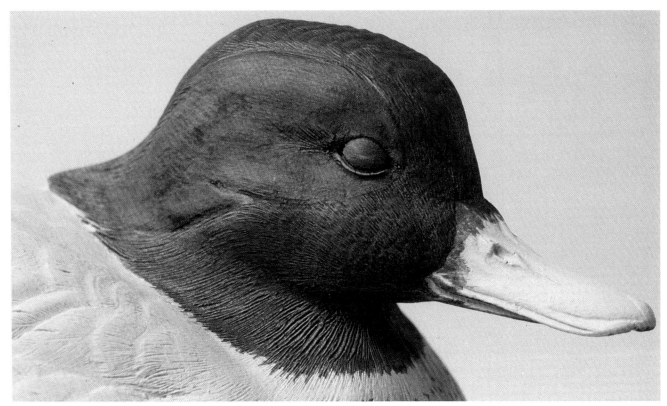

With three washes of color the green has the proper depth and value. Consult your reference material to obtain accurate color values.

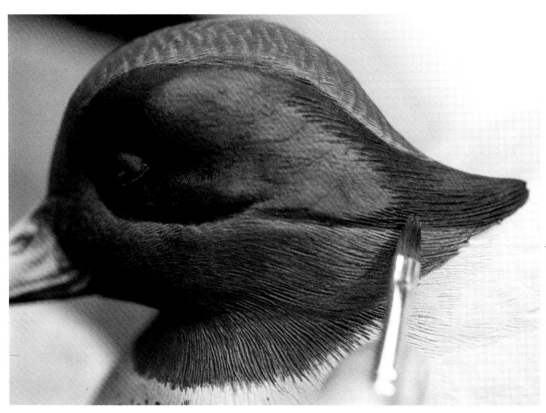

Jim darkens the perimeters of the green with a mix of 50% burnt umber and 50% carbon black. The area should be darkest in front of the eye and at the tip of the crest. Jim dampens the edges of these areas and blends the darker colors to water.

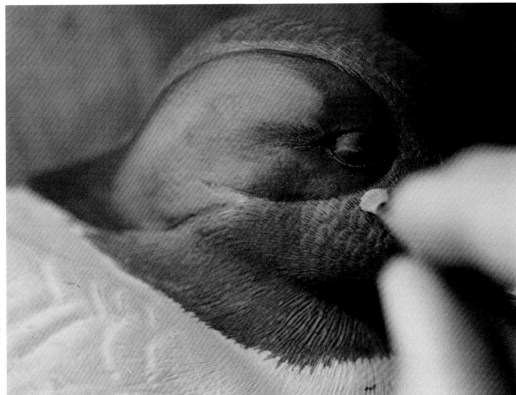

The green area is high-lighted by some very light yellow oxide or yellow ochre feather edges applied with a size 2 Raphael #8408 brush. A few very subtle cadmium yellow highlights will also be added.

Jim will add feather detail to the crown of the head by highlight-ing the carved feathers with a mix of 60% titanium white, 10% burnt sienna, and 30% burnt umber, followed by a couple of very thin washes of burnt umber. Here he mixes the colors with a palette knife.

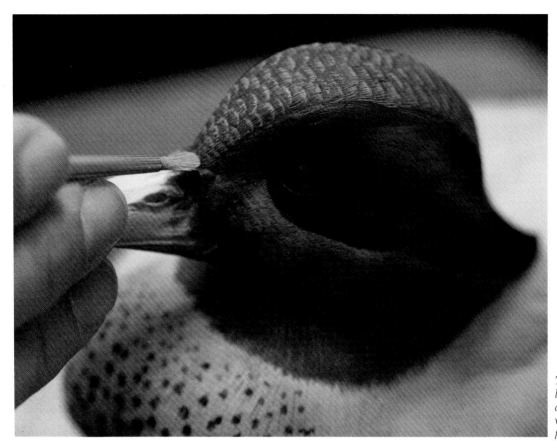

The feathers are high-lighted by applying the color to their edges with a small feather-flicking brush.

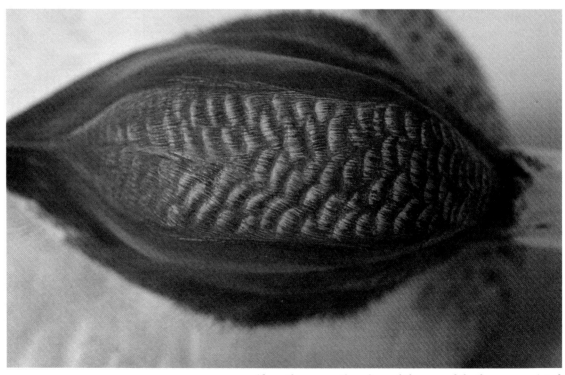

Along the crown the edges of the carved feathers are painted. The area is darkened with a thin wash of burnt sienna and one of burnt umber.

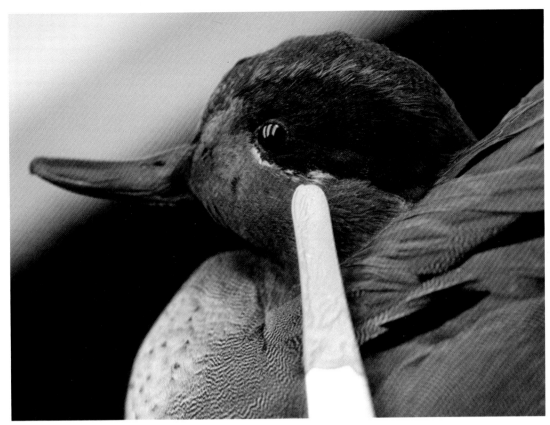

Jim will paint the feather line that separates the green and brown areas of the head with a buff color made by mixing 50% titanium white, 25% yellow oxide, and 25% burnt umber. Here he checks the color with that of his taxidermy mount.

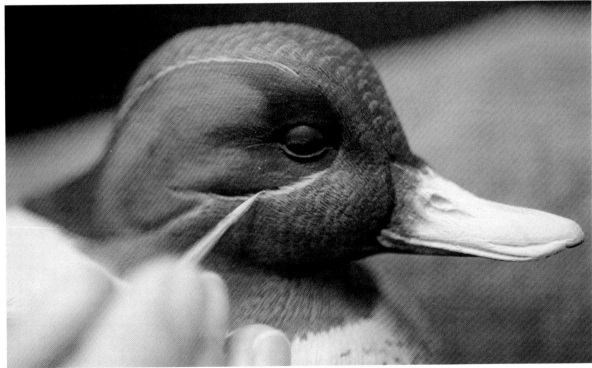

The line runs around the perimeter of the green area and is most pronounced under the eye. Note that Jim has painted a thin black line around the base of the bill where it meets the head. This color is a mix of 50% carbon black and 50% burnt umber.

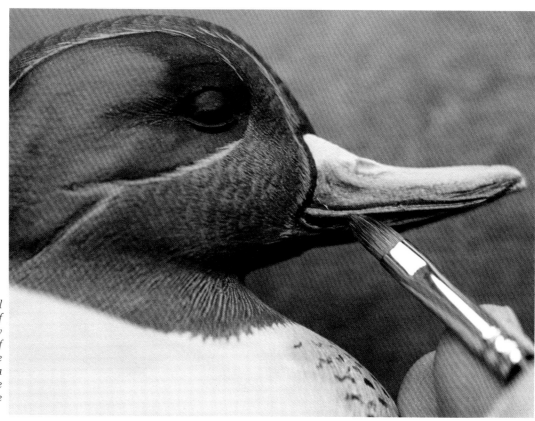

Before painting the bill Jim applied a coat of gesso tinted with raw umber. Then a wash of 30% ultramarine blue and 70% burnt sienna is applied along the lower portions of the bill.

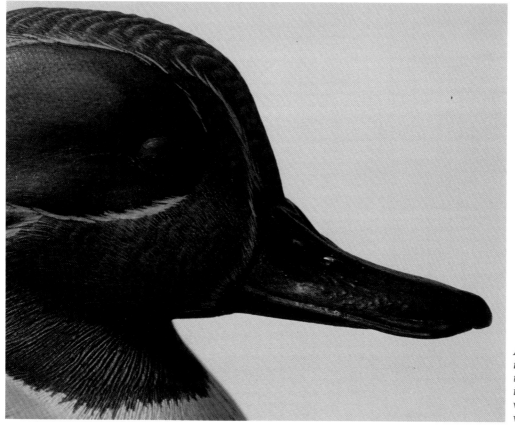

Additional ultramarine blue is added to the mix to paint the top of the bill. The result is a slightly leathery look with a deeper, nearly black value on top of the bill.

Jim prepares the tertials, scapulars, and upper rump of the teal by applying in washes a mix of 45% nimbus gray, 25% burnt umber, 25% raw umber, and 5% carbon black (see color chart). To this mix he adds a little iridescent white—about 5% of the total mass. Jim applies three washes to the tertials and scapulars and two to the rump area.

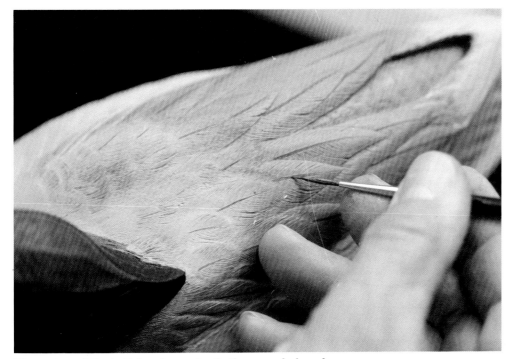

The centers of the tertial and scapular feathers are darkened with a mix of 55% raw umber, 25% burnt umber, 15% nimbus gray, and 5% carbon black (see color wheel). The lining brush is used to paint the quills with this color.

The base color for the tertials, scapulars, and upper rump area is 45% nimbus gray, 25% burnt umber, 25% raw umber, 5% carbon black, plus 5% iridescent white.

The centers of the tertials and scapulars are painted with a mix of 55% raw umber, 25% burnt umber, 15% nimbus gray, and 5% carbon black.

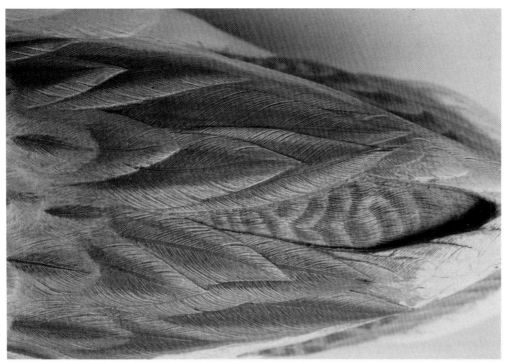

The color is blended onto the tertials and scapulars with two size 6 filbert-type brushes, darkening the centers. Feathers in the rump area that have quills showing are also painted.

Testors brown model paint is used to paint the eye, then a dab of Testors black enamel is used to create the iris.

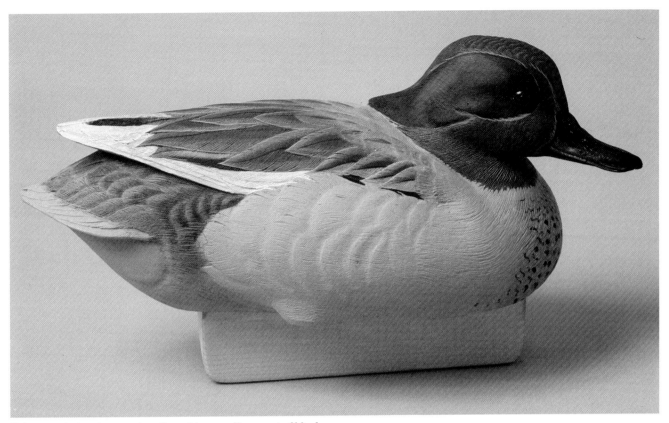

Prior to painting the speculum Jim adds a small amount of black to the lower part of the tertial feathers. He paints the primaries with titanium white tinted with a small amount of raw umber.

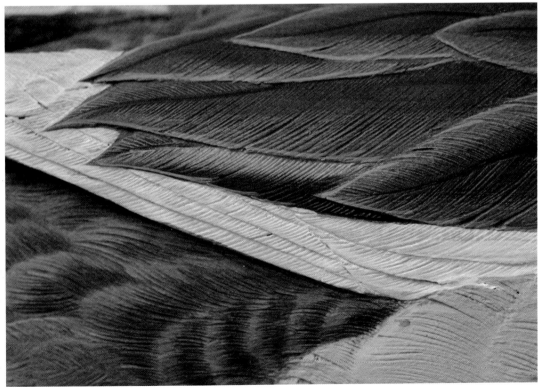

Jim mixes equal amounts of titanium white and gesso, adds enough raw umber to produce a buff color, and uses this color to carefully edge the primary and scapular feathers.

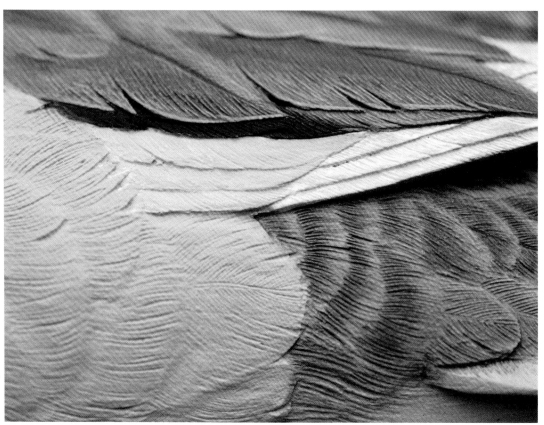

Cadmium yellow or yellow light is used as the base coat for the speculum.

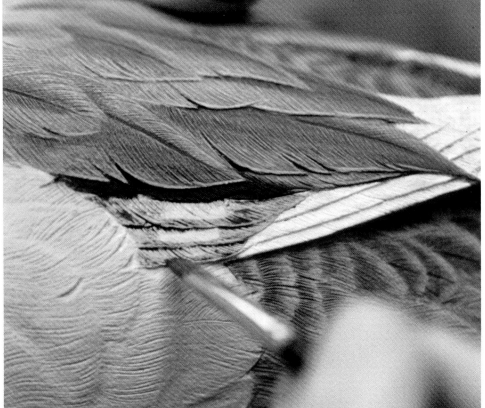

A mix of approximately 90% pine green or Hooker's green and 10% carbon black is applied over the yellow using the color-to-water technique. The centers of each feather are dampened, the green is applied on both sides, and the color is blended into the water to achieve a smooth transition. Two or three washes of this color are used. The final wash contains a small amount of green pearl essence and covers the entire scapular area, blending the yellow with the green.

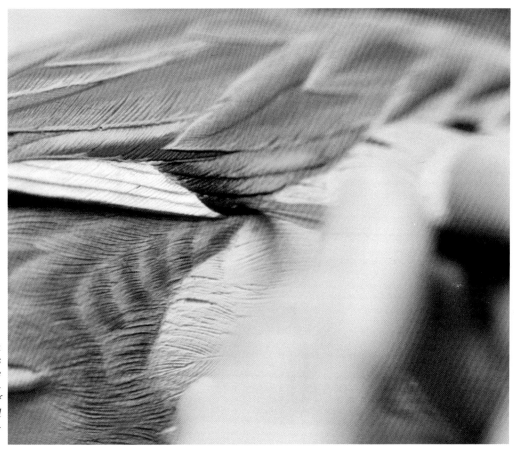

A mix of 60% carbon black and 40% burnt umber is blended into the tip using the color-to-water blending technique. A small amount of blue pearl essence is added to the paint to provide iridescence.

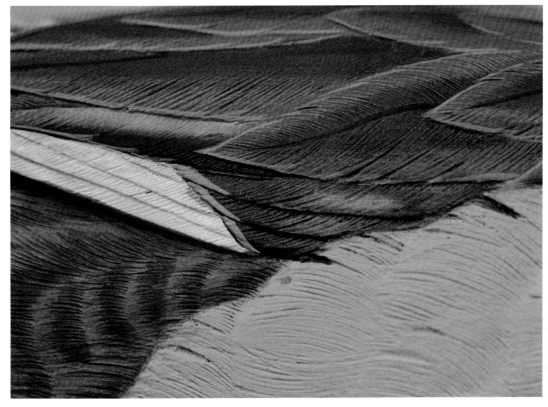

A narrow gray line of 75% gesso mixed with 25% raw umber establishes the rear margin of the speculum.

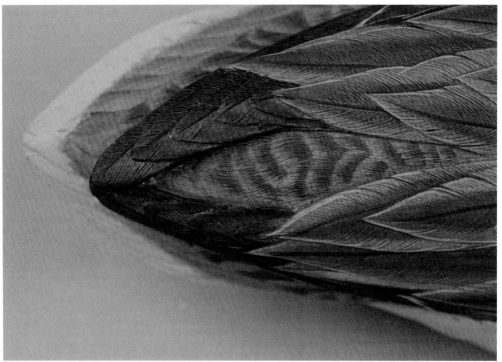

The primaries have been gessoed again to cover any brown paint that might have spilled over onto them. Jim then applies a mix of 60% burnt umber, 30% titanium white, 5% carbon black, and 5% raw sienna. After three washes of this color Jim darkens the outer halves of the feathers by adding a small amount of burnt umber and carbon black to the base color and painting them with this combination.

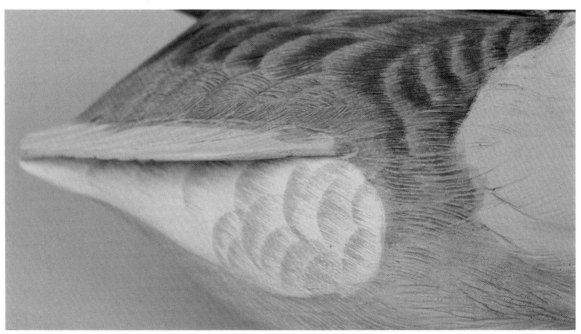

Under the rump of the teal Jim adds a mixture of 80% gesso, 10% yellow oxide, and 10% burnt umber to produce a champagne color. Then he flicks on a series of feather edges with straight raw sienna.

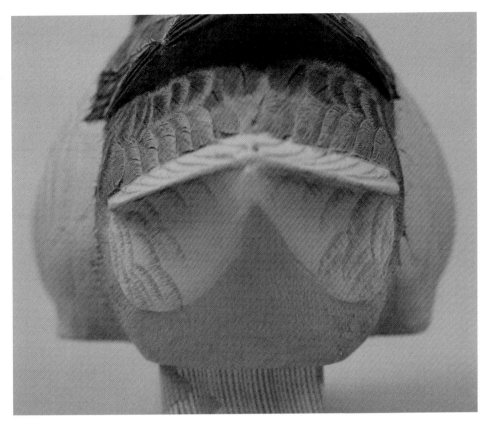

Titanium white with a small amount of raw umber is used with a size 0 brush to create subtle feather markings along the tip of the tail.

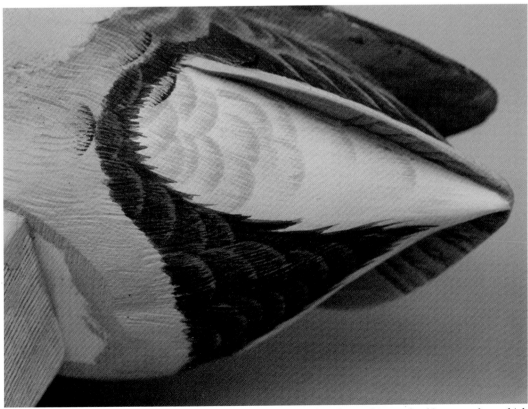

The area is finished with one thin wash of burnt umber, which tones it down and brings the color values closer together.

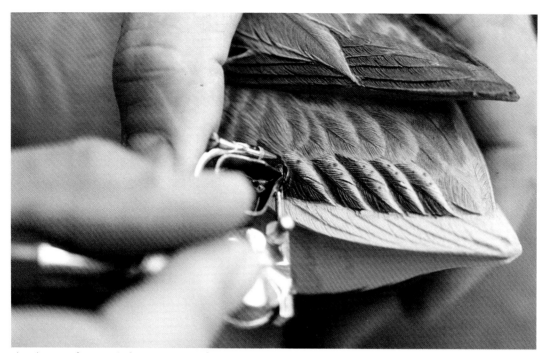

A mixture of 70% nimbus gray, 15% burnt umber, and 15% carbon black provides the base color for the tail. This color is applied under the rump and to the lower half of the tail covert feathers. The champagne-color mix used on the rump is blended into the top edges of the feathers, the quills are painted with a mix of 50% carbon black and 50% burnt umber, and the airbrush is used with the same color mix to add small dots to the upper parts of these feathers.

The outer row of tail feathers is painted with a slightly darker version of the base color mix made by adding approximately 5% each of carbon black and burnt umber. The paint is applied in a color-to-water blend. Jim uses a size 2 and size 4 filbert brush, applying the color with the smaller one and using the larger one to wet the outside edge of each feather. As a result, the outside edge is lighter. The feathers are finished by applying titanium white or gesso to which has been added 10% to 15% raw umber to produce a buff color. The lining brush is used to apply this color to the edges of the feathers. The quills are darkened with the carbon black/burnt umber mix. If the tail is too light, a thin wash of burnt umber over the entire area will darken it.

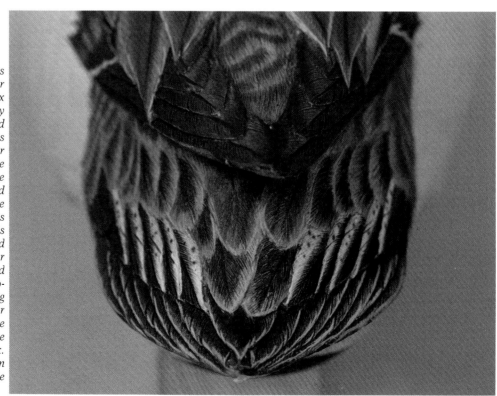

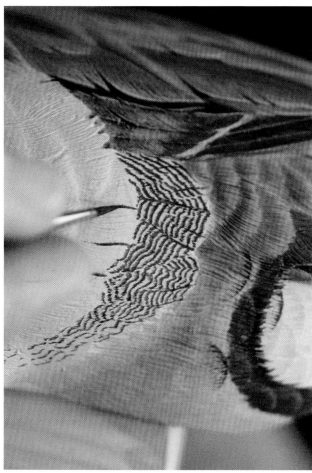

The vermiculation is applied with a size 1 or size 2 Raphael #8408 brush. The color is the same carbon black/burnt umber mix used earlier for the spots on the breast. Before beginning the vermiculation Jim cleaned the area with a paper towel dampened with Windex. The Windex, which contains ammonia, removes fingerprints and oils that could cause the paint not to adhere. If Windex is applied to the painted area, use extreme caution. Don't rub the bird with the paper towel, but blot gently, Jim advises.

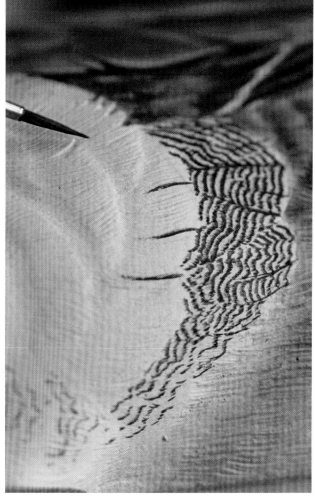

A taxidermy mount is a very helpful guide for establishing the pattern of vermiculation. Jim begins at the rear of the side-pockets and works forward until the area is completed.

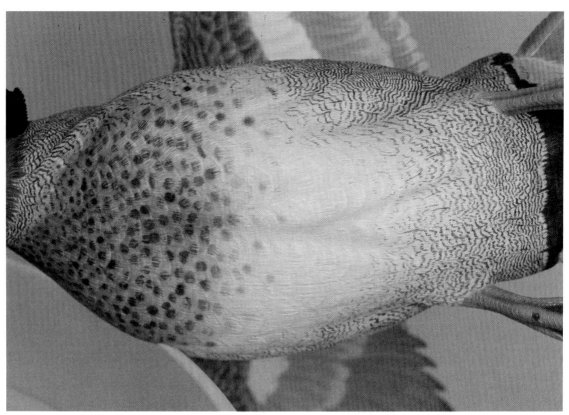

If you are painting a teal drake whose belly shows, be aware of the vermiculation pattern in that area. The vermiculation blends to white just below the breast and lower sidepockets.

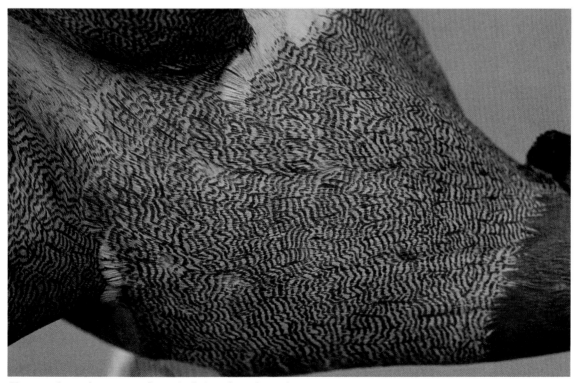

Close-up shows the pattern of vermiculation along the neck.

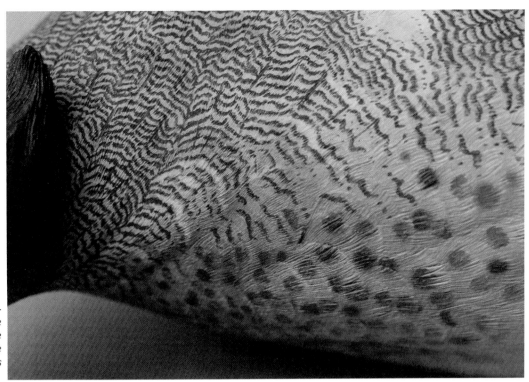

Note how the lines of vermiculation blend with the spots of the breast. The color should be the same for the vermiculated lines and the spots.

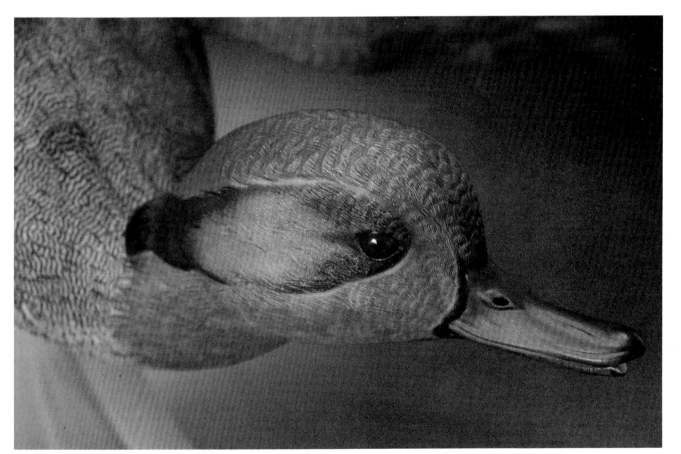

Close-up of the head of a teal drake from Jim's recent carving, Red River Rockets.

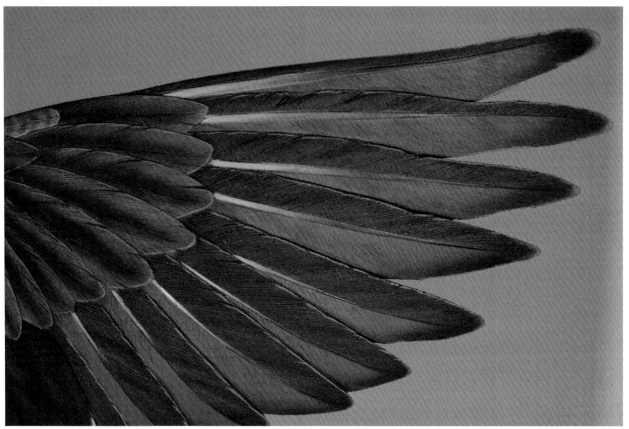

Detail of outstretched wing shows the darker value of color along the top portions of the wings.

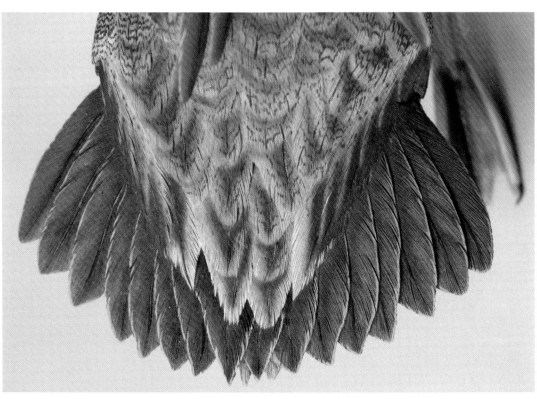

Upper view of the tail feathers.

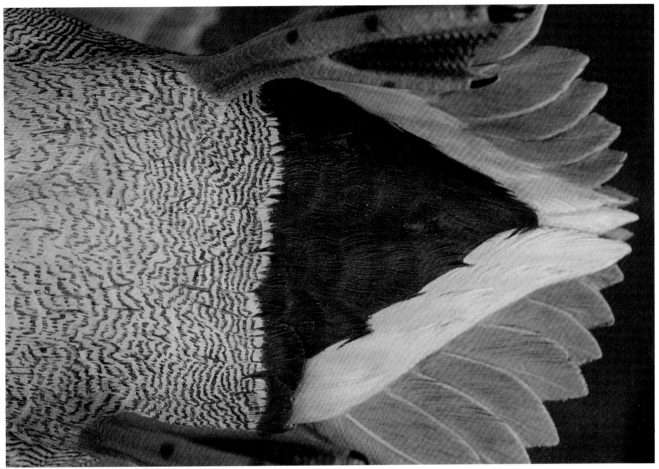

Detail under the rump of the drake.

4

The Canvasback Drake

The canvasback, that handsome diving duck of such legendary waterfowling haunts as the Chesapeake Bay's Susquehanna Flats, provides several interesting painting exercises. Its back, for example, is not simply white, but has subtle shadings and detail that give the bird definition. The rust-colored head seems at first a straightforward painting task, but look closely and you'll see along the cheek some subtle highlights of light red and perhaps even yellow. Then there are the little feather edges along the crown, the variances in color value on the primary and tail covert feathers, and, of course, the vermiculation.

Ah yes, the vermiculation. The canvasback drake provides a postgraduate seminar in vermiculation. In some areas it's bold and well defined, and in other areas the lines are small and subdued, almost disappearing into a wash of white feathers. You can vermiculate with an artist's pencil, a draftsman's pen set, or a fine sable paintbrush.

Jim says that no aspect of painting the canvasback should be considered intimidating. Techniques such as painting white on white, highlighting cheek contours by blending color to water, and vermiculation are not difficult to learn. All it takes is practice, good reference material, and good work habits, which include keeping a clean work area, mixing paints care-

MATERIALS & COLORS

Hyplar matte medium-varnish

Testors model enamel:
red for eye, black for pupil

Berol Prismacolor pencil:
cold gray dark

gesso

Payne's gray

raw umber

burnt umber

Hyplar burnt sienna

carbon black

Liquitex titanium white

iridescent white

Hyplar or Liquitex iridescent silver

yellow oxide

Hyplar ultramarine blue

naphtha red light

fully and thoroughly, and taking the time to do each job well. Don't get discouraged.

Painting a bird like a canvasback might seem intimidating at first, but in this session we'll break the job down into a series of small tasks, none of which is difficult to master. The drake in this session is one of Jim's acrylic study birds, so he begins by applying gesso directly to the surface.

Jim mixes 85% gesso, 10% Payne's gray, and 5% raw umber to produce the base color for the sidepocket areas and the back (see color chart). Gesso is a thick medium and should always be applied by brushing with the carved feather flow of the bird using a stiff brush such as a size 18 Raphael #355. Apply enough

coats to cover any irregularities such as plastic filler. The drake should have a uniform surface before painting begins. Jim usually applies two or three coats, allowing each to air dry between applications. Drying gesso with a hair dryer could cause tiny air bubbles to form.

Jim begins by using a soft lead pencil to lightly outline the black areas of the breast and rump. He uses a taxidermy specimen or photographs as reference material to determine the margins of these areas. In addition to the aviary attached to his studio, he keeps comprehensive files on all the waterfowl species he carves. His files include photographs, magazine articles, painting notes, and other information.

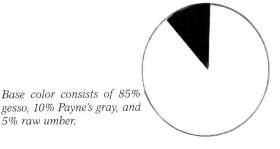

Base color consists of 85% gesso, 10% Payne's gray, and 5% raw umber.

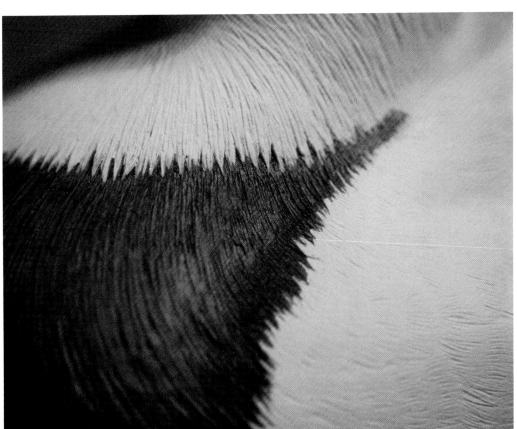

Jim applies a series of washes to the breast and rump. The color is his standard mix of 40% Hyplar ultramarine blue and 60% Hyplar burnt sienna. This is a more transparent mix than a color containing carbon black, which is heavily pigmented. The paint is applied with a size 6 feather-flicking brush. The feather edges of the black breast are softened with feather streaks pulled into the white area. Jim uses the edge of a size 4 filbert-type brush or a size 2 Raphael #8220 lining brush to do this. The feather marks must be pulled into the white before the paint has had a chance to set up. Then he applies several more washes of black to the breast and rump, building color through a series of thin applications.

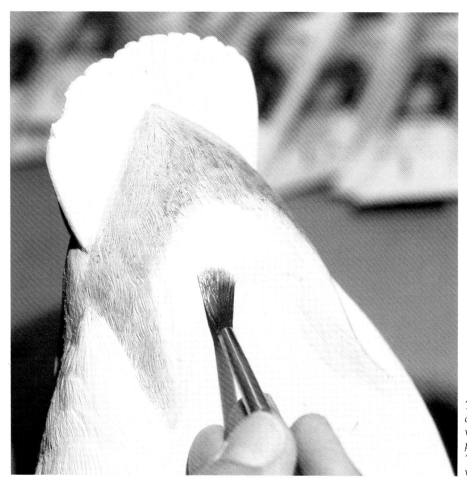

The same color mix is used on the top and the bottom of the rump area. "Don't worry about paint spilling over onto the primaries or tail feathers," says Jim. "Those areas can be neutralized later with gesso before painting."

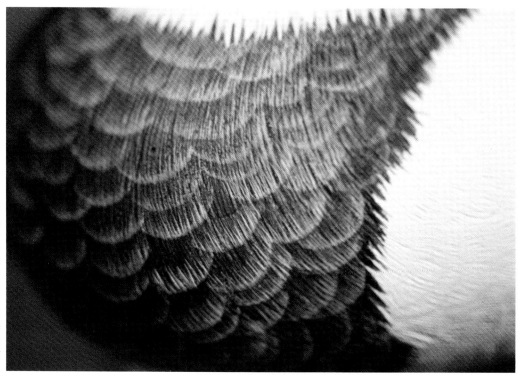

Jim adds feather edges to the breast and rump with a mix of 75% Liquitex titanium white and 25% raw umber. Straight white feather edges would have a stark, graphic quality, so Jim warms the mixture with the raw umber. A feather-flicking brush is used, and he starts on the lower portion of the breast and works upward.

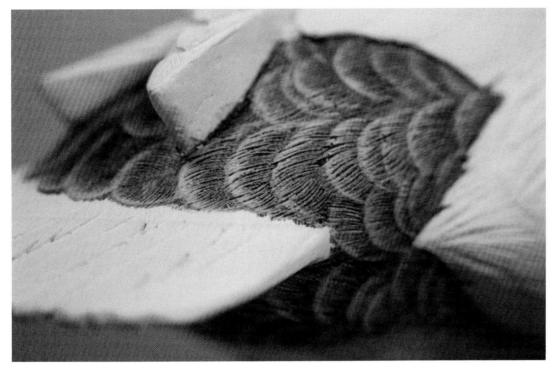

The same color is used to paint feather edges on the rump. The edges should not be of uniform size and evenly spaced. Make them slightly irregular and they will appear more realistic.

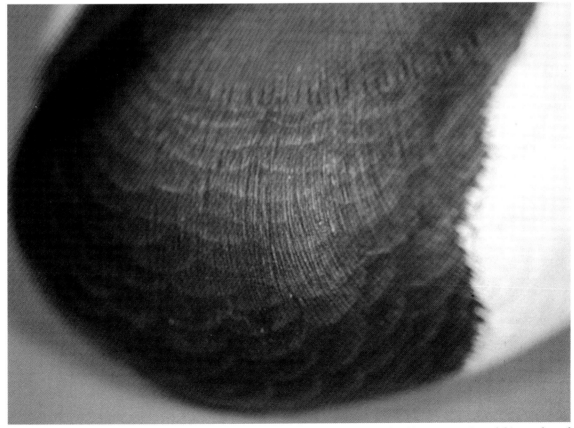

The feather edges are subdued by a succession of thin washes of burnt umber. These washes tone down the feather markings, making them more subtle, and they add a bit of warmth to the black breast.

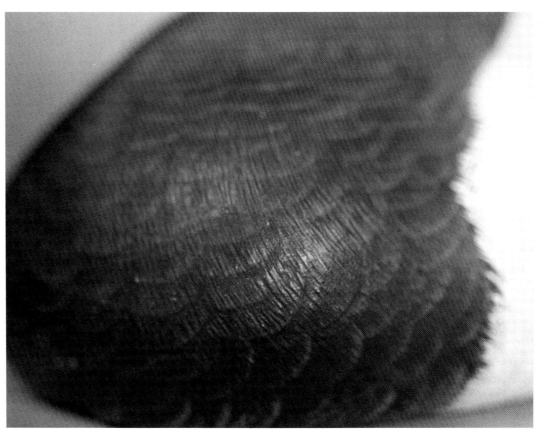

The size 6 Liquitex #511 brush is used to apply the wash. Jim diluates the color greatly with water before applying, then dries it with a hair dryer and applies a second wash.

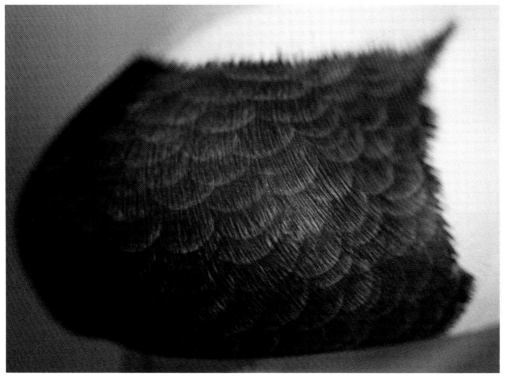

You should apply enough washes to subdue the feather edges, but not enough to turn the breast burnt umber. Tinting the titanium white feather edges with raw umber helps reduce the number of washes needed.

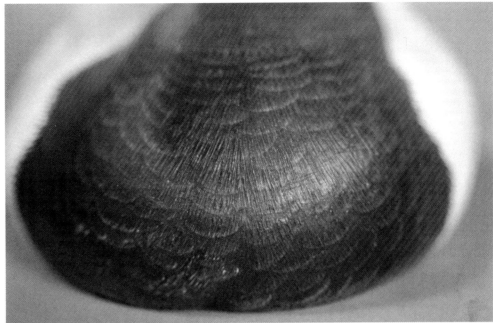

The feather edges on the bottom portion of the breast are somewhat whiter than those on the upper breast so Jim applies only one wash to this area. The second and third washes are applied to only the top two-thirds of the breast. The same wash should be applied to the rump at this time. The breast can be finished with a wash of matte medium-varnish diluted in equal parts with water to provide a slightly waxy look common to diving ducks.

The base color of the head is a mix of 70% burnt sienna and 30% burnt umber.

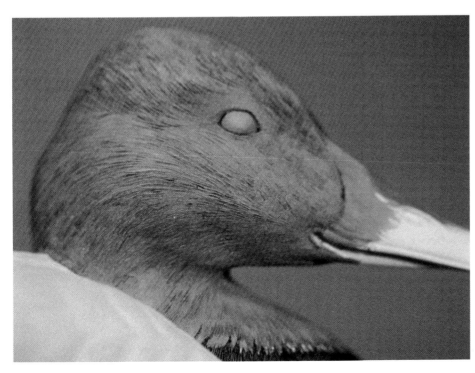

The head is painted with a combination of 70% burnt sienna and 30% burnt umber to produce the rusty base color (see color chart). The color is built up through a series of three or four thin applications. A small lining brush is used to cut in the feather edges where the red meets the black breast. If paint spills over onto the neck while painting the breast, Jim neutralizes the area by applying a base coat of gesso tinted with yellow oxide. Because acrylic paints are transparent, it is imperative that they be applied over a uniform surface.

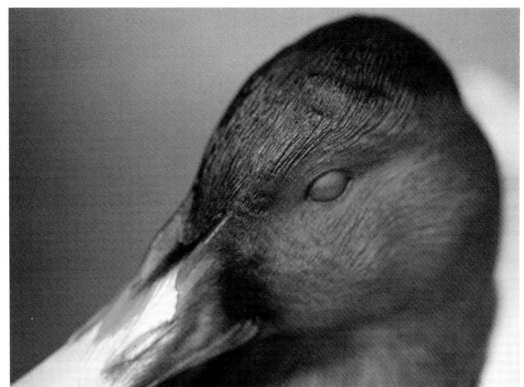

The crown and the area immediately behind the bill are painted with Jim's standard Hyplar black mix. Jim dampens the outer margins of these areas with water, then blends the color to water to produce a smooth, gradual edge.

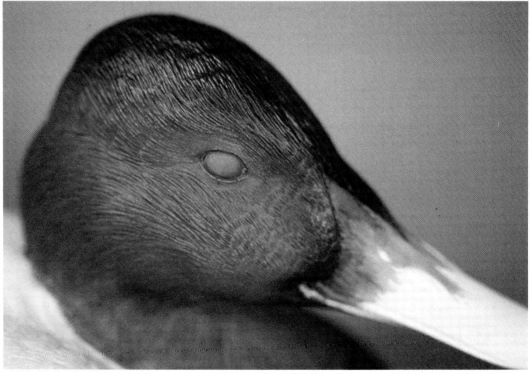

The top of the head is slightly darker than the outer edges, so Jim applies the first wash to the entire area. Then the second and third washes are applied only to the top. The bill can at this point be painted with the same standard Hyplar black mix. Finish the bill with two applications of matte medium-varnish diluted in equal parts with water.

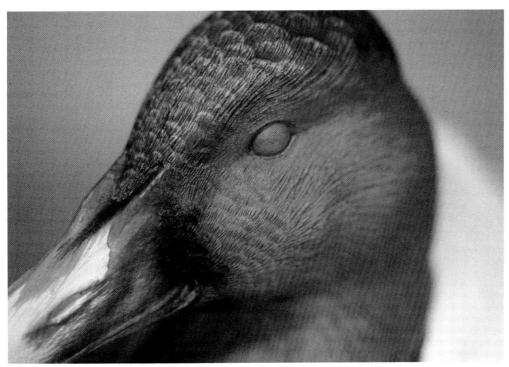

With the crown dry Jim adds small feather edges to the dark area with a size 2 Raphael #8404 feather-flicking brush. The color is the titanium white/raw umber mix used for the breast and rump feather edges, which has a reddish cast. After applying the feather edges to the crown he follows with a couple of thin washes of the 70% burnt sienna/30% burnt umber mixture. A subtle highlight is added to the cheeks by applying one or two very thin washes of naphtha red light.

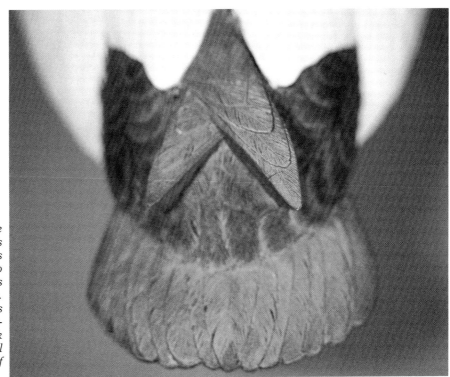

The primaries and tail feathers are painted the same raw umber/Payne's gray/white gesso base color. Jim tints this mix very slightly with iridescent white to provide the subtle glitter to the feathers that seems to be common in diving ducks. If you spilled black paint on these areas while painting the rump, gesso them before applying burnt umber. The black applied to the rump is darker and will show through the burnt umber washes if not covered with gesso.

With three or four washes of base color applied, Jim darkens the bases of the tail covert feathers with a wash of 70% burnt umber and 30% carbon black. The color is applied with the color-to-water blending method. First, Jim dampens the outer edges, then applies paint to the inner portions and blends the color to water, creating a gradual transition. The same color is used with a lining brush to darken the quills and feather splits. Jim completes the area using the size 2 Raphael #8220 lining brush to add a buff edge to the tail covert feathers. This is the same color (75% titanium white, 25% raw umber) used for the feather edges on the head.

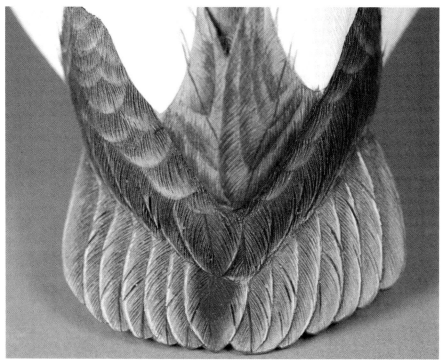

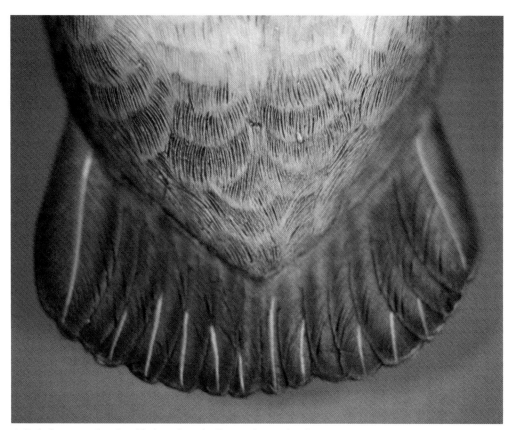

A little burnt umber is added to the mix Jim used to paint the tops of the tail feathers, and this color is applied to the bottoms of these feathers in a series of about three applications. The same buff color he used to edge the upper tail covert feathers is used to paint the quills beneath the tail.

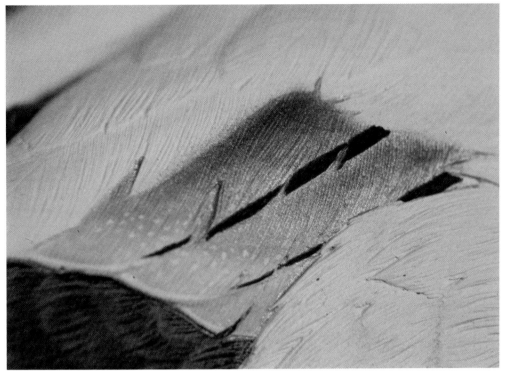

The base color of the speculum is iridescent silver, to which Jim adds small amounts of burnt umber, carbon black, and gesso (see color chart). A size 4 filbert brush is used. A black edge is added to the feathers by applying carbon black tinted with burnt umber with the size 2 #8220 lining brush. Note the shadow effect along the upper corner.

The speculum is painted with a mix of 75% iridescent silver, 10% carbon black, 10% burnt umber, and 5% gesso.

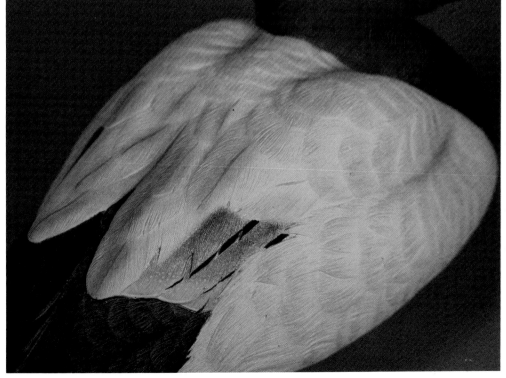

A small white line is added to the rear edges of each speculum feather; then Jim uses a very thin wash of about 60% burnt umber, 25% gesso, 5% Mars or carbon black, and 10% iridescent white to add definition to the tertial and scapular feathers. This step is not intended so much to provide color as it is to help show the carved feather texture by darkening the grooves left by the burning pen. Jim dampens the area around these feathers, then applies the pigment and blends it to water, creating a very subtle wash.

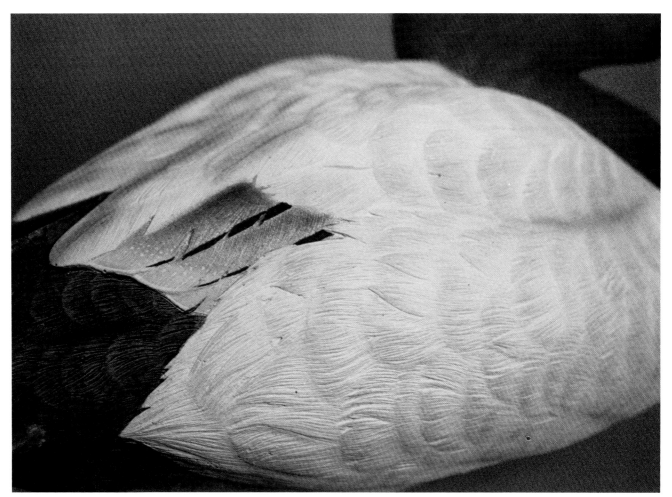

The feather-flicking brush is used with watery burnt umber to edge the white feathers along the sides of the drake.

Different carvers use different methods of adding vermiculation. It can be duplicated by using a pen or brush to create a series of wiggly lines, or it can be a series of dots, such as in this close-up photo. Jim says that the most important resource a painter can have is good reference material, preferably a taxidermy mount or a live bird. When painting vermiculation Jim will often tether one of his aviary birds and have it on his work table as he paints.

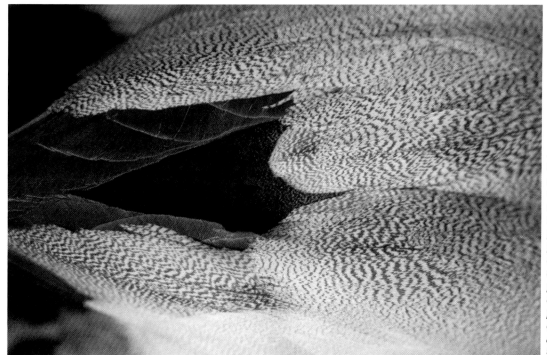

Depending upon the species of bird and the size and pattern of the vermiculation, Jim uses three methods of application: artist's pencil, draftsman's pen, or brush. For this application he will use a Berol Prismacolor pencil in cold gray dark. A Rapidograph pen also can be used, or a fine brush such as the size 2 Raphael #8404.

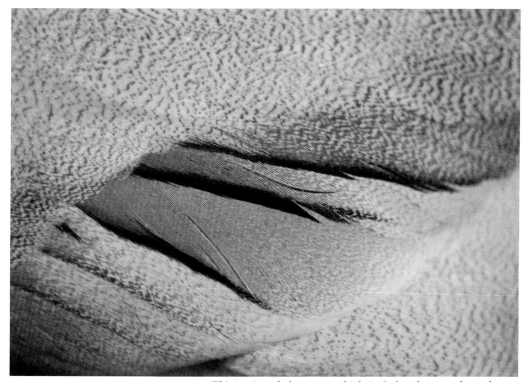

This series of close-ups, which includes the next four photos, shows the pattern and size of vermiculation lines on the sides and back of the drake. Vermiculation is much bolder on the back, along the scapular and tertial feathers, which were darkened earlier with a wash. Vermiculation on the sidepockets is much lighter, consisting of a series of randomly spaced dots instead of bold lines. If your vermiculation along the sides is too dark, you can lighten it by adding a thin white wash.

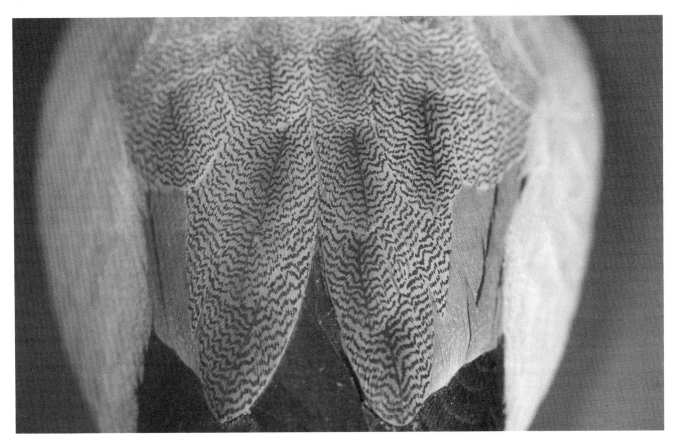

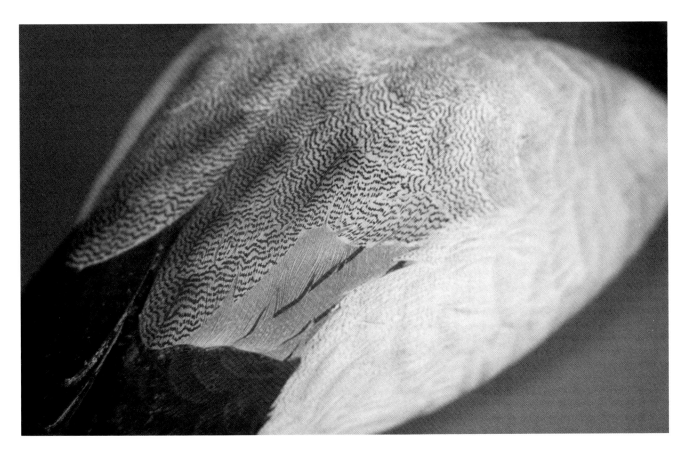

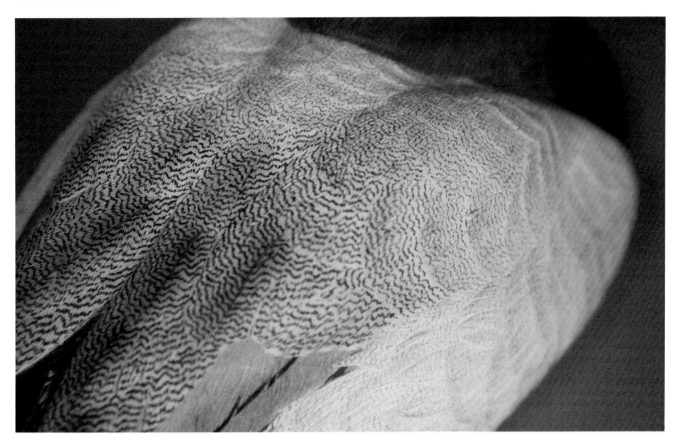

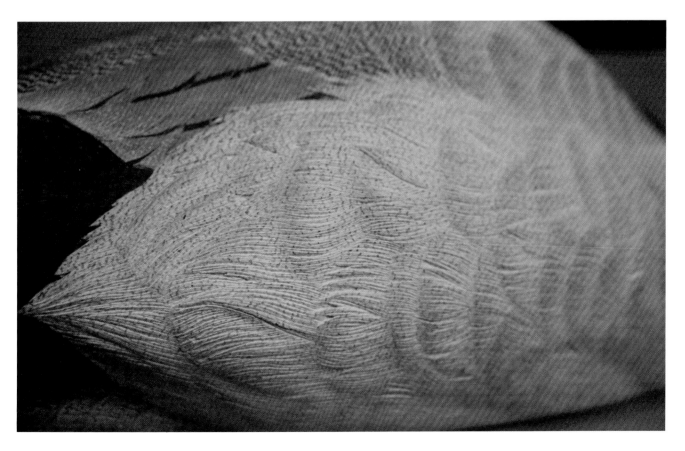

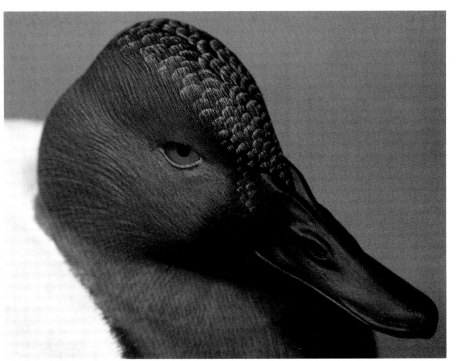

Close-up photo shows the painted bill and eye. Because this is a molded study bird it does not have glass eyes. These were painted with Testors enamel paint (red for the eye, black for the pupil). Two applications of equal parts matte medium-varnish and water give the bill a waxy, lifelike look.

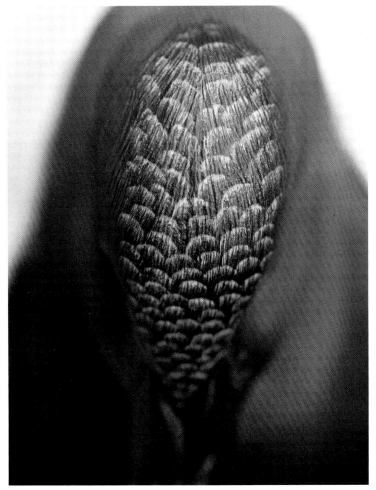

Close-up of the crown shows the white feather edges.

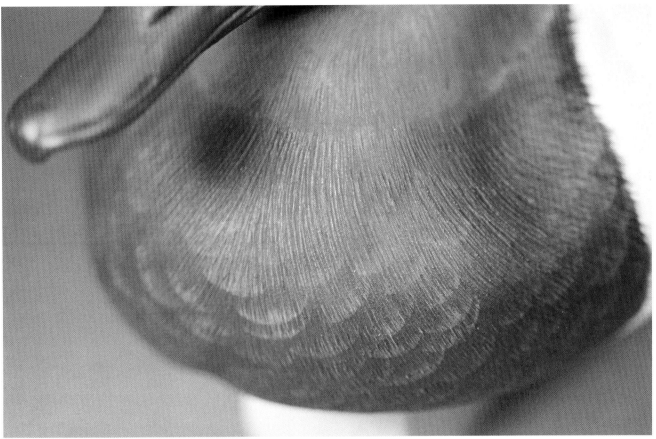

Feather edges on the breast should be subtle. These were painted with titanium white tinted with raw umber, then a series of burnt umber washes further toned down the contrast.

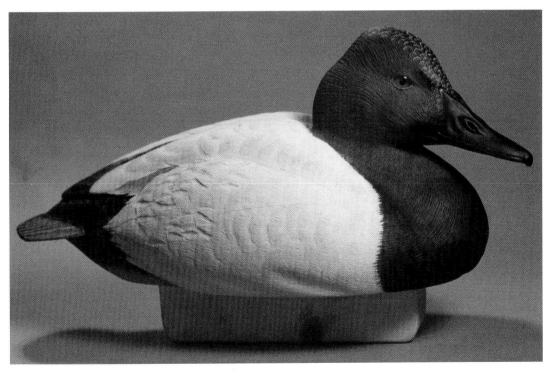

Jim's completed canvasback drake.

5

Black on Black, White on White: The Bufflehead Drake

The bufflehead drake presents an interesting challenge, and an important lesson, because to be successful the painter must master the subtleties of painting white on white, and black on black.

"The sides and breast of the drake appear white, but the painter must retain feather detail in those areas or the bird will have a paint-by-number look," says Jim. "The back looks black from a distance, but if you look closely you'll see all sorts of detail and texture. This is where acrylics are so valuable. In applying transparent washes of color we can build up values and create depth."

Again, Jim is demonstrating his painting techniques on one of his molded study birds so he begins with applications of gesso tinted with Payne's gray and raw umber to produce a very light gray. When white feathers are added, they will show up against the gray background. Then subsequent washes of white will lighten the gray base coat, bringing the feather details and the base color closer together.

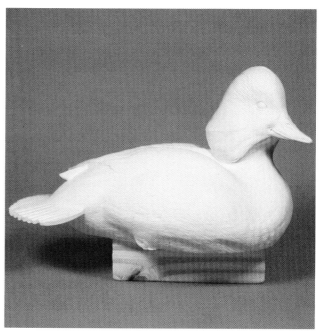

The molded study bird, ready for painting.

MATERIALS & COLORS

Hyplar matte medium-varnish

Testors model enamel:
brown for eye, black for pupil

gesso

raw umber

burnt umber

Hyplar burnt sienna

Payne's gray

carbon black

Mars black

phthalo green

dioxazine purple

titanium white

yellow oxide

naphtha red light

Hyplar ultramarine blue

green pearl essence powder

purple pearl essence powder

white pearl essence powder

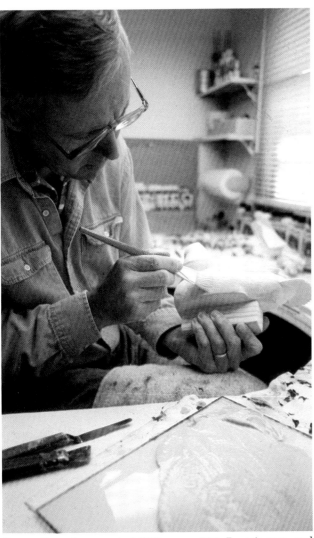

Jim applies a base coat of 80% gesso, 10% Payne's gray, and 10% raw umber (see color chart). The object is to give the bird a slightly gray base coat on which the white feather markings will show clearly.

The base color consists of 80% gesso, 10% raw umber, and 10% Payne's gray.

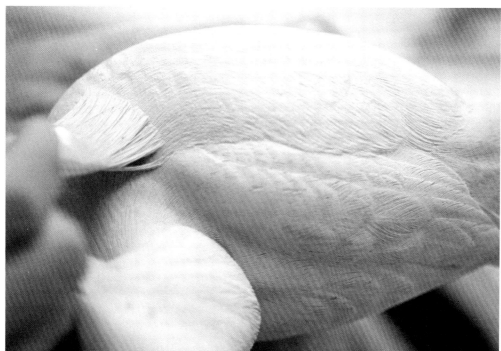

Jim advises to always apply gesso with a stiff bristle brush such as the size 18 Raphael #355 and work in the direction of the texture lines. Let the gesso air dry. It's a thick medium and if it dries too quickly, pinholes could develop. Use a hair dryer or similar heat source to dry color washes only.

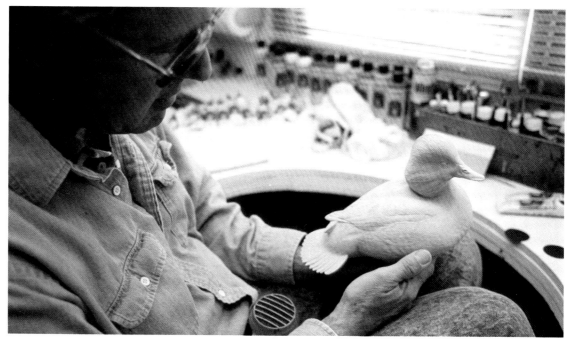

Allow the gesso to dry and look carefully at the surface of the bird. The finish should be smooth and uniform with no light or dark areas and no highlights. If a plastic filler has been used around the eyes or neck, sufficient coats of gesso should be applied to cover and seal these areas. The molded study bird seals fairly easily. Jim emphasizes the importance of keeping a clean work area and mixing the gesso and pigment thoroughly. Never let dried paint accumulate on your palette because particles could be transferred to the bird. Keeping records of paint ratios, including color samples, will make painting your next bufflehead drake much easier.

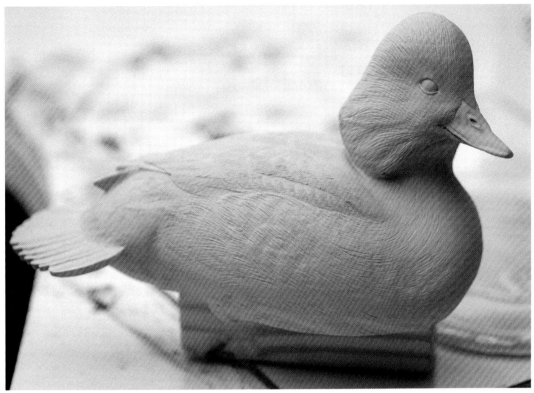

The third application of gesso has sealed the study bird, and Jim is ready to paint.

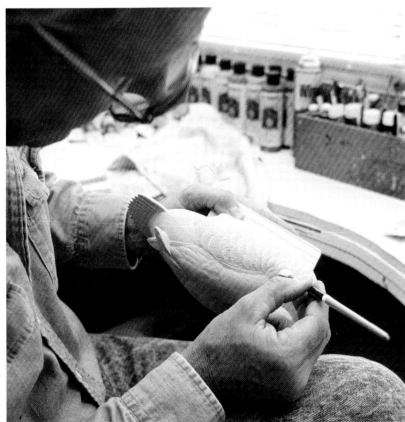

He begins by using straight titanium white and a flattened feather-flicking brush to add feather detail on the sides and breast. The brush Jim uses has been adapted for this procedure by gradually flattening the sable bristles. After each use Jim flattens the bristles with a clean palette knife and stores the brush so the bristles will remain flat. In time the brush becomes "trained" for feather flicking.

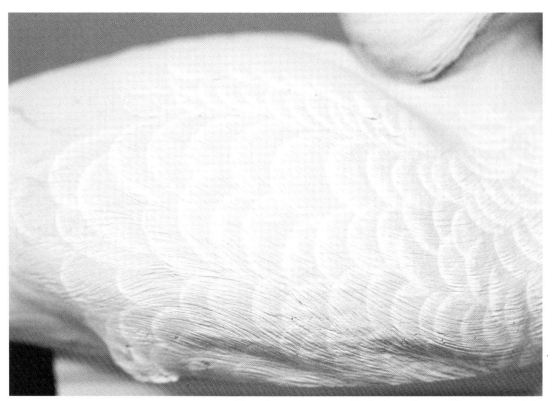

The white edges are added along the outside margins of the feathers that have been carved into the bird. The flicking technique depends upon having the correct ratio of water to paint on the brush. Jim dampens his brush with water, picks up a little paint, and lightly brushes it along the edges of the feathers. If the brush contains too much water, it won't fan out; if it's too dry, the paint won't pull out of the brush. Practice this technique before applying it to a carved bird.

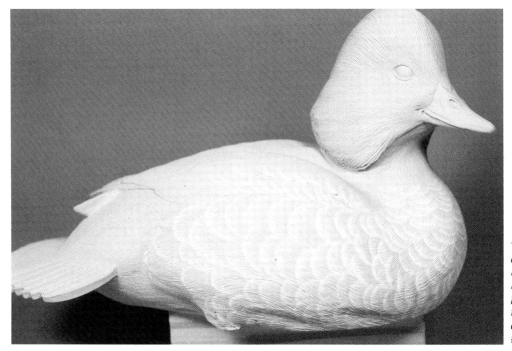

The bufflehead with feather details added to the sides and breast. Jim says a variety of brushes can be adapted to the feather-flicking technique. He uses a size 6 Raphael #8404, as well as a size 6 Liquitex #511.

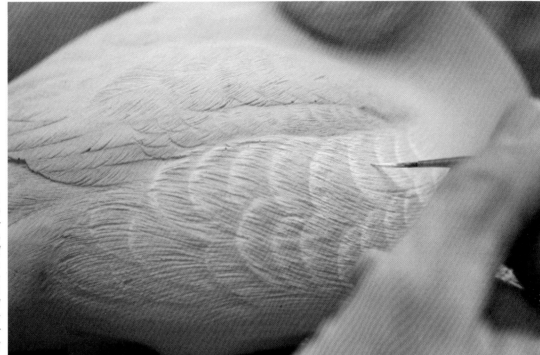

A size 0 or size 1 brush can be used to extend the feather marks slightly or to retouch those that did not transfer well from the larger brush. Here Jim uses a size 1 Raphael #8408 to pull a little white paint through the feather markings, extending them slightly.

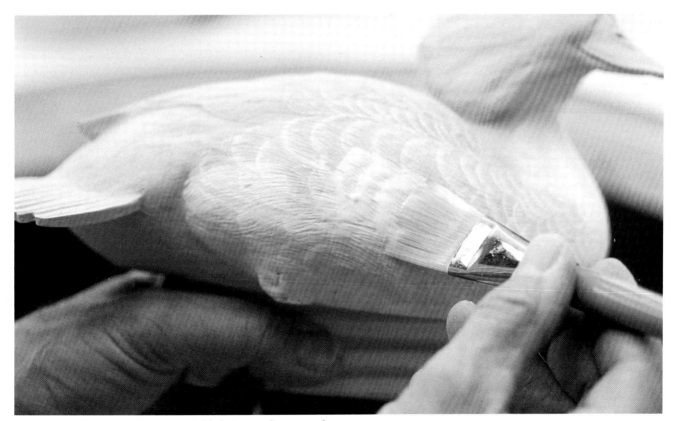

After the feather edges have been added Jim applies several coats of a thin wash of titanium white, blending each wash of color into water. He first dampens the area around the sides and breast, then applies the white wash and blends the white into the water, producing a smooth, gradual transition

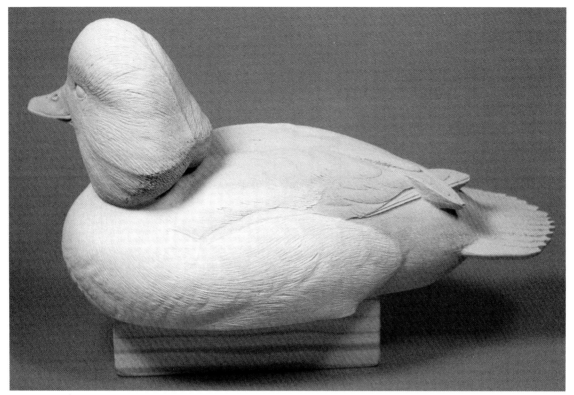

Four washes of white have been applied. The goal is to make the area as white as possible but still have the white feather edges visible. "Sometimes it takes three washes, sometimes ten," Jim says. "The goal is to make the two values of white as close as you can but still retain some separation."

A little Payne's gray and burnt umber (5% each) are added to the white, and a thin wash is applied in the shallow creases along the breast and sides. This produces a slight shadow in these indentations.

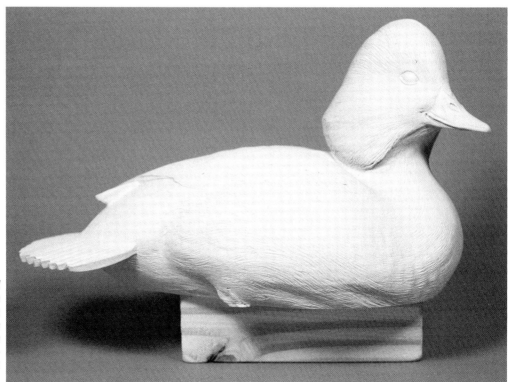

Matte medium-varnish is diluted equally with water and applied over the sides and breast, sealing the area and providing a slightly waxy look. Jim adds a small amount of yellow oxide (about 5%) to the matte medium-varnish.

Jim begins painting the head by first sketching very lightly the margins of the white area. The dimensions of the white patch will vary depending upon the attitude of the bird. If the head is snuggled down into the body, it will be smaller than if the head is extended or if the feathers are fluffed out. Consult your reference material.

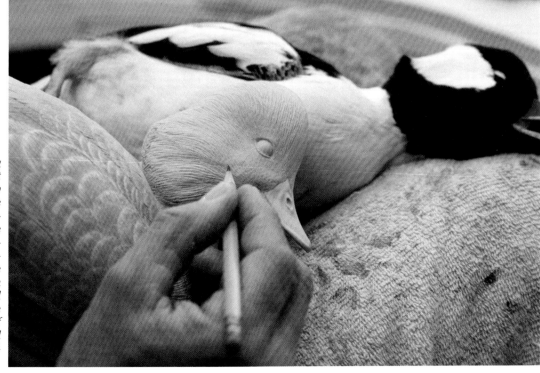

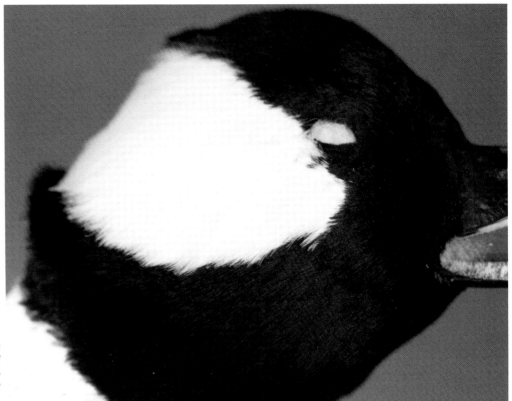

Note the white patch on this taxidermy specimen. Small white feathers overlap onto the dark area, creating a soft transition.

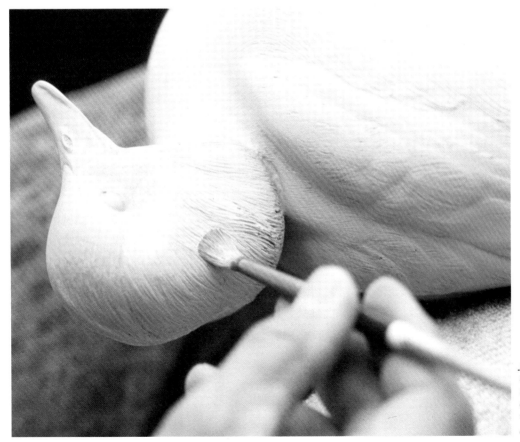

Jim paints the patch titanium white, blending color to water along the margins of the patch. Three or four washes of white will be applied.

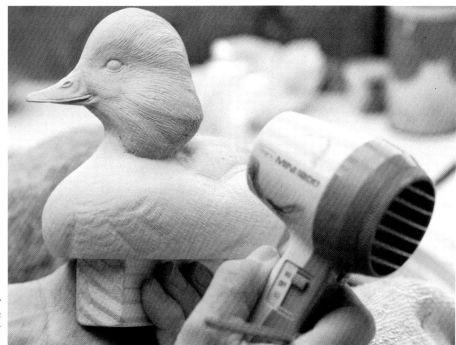

Although Jim doesn't use the hair dryer on a thick medium like gesso, he does use it when applying washes of color. It speeds up the drying time considerably.

The green color for the head is a mix of 50% phthalo green and 50% carbon black. Green pearl essence powder is added to provide iridescence.

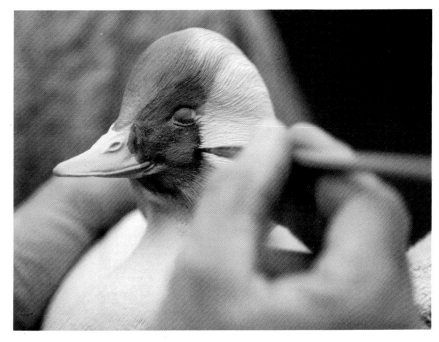

Now Jim applies a mixture of 50% carbon black and 50% phthalo green (see color chart) to the face of the bufflehead. He dampens the crown and throat of the bird before painting, blending color to water. A small lining brush creates the transition area between green and white.

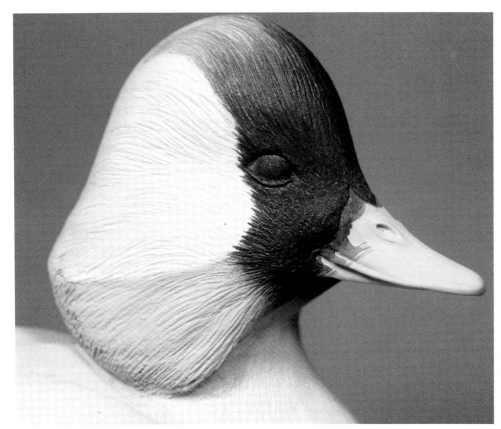

Pearl essence in iridescent green color is added to the green paint mixture to add depth to the color. Don't worry about green spilling onto the bill because the bill will be gessoed before painting.

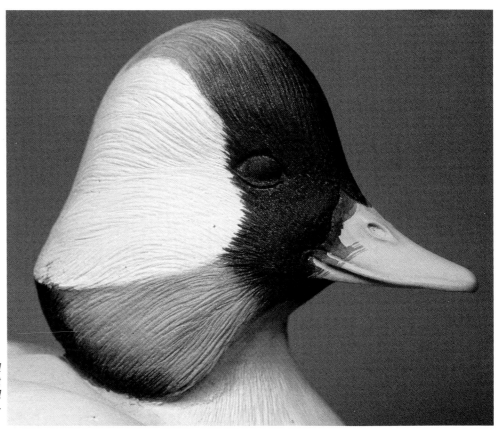

Three washes have been applied and the green looks good. It should be slightly darker behind the bill and blended to water beginning just over the eyes.

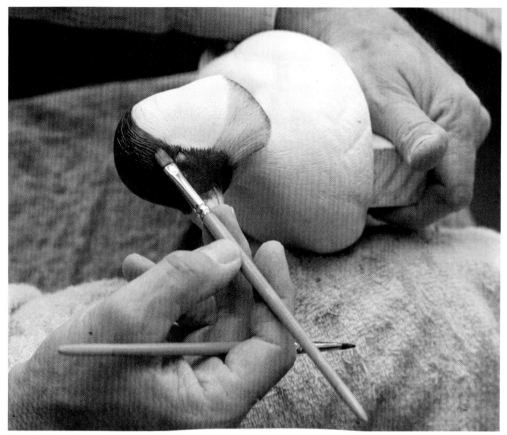

Jim paints the crown of the head and the lower cheek with 50% dioxazine purple and 50% carbon black (see color chart). He dampens the green areas with water and blends the purple into the water, overlapping the dried green paint.

The purple area of the head is a mix of 50% dioxazine purple and 50% carbon black. Purple pearl essence powder is added to the mix for iridescence.

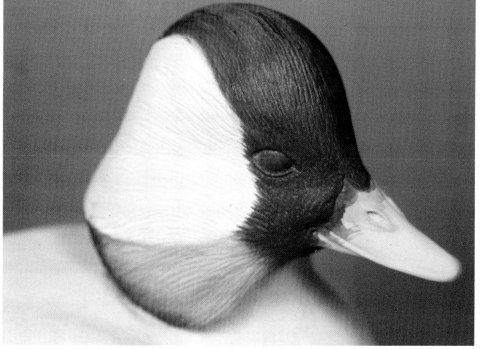

Two washes of purple have created good coverage, but the transition between the purple and green is still somewhat abrupt.

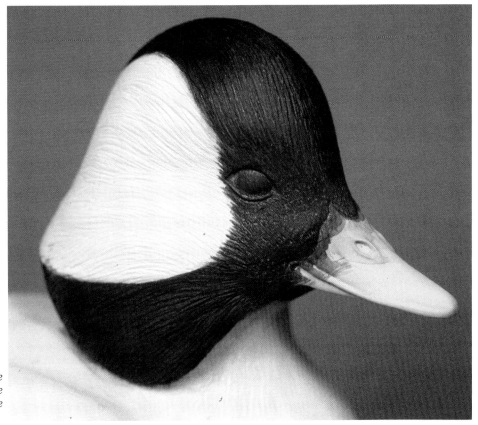

Jim applies a third wash to the crown, making the transition to the green more subtle, then paints the lower cheek of the bird.

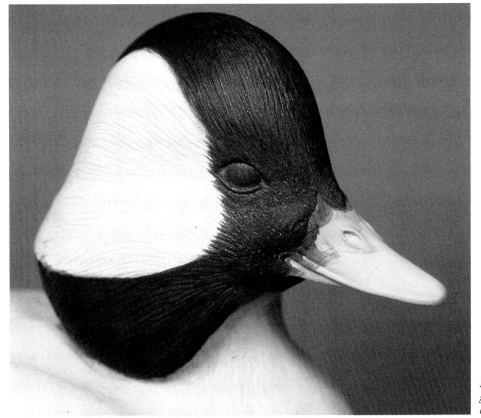

Four washes each of purple and green have been applied and the colors look rich and deep.

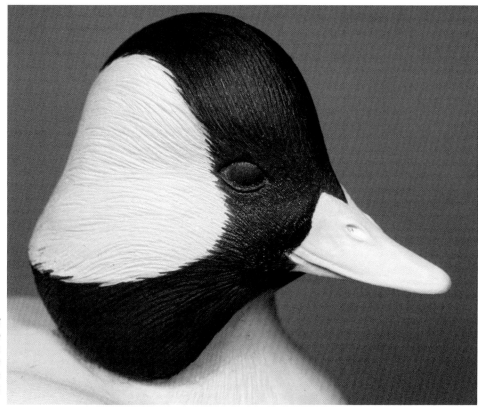

Here Jim has used the size 2 Raphael #8220 lining brush to create a transition area between the white and purple areas. He did this by painting small, hairlike feathers onto the white, providing a soft edge.

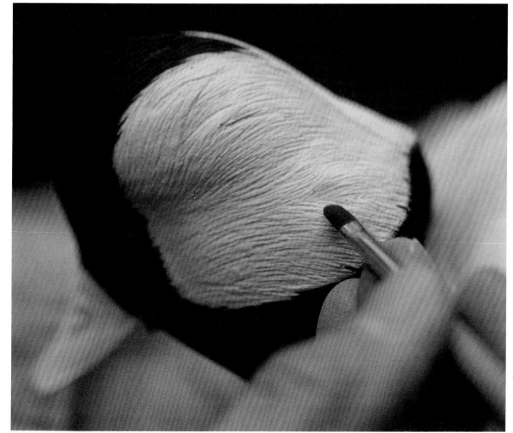

A light wash of Payne's gray over the white patch soaks into the valleys of the texture lines and gives them definition.

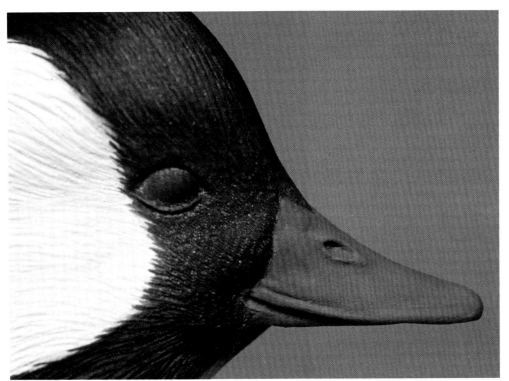

Jim paints the gessoed bill with a mix of 50% titanium white, 15% Payne's gray, 5% carbon black, and 30% raw umber (see color chart). He varies the ratios to produce three values of paint: dark gray, medium gray, and light gray. Here, he begins by applying dark gray to the entire bill.

The bufflehead bill is painted with a mix of 50% gesso or titanium white, 30% raw umber, 15% Payne's gray, and 5% carbon black.

Jim uses the airbrush to add the medium value of gray along the margins of the bill. The lightest value is used on the tip. These colors could be brushed on in successive washes. The color of the bufflehead bill varies from bird to bird, so check your reference. There is no exact color formula.

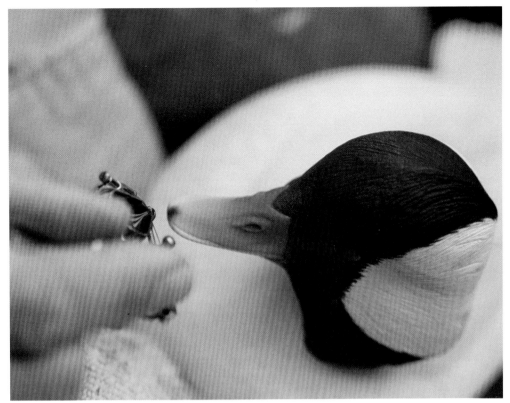

With the tip of the bill lightened, Jim uses the airbrush loaded with black to add the nail. The black is 55% burnt sienna and 45% ultramarine blue (see color wheel).

The nail is painted with a black mix of 55% burnt sienna and 45% ultramarine blue.

Matte medium-varnish gives the bill a slightly moist, lifelike look.

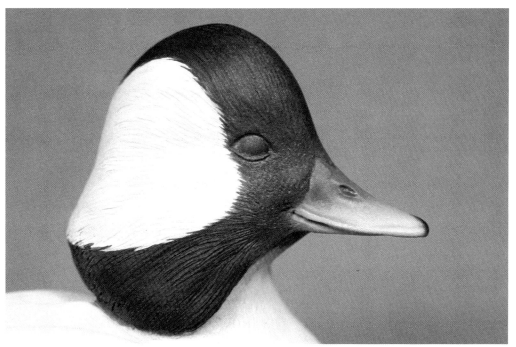

The completed drake head.

The back, wings, and upper rump are painted with a mix of 70% burnt sienna and 30% ultramarine blue.

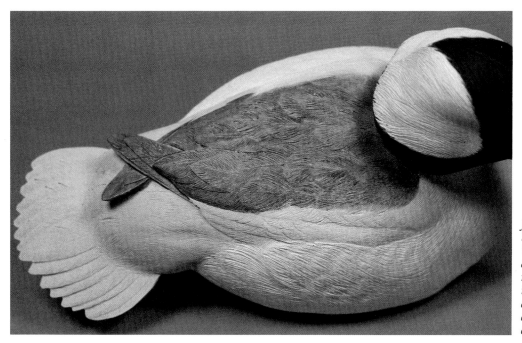

Jim begins painting the body by applying a base mix of 70% Hyplar burnt sienna and 30% Hyplar ultramarine blue to the wings. As the color chart shows, this area changes value greatly as successive washes are applied.

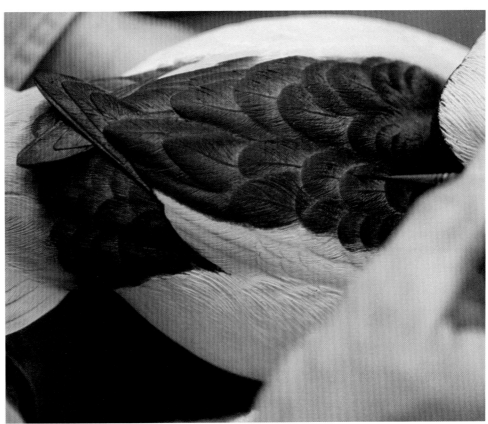

With one wash of carbon black the black feather edges and quills are too prominent. Jim's goal here is to make the area nearly black but still to have the feather edges show.

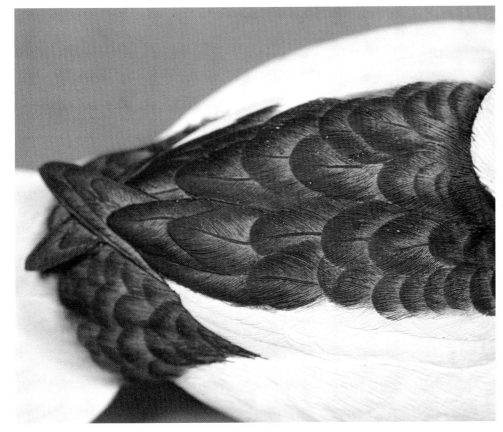

A second wash brings the values closer together, but Jim still does not have his desired black-on-black effect.

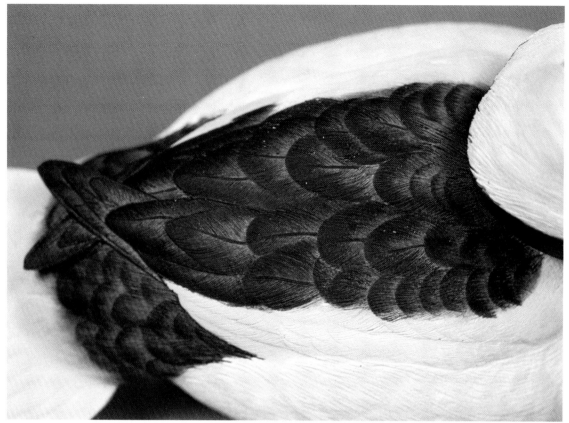

A third wash brings the values still closer together.

The fourth wash is just about right. There still is tonal separation in the dark areas; another wash might obscure these subtle differences in value.

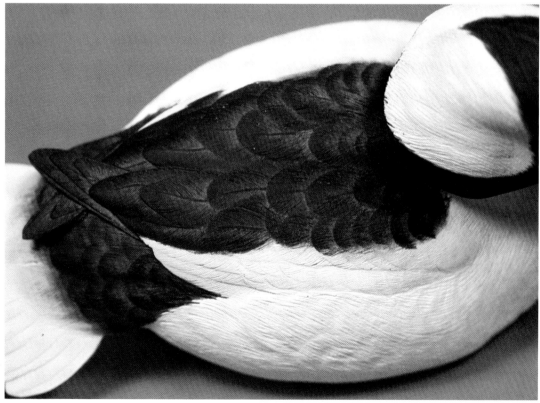

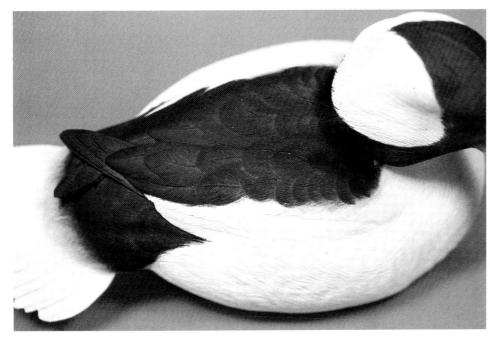

Jim paints the rump with a mix of 80% gesso, 10% burnt umber, and 10% carbon black (see color chart). He then uses straight Mars black to darken the feather edges and the quills.

The upper and lower rump feathers are painted with a mix of 80% gesso, 10% burnt umber, and 10% carbon black.

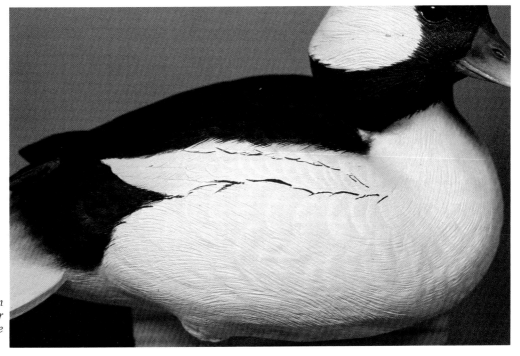

Jim uses Mars or carbon black paint to create feather edges along the flanks of the bufflehead.

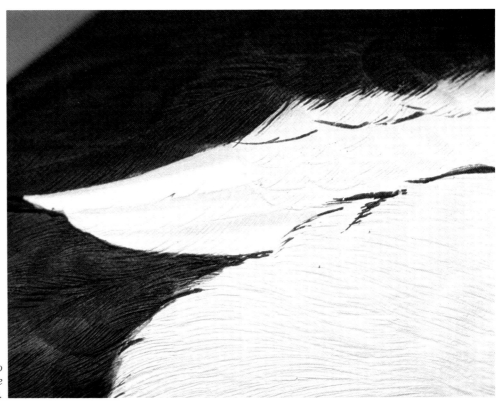

Titanium white is used to lighten the speculum. Note the underlying black feather edge.

A mix of 90% gesso or titanium white, 5% carbon or Mars black, and 5% burnt umber is used on the rump, with the gray being blended into the dark values along the back with the color-to-water technique.

The bottom of the rump also is painted the same shade of gray.

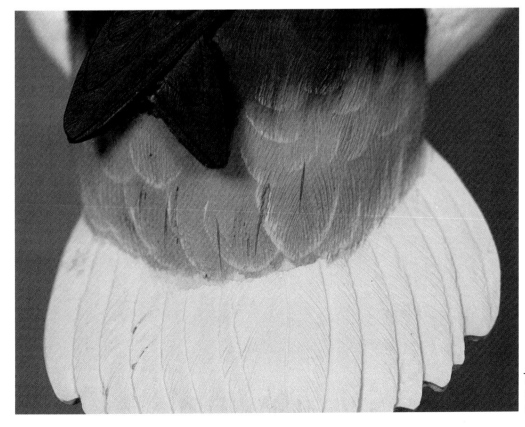

Jim uses titanium white tinted with about 5% to 10% raw umber to edge the feathers of the tail coverts.

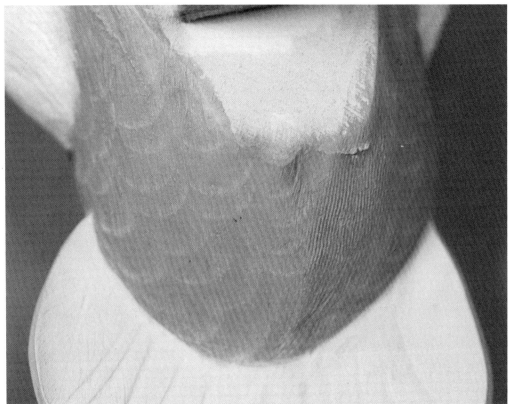

The same mix is used to create subtle feathers along the bottom of the rump.

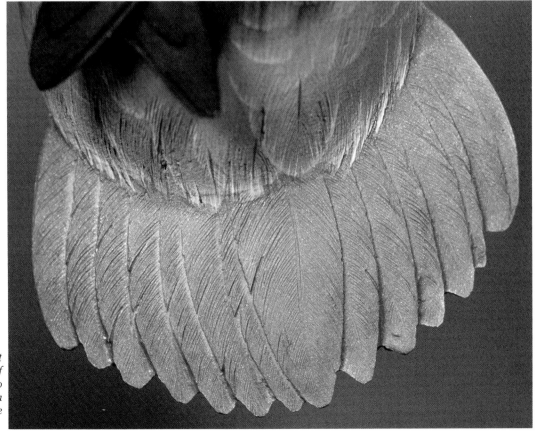

The tail feathers get three to four washes of the base-color mix to which has been added a small amount of white pearl essence.

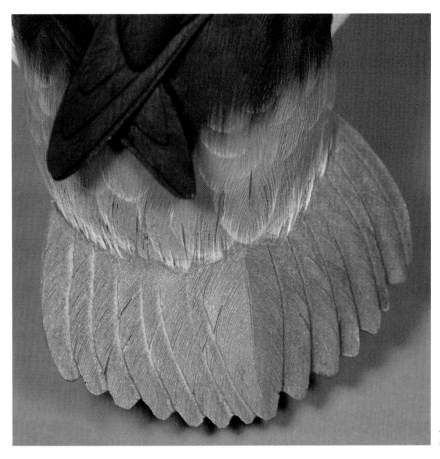

After three washes the tail feathers have the correct value.

Since this is a molded study bird, the eye must be painted. Jim uses brown and black Testors paint, which dries to a high gloss.

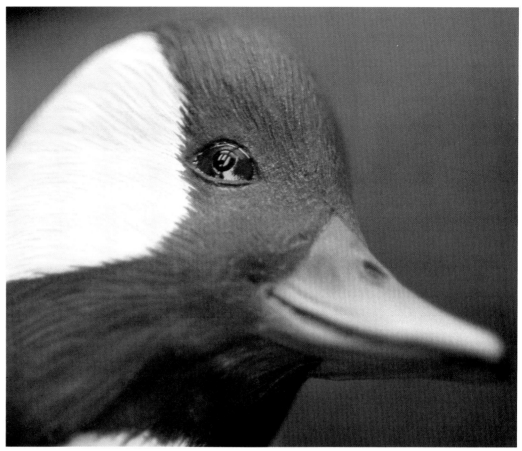

The brown paint is used for the pupil, and the iris is made with a dab of black applied with the head of a pin.

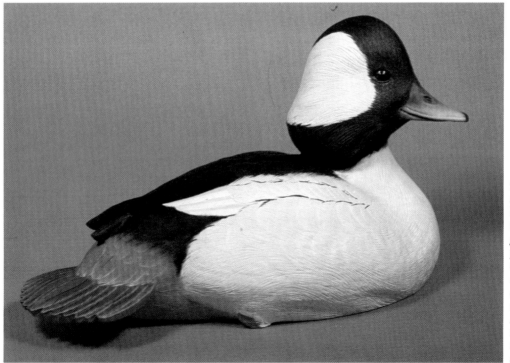

The finished bufflehead drake. Jim completed the job by mixing between 5% and 8% naphtha red light with gesso to come up with the pink shade applied to the exposed leg on the right side of the bird. He detailed the quills along the wings and tail by using the size 2 Raphael #8220 lining brush to apply a small amount of matte medium-varnish to each.

6

Stretching the Limits of the Color Spectrum: The Wood Duck Drake

The wood duck drake is one of the most colorful—some might say gaudy—of our North American waterfowl. With bright red eyes, a bill that ranges from yellow to orange to red, a chestnut breast, and body colors of iridescent blue and green, the wood duck is spectacular, a bird that will stretch the limits of the visible spectrum.

Yet, the wood duck offers many challenges in the subtle business of blending colors and in building color through successive washes. The darker areas of the bird's body appear in some places to be black, but if the sun strikes the feathers at just the right angle, you see deep shades of violet or green. One of the advantages of acrylic paints is that they are transparent, and by layering colors of different values the artist can build very realistic subtlety and depth.

Jim emphasizes that some experimentation is called for here. He uses different colors of pearl essence powder to add iridescence, and he applies color in a succession of very thin washes, evaluating it as it gains depth with each succeeding application. Jim advises beginning painters to use his methods as a starting point and then to develop their own techniques and painting styles. This advice certainly holds true with the wood duck, whose brilliant colors and subtle shadings lend themselves to the liberal use of artistic license.

As in other sessions in this book, Jim is painting a study bird made of acrylic and wood fibers and cast from his original wood carving. He begins painting the study bird by applying several coats of a base coat consisting of 80% gesso, 10% raw umber, and 10% Payne's gray. This base coat is applied over the entire bird. He uses a stiff bristle brush such as the size 18 Raphael #355, always applying the gesso in the direction of the feather flow lines. The gesso should be allowed to air dry. It is a thick medium and use of a hair dryer or other heat source could produce air bubbles. Jim applies enough coats of gesso to produce a uniform working surface. If you used a plastic filler

around the neck or in other areas, enough gesso should be applied so the filler will not show through. On most birds Jim uses three applications of gesso. Remember, acrylic paints are transparent, and the surface on which they are applied must be uniform and without imperfections.

MATERIALS & COLORS

Hyplar matte medium-varnish
gesso
iridescent white
titanium white
carbon black
raw umber
burnt umber
raw sienna
Hyplar burnt sienna
dioxazine purple

burgundy
phthalo green
pine green
Hooker's green
Hyplar phthalo violet
yellow oxide
yellow light
naphtha red light
Hyplar ultramarine blue
phthalo blue
Payne's gray
iridescent silver
blue-green pearl essence powder
blue pearl essence powder
violet pearl essence powder
slate blue pearl essence powder
yellow pearl essence powder
copper pearl essence powder

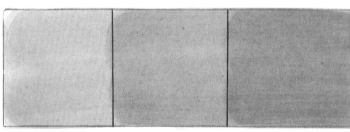

The gold color of the sidepockets is a mix of 75% raw sienna, 20% titanium white or gesso, and 5% burnt umber.

With a smooth coat of gesso applied, Jim is ready to paint the sidepocket feathers. This color is made by mixing 75% raw sienna, 20% titanium white or gesso, and 5% burnt umber (see color chart). Jim uses a pencil to lightly define the sidepocket areas, using a taxidermy mount as reference. This photograph shows the color chart and the effect of building color through three washes.

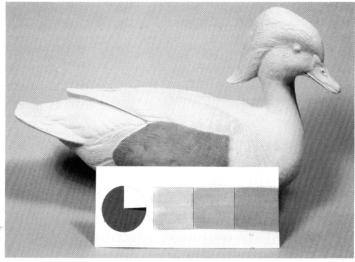

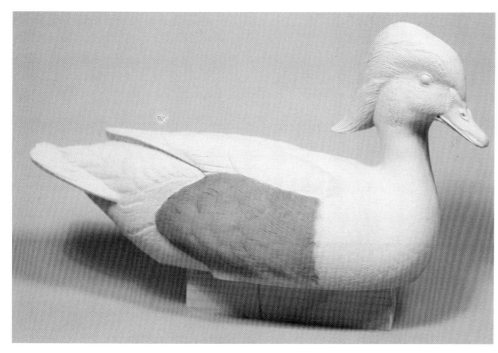

Paint is applied to the sidepocket feathers using the color-to-water blending method. Jim first dampens the perimeter of the area with water, then adds the color. The water creates a smooth edge along the margin of the color.

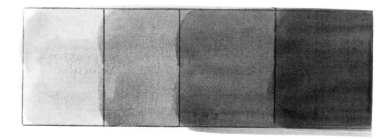

The base color of the breast is 80% burnt sienna, 18% dioxazine purple, and 2% carbon black.

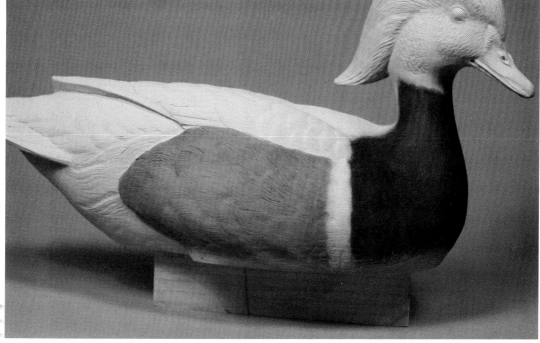

With both sidepockets painted, Jim mixes 80% burnt sienna, 18% dioxazine purple, and 2% carbon black (see color chart) to produce the chestnut color of the breast. Again he uses a taxidermy mount as a guide in defining this area and he lightly sketches the margins with a #2 lead pencil.

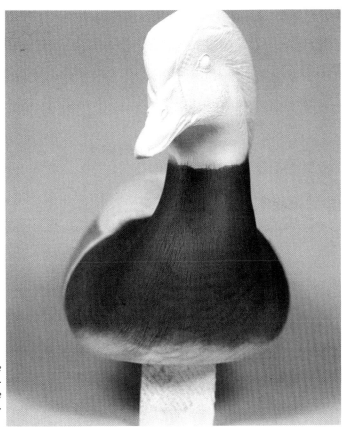

The color is applied in a series of very thin washes. Because these washes are thin, they can be dried with a hair dryer without damage. Jim cautions that if you use a hair dryer be sure the area cools off before applying successive washes because applying paint to a warm surface will cause it to dry too quickly.

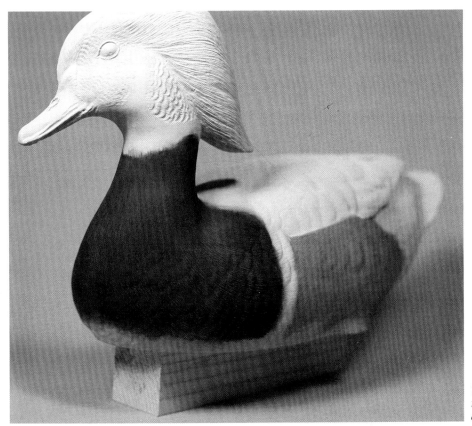

The color-to-water blending technique is used on the breast, producing a soft edge where pigment meets water.

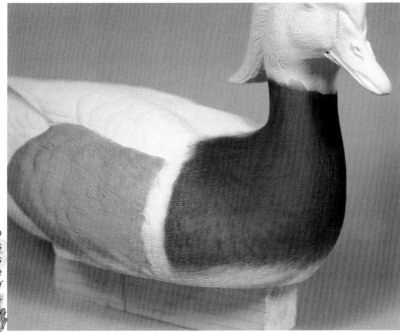

Jim used four thin washes of the chestnut color to achieve the value he wanted on the breast. He saves the remaining paint, keeping it on a corner of his palette under a plastic cup to retard drying. The upper portion of the breast is painted with a mix of 60% burgundy, 38% dioxazine purple, and 2% carbon black (see color chart). A small amount of violet pearl essence powder is added to the final wash.

The top portion of the breast is darkened with washes of 60% burgundy, 38% dioxazine purple, and 2% carbon black.

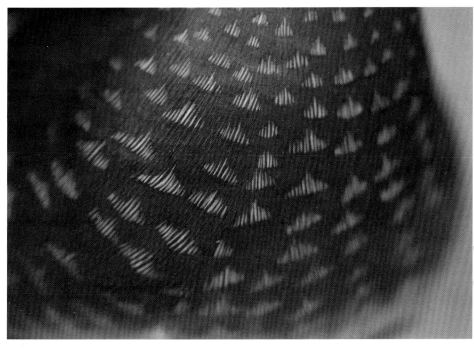

Jim uses white gesso tinted with 10% raw umber to paint the diamond markings on the breast of the duck. The same color will be used on the head and bill, so Jim mixes a sufficient quantity and saves the excess paint. Good reference material is essential to duplicate these small markings. Jim uses a taxidermy mount, but good quality sharp photographs are also effective.

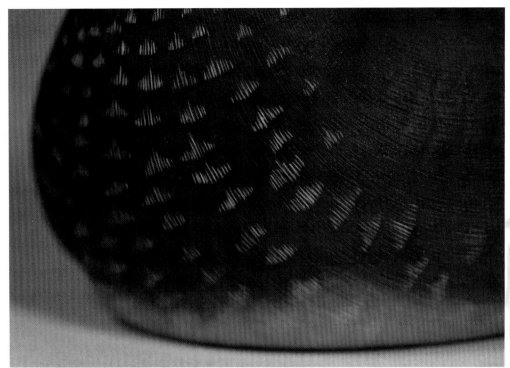

Note that the marks are smaller near the neck of the bird and increase in size as the breast widens. Jim applies the paint with very light strokes of a size 2 Raphael #8220 lining brush or a size 1 Raphael #8408. The white markings can be retouched slightly with the chestnut paint left over from painting the breast. A final treatment with matte medium-varnish diluted equally with water will give the breast a realistic, waxy look.

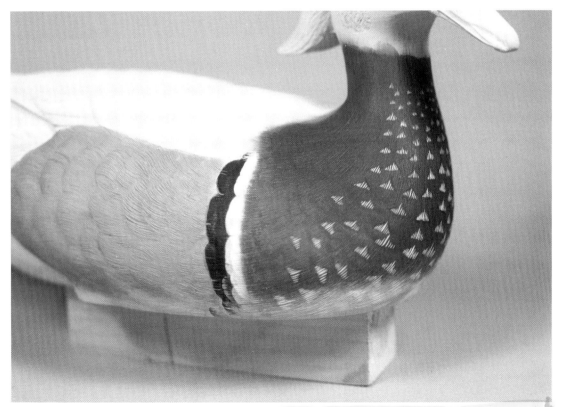

Jim uses his standard black mix of 40% Hyplar ultramarine blue and 60% Hyplar burnt sienna to produce the black feather edges along the front edge of the sidepocket feathers on both sides. He uses a size 6 Raphael #8404 or size 6 Liquitex #511 feather-flicking brush to do this, then uses the same brush to flick carbon black feather edges.

A filbert-type brush such as the Raphael #8240 is used to apply the white sidebars just forward of the black markings. He turns the brush on edge and very carefully pulls the white edge into the chestnut area of the breast. The white is a mix of 70% gesso, 25% raw umber, and 5% iridescent white. The Raphael #8220 lining brush is used to extend some black markings into the white. These marks are intended to resemble feather overlaps, producing a layered look. As a final treatment Jim flicks on titanium white feather edges.

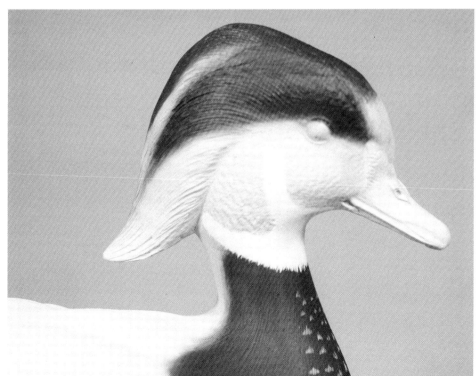

The head is painted first with an application of green made by mixing 40% phthalo green, 20% pine green, and 40% carbon black. Green pearl essence powder is added to the mix.

Jim begins detailing the head by lightly sketching the color design with a pencil, then he paints the white area on the neck and face with the same color used for the white sidebars, flicking on small feather edges with titanium white. The green wash is a mixture of 40% phthalo green, 20% pine green, and 40% carbon black (see color chart). A small amount of green pearl essence powder is added to the paint to provide iridescence.

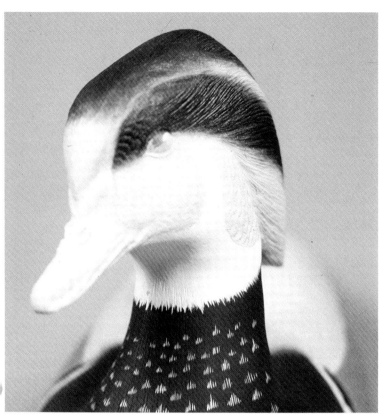

Jim carefully checks his taxidermy mount to determine the color design of the head. The green is applied first to the crown and then to the area beginning behind the bill and extending along the eye to the crest.

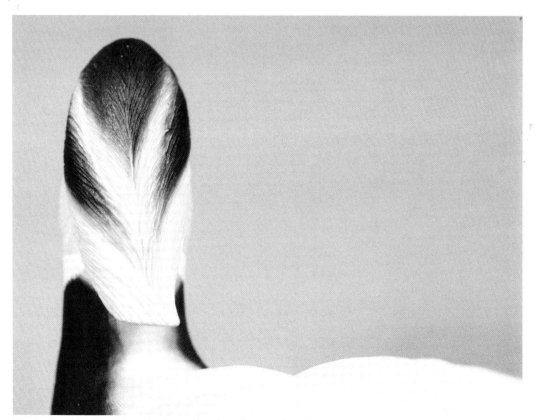

The back of the head showing the application of green along the crown and crest.

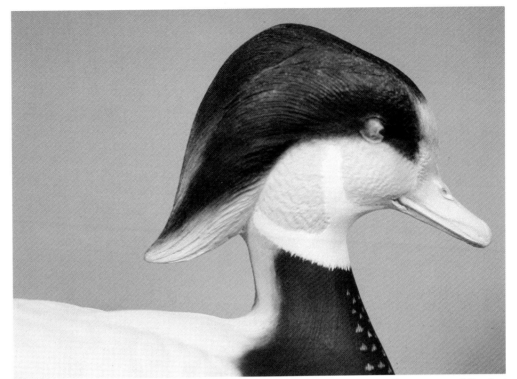

The crest has a blue and violet hue as well as green, and Jim first applies blue by mixing 60% carbon black, 40% phthalo blue, with blue pearl essence added (see color chart). He dampens the green portion of the crest with water, then applies the blue mix with a size 6 Raphael #8240 brush, blending the color into the water.

The blue wash that follows the green is a mix of 40% phthalo blue and 60% carbon black, with blue pearl essence added.

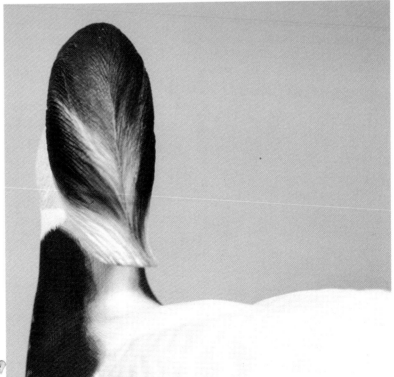

The back of the head shows the overlapping of the blue and green values.

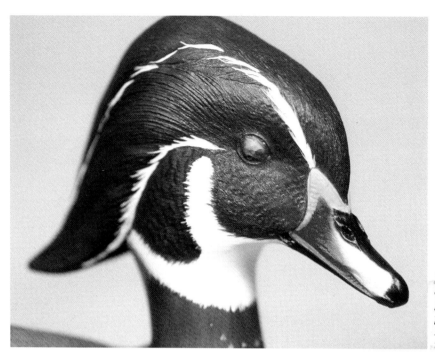

The same blue color mix is applied to the cheek and the area below the crest with the filbert brush. Jim uses the edge of the brush to pull tiny feathers into the white area. A size 2 Raphael #8240 brush with carbon black is used to add feather edges in this blue area.

The third color applied to the head is a violet mixture made by mixing 35% Hyplar phthalo violet, 35% burgundy, and 30% carbon black.

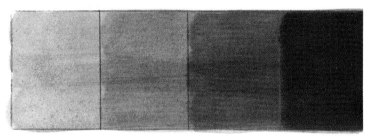

A mixture of 35% Hyplar phthalo violet, 35% burgundy, and 30% carbon black (see color chart) produces the violet shade used to highlight the crest and to add a line immediately behind the eye. A small amount of violet pearl essence is added to the color to produce iridescence. The area around this color is dampened with water, and the color is blended into water to soften the margins. The size 2 Raphael #8220 lining brush with the white mix saved after painting the breast marks is used to paint the white hairline feathers that begin behind the eye and at the corner of the upper mandible.

The bill is repainted with gesso to cover any paint that may have spilled onto it during the painting of the head. It then gets a base coat of the white mix used in painting the hairline feathers in the previous step. A mix of 75% yellow oxide, 20% yellow light, and 5% gesso (see color wheel) is applied to the base of the bill using the color-to-water blending technique. The red color is 95% naphtha red light and 5% carbon black (see color wheel) and is applied as shown blending color to water. A black mixture— 60% burnt sienna, 35% ultramarine blue, and 5% carbon black (see color wheel)—is applied to the top of the bill, the nail, and the bottom of the bill. The bill is finished with two or three thin applications of matte medium-varnish in equal parts with water and is buffed gently with #000 steel wool if it appears too glossy. Be careful not to rub too hard!

The yellow is a mix of 75% yellow oxide, 20% yellow light, and 5% gesso.

The red is a mixture of 95% naphtha red light with 5% carbon black.

Black is made by mixing 60% burnt sienna with 35% ultramarine blue and 5% carbon black.

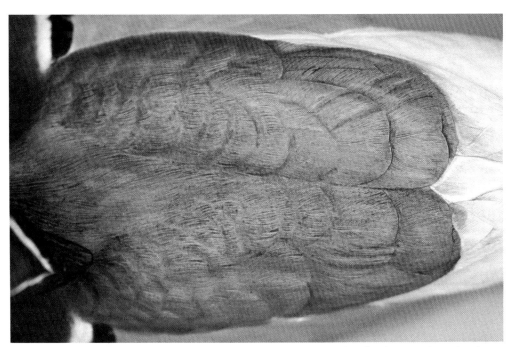

The base color for the back and under the rump is a mix of 75% raw umber, 20% burnt umber, and 5% carbon black (see color chart). The margins of these areas are moistened with water and the color is blended to water.

A base color of 75% raw umber, 20% burnt umber, and 5% carbon black goes on the back and under the rump.

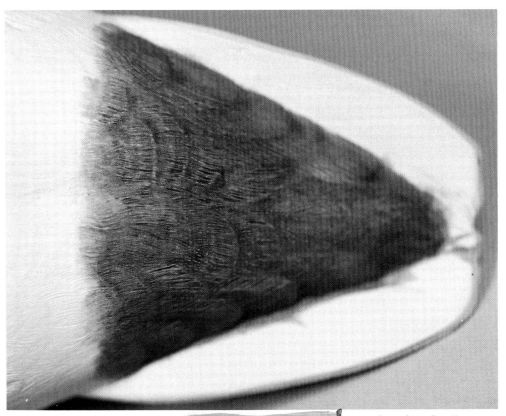

Three washes of color are used to produce the value Jim wants on the back, and on the feathers beneath the rump, as shown here.

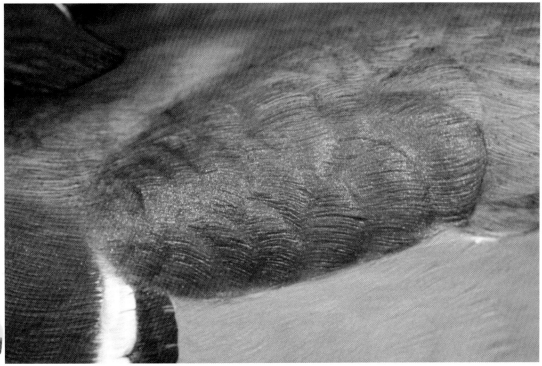

Jim paints the first row and a half of scapular feathers on each side with 70% carbon black and 30% phthalo blue to which has been added a small amount of slate blue pearl essence. As before he dampens the margins of the area with water and blends color to water to provide a soft edge. Three washes have been applied here.

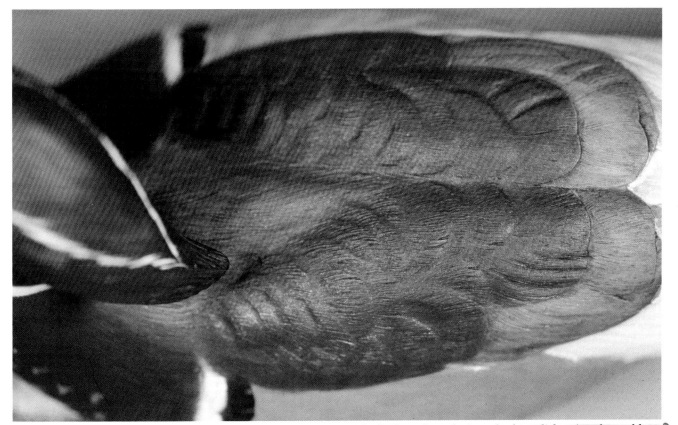

The feathers along the inner back are lighter in color and have a greenish cast. A mix of 40% phthalo green and 60% carbon black is used here, with some green pearl essence added. The color is blended to water over the blue/black outer scapulars.

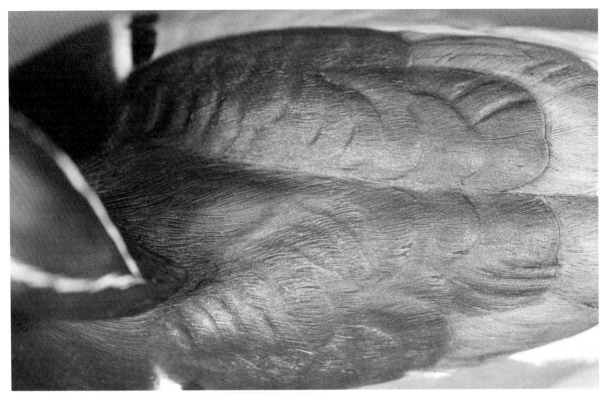

The inner back is highlighted by first applying one or two washes of pine green tinted with yellow pearl essence. Then one or two washes of pine green with copper pearl essence are applied, allowing some of the yellow iridescence to show through, as shown in this photograph.

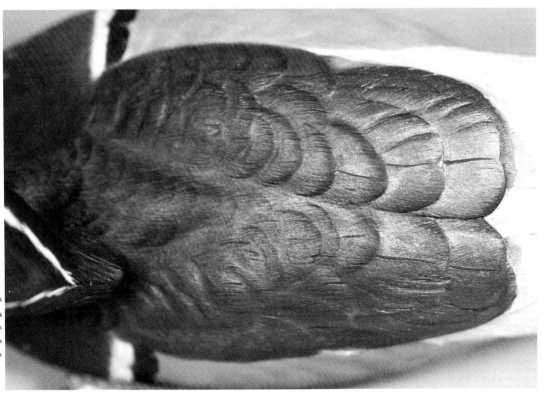

The cape area is darkened with several washes of raw umber tinted with 5% carbon black. Straight carbon black with some green pearl essence is used to darken the feather edges on the scapulars and tertials.

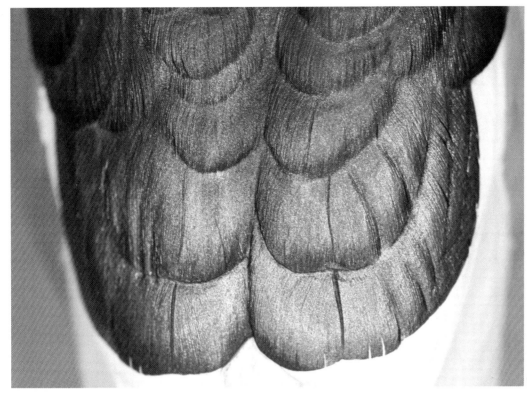

The inner halves of these feathers are highlighted by first applying a wash of pine green or Hooker's green with yellow pearl essence, followed by one or two washes of green with copper pearl essence, which is watered into the yellow, leaving some of the yellow iridescence showing.

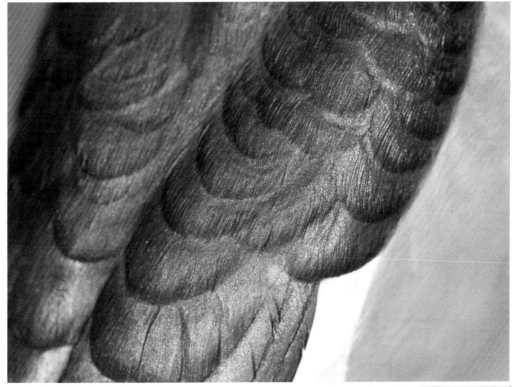

A mix of 50% carbon black and 50% burnt umber is used to paint the quills and feather splits and to darken shadow areas textured during the carving process. The overlapping of colors and the addition of pearl essence powder produce realistic depth of color and iridescence.

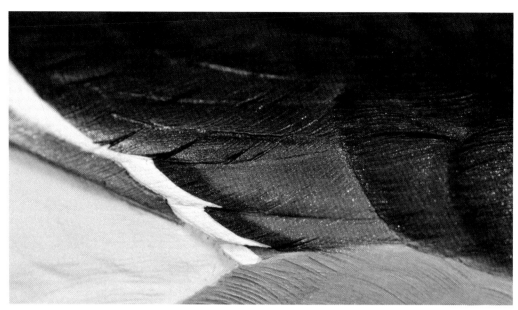

Before going to the primary feathers Jim paints the speculum. He first applies straight gesso to cover any paint spill-over, then applies a mixture of 60% phthalo green and 40% phthalo blue, to which has been added a small amount of carbon black and some blue pearl essence. The forward corner of the top speculum feather gets a wash of the same color mix but with violet pearl essence, then the lower feather is painted with the same color to which blue-green pearl essence has been added. Jim blends these washes to water, producing a gradual transition from dark blue to lighter blue. A final wash of black (50% carbon black and 50% burnt umber) darkens the feather edges, and the very tips are painted white (gesso, raw umber, and iridescent white).

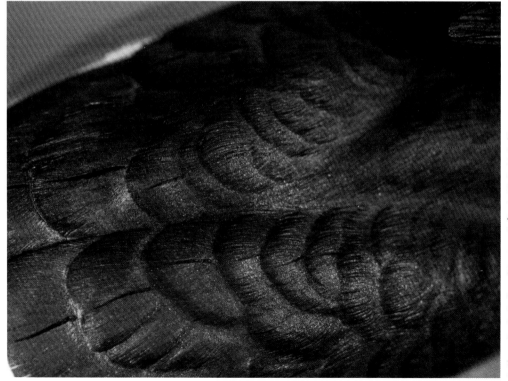

The lower tertials are painted first with carbon black and blue-green pearl essence. The inner feathers have a greenish cast and are painted with a mix of 60% phthalo green and 40% carbon black with some green pearl essence. The edges are darkened with a mix of 70% carbon black and 30% ultramarine blue with blue pearl essence. The corners of the inner halves get a wash of 50% phthalo violet and 50% carbon black with violet pearl essence. Jim carefully flicks feather edges of straight carbon black on all but the tertial feathers and paints the quills carbon black.

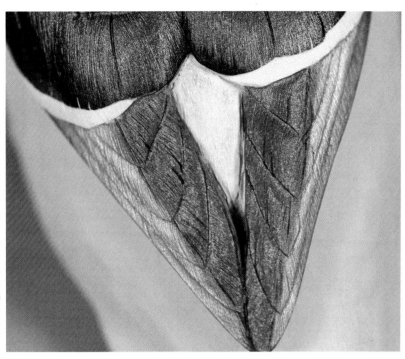

The edges of the tertials are painted with the gesso/ raw umber base mix used earlier. The primary feathers are painted first with two washes of a mix of 75% burnt umber, 20% titanium white, and 5% carbon black. Then Jim applies a mix of 90% titanium silver, 8% titanium white, and 2% raw umber to the outer, or lower, feathers. If desired, these feathers can be made browner by adding more raw umber. The inner halves of the primaries get a wash of 50% phthalo green, 35% titanium blue, 10% burnt umber, and 5% carbon black with blue-green pearl essence added. The feathers are edged with carbon black and blue pearl essence, then a thin wash of carbon black with violet pearl essence is applied. The quills are painted with the equal mix of carbon black and burnt umber, followed by matte medium-varnish diluted equally with water.

The upper rump and tail feathers are painted with a mix of 40% phthalo green and 60% carbon black to which green pearl essence has been added. On the upper rump Jim flicks carbon black edges on all feathers and paints the quills black. The outside edges of the tail feathers are painted with the same mix, but yellow pearl essence is added to produce a golden iridescence. A final wash of the same color with copper pearl essence is applied. The two center tail feathers have a bluish cast, so Jim mixes some blue pearl essence and violet pearl essence with the original color and applies it here. Black feather edges are flicked on, and the quills are painted black.

*A mixture of 80%
burnt umber and 20%
carbon black with
green pearl essence is
used to paint feather
details under the
rump.*

*The underside of the tail feathers are painted with a mix of 75%
burnt umber, 15% gesso, 5% iridescent white, and 5% carbon
black. The tips of the feathers are darkened by increasing the
amount of carbon black in this mix and applying it to the edges
with a large feather-flicking brush. The quills are painted with a
thin wash of raw sienna.*

The flowing burnt sienna feathers of the drake's flanks are painted in two sequences. First, Jim paints the lower one-third of the area with a mix of 85% burnt sienna and 15% burnt umber. The top two-thirds gets an application of 60% burgundy, 35% dioxazine purple, and 5% carbon black to which violet pearl essence is added. Three washes are applied to each area and are blended together using the color-to-water blending technique. The hairlike streamers are painted raw sienna with copper pearl essence using a Raphael #8220 lining brush. The tips are painted yellow oxide with yellow pearl essence. A thin wash of carbon black is used to gradually shade these feathers from the base out.

Jim now paints the black-and-white bars above the sidepocket feathers. He uses the pencil to lightly lay out the design, then he paints the black area first with a mix of 60% Hyplar burnt sienna, 35% Hyplar ultramarine blue, and 5% carbon black using a filbert-type brush.

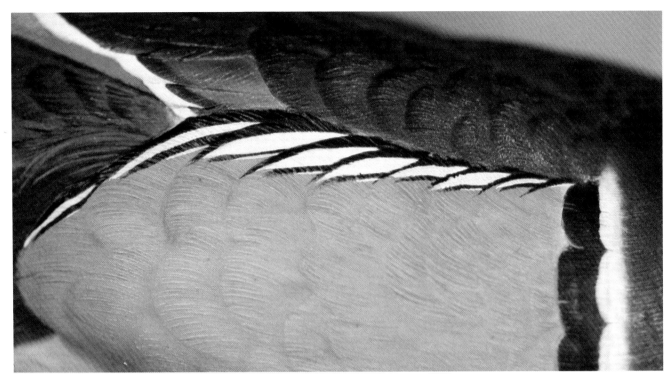

White gesso tinted with 10% raw umber is used to fill in the white feather markings.

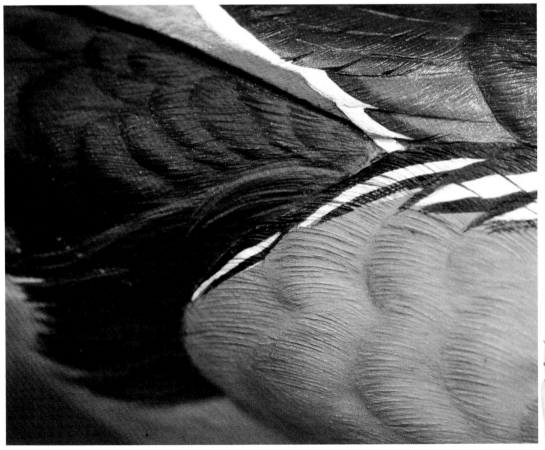

The black-and-white bars look a little too perfect, so Jim adds some feather splits by painting black lines through the white bars with the size 2 Raphael #8220 lining brush. These random lines add to the illusion of realism.

Vermiculation—those irregular black stripes along the sides of the bird—can be done either with a small brush or with a pen such as a Rapidograph. In most cases Jim prefers the brush because brush marks are irregular and the marks left by the pen have a mechanical look. He uses a size 1 or 2 Raphael #8408 sable brush for vermiculation, applying the same paint mixed for the black bars above the sidepocket feathers. Before beginning the vermiculation Jim lightly flicks feather edges on the sidepockets with thin burnt umber. To vermiculate with the brush Jim holds it perpendicular to the surface of the bird and applies the vermiculation lines with a series of dots. If a line is too light in value, he darkens it before going to the next line. When the lines are completed Jim adds a few horizontal feather splits with the same brush.

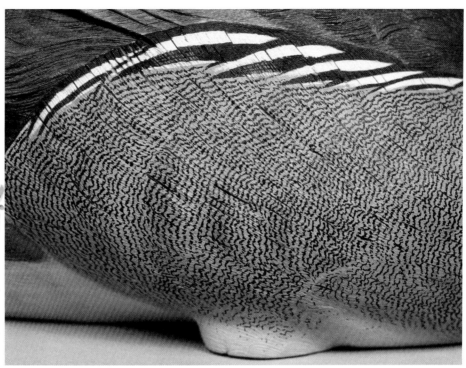

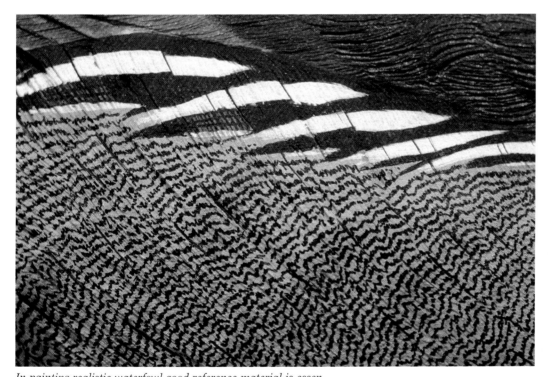

In painting realistic waterfowl good reference material is essential, especially when it comes to the fairly tedious procedure of vermiculation. Notice in this close-up photo that although the marks are somewhat irregular and random, there is an overall pattern and flow of feathers. The black splits in the white feathers extend a flow pattern begun in the vermiculated sidepockets. Good reference material is important in discovering and duplicating subtle details such as this. Live birds, taxidermy mounts, and sharp photographs are all good resources.

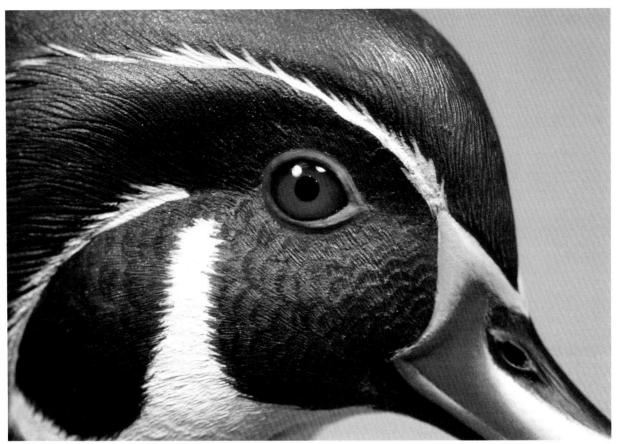

Jim finishes the wood duck drake by painting the membrane around the eye. First, a coat of straight carbon black is applied to the inner portion of the eye adjacent to the membrane, then a mix of 95% naphtha red light and 5% yellow light goes on. Straight yellow light is blended to water in the lower corners of the eyes to provide a highlight.

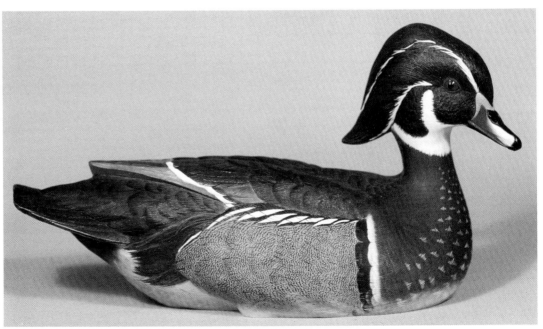

Jim's completed wood duck drake.

7

Testing Your Repertoire of Techniques: The Shoveler Drake

"The shoveler drake is rather gaudy, and it's a challenge to capture the bright whites, the rusty breast, and the iridescent green head," says Jim. "The shoveler will test your painting skills. It's a colorful bird, but it also has a lot of subtle color values."

Specifically, the shoveler will give you a good workout in painting white on white, in blending color to water, in highlighting contours, and in vermiculation. Although the bird will test your repertoire of techniques, no step is actually difficult, so take it one task at a time and let the project build little by little.

Jim's technique of painting white on white, which was also illustrated in painting the bufflehead drake,

MATERIALS & COLORS

Krylon matte finish spray #1311
Testors model enamel:
yellow for eye, black for pupil

gesso
nimbus gray
Liquitex titanium white
raw umber
burnt umber
burnt sienna
carbon black
cobalt blue
phthalo blue
ultramarine blue
Jo Sonya phthalo green
pine green
yellow oxide
yellow light
iridescent white
green pearl essence powder
blue pearl essence powder

is an example of beginning with a graphic technique and gradually making it appear subtle. He paints a nimbus gray base coat, adds white feather markings, and then covers the entire area with a series of thin white washes until the area is white but the feather markings still show. It's an effective and fairly easy technique that requires as much patience and practice as artistic skill. Mastering this technique will help you create the illusion of softness and depth in painting white feathers.

Jim demonstrates two techniques for painting highlights in this session. A yellow wash highlights the cheek contour on the bird's green head, and a yellow base coat produces a highlight on the speculum.

As with the other birds discussed in this book, it is vital to have good reference material and to know how to apply that reference to your work. Taxidermy mounts and study skins are excellent sources. Jim has an aviary attached to his studio, and sometimes he will bring in live birds to study as he paints. At the very least have good, sharp photographs that show close-up detail of the bird you're painting.

As we begin another session we should reiterate the importance of maintaining a clean work area. Jim uses a piece of plate glass as a palette, placing under it a white paper towel to provide a neutral background. The glass should be kept scrupulously clean, and dried paint particles should never be allowed to accumulate because they will inevitably find their way onto your work in progress, creating nasty streaks. Being neat, organized, and methodical in your work habits will make life much easier.

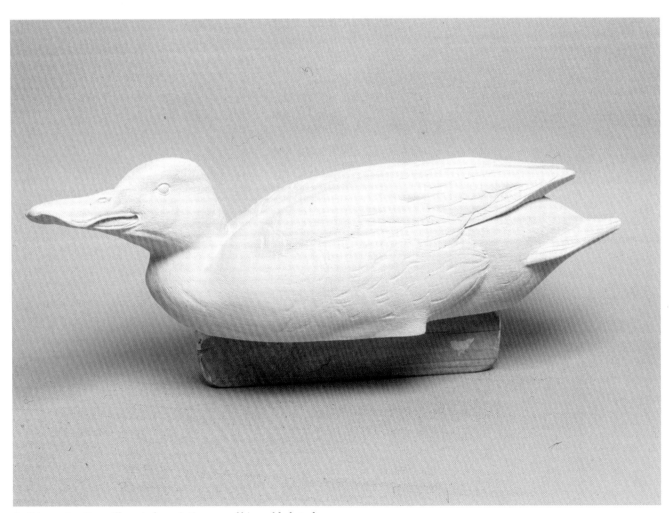

In this session Jim will again be painting one of his molded study birds, so before painting, he seals the bird with several coats of gesso to provide a uniform base for the acrylic paints.

White gesso is tinted with about 15% raw umber to produce the white base color of the shoveler. Jim uses a stiff one-inch brush, in this case a size 18 Raphael #355. A wide brush provides a more uniform application and is less likely to produce streaks. Always brush on the gesso with the feather flow. Apply enough coats to provide a uniform surface that will cover any imperfections such as plastic filler around the neck or eyes.

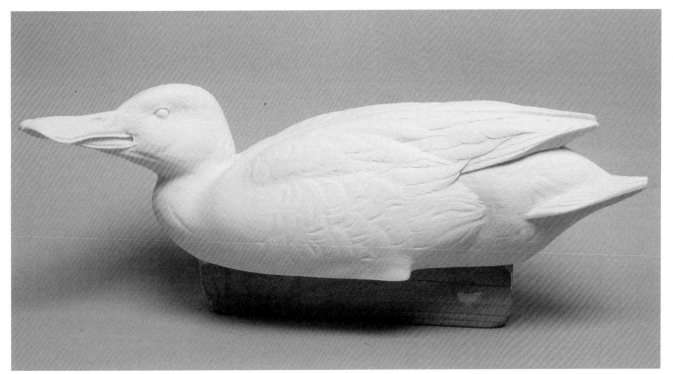

Jim has applied three coats of base color to this bird, allowing each coat to air dry, and it is now ready to paint. Because gesso is a thick medium, applying heat with a hair dryer to reduce drying time could produce pinholes as the gesso dries and contracts.

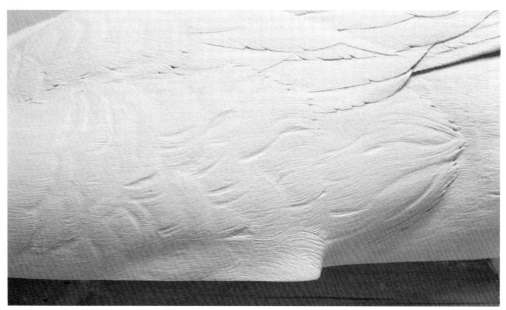

*Jim begins applying color by painting the upper and rear por-
tions of the sidepockets with a cream color made by mixing 15%
yellow oxide and 5% burnt umber with 80% gesso (see the color
wheel).*

*The cream color applied
to the upper and rear
sidepockets is made of
80% gesso, 15% yellow
oxide, and 5% raw um-
ber.*

*The lower sidepockets and
under the rump are painted
with 85% burnt sienna, 10%
cobalt blue, and 5% burnt
umber.*

*The lower two-thirds of the
sidepockets get an applica-
tion of 85% burnt sienna,
10% cobalt blue, and 5%
burnt umber (see color
chart). Jim uses a one-inch
Raphael #8250 brush. He
advises saving this mix for
later touch-ups should
some of the paint chip or
become marred during the
painting process. Three
washes of color have been
applied to the left side-
pocket in this photograph.*

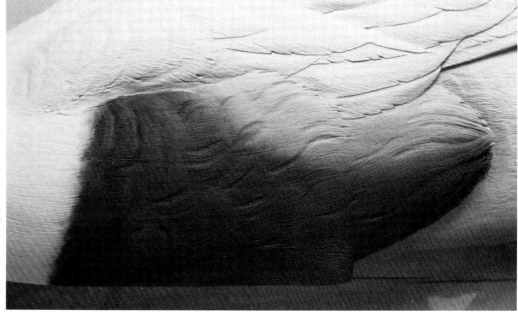

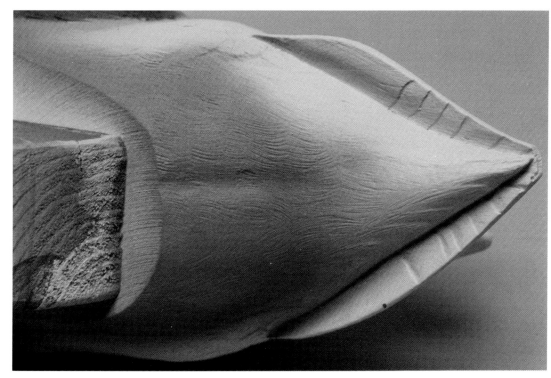

The same color mix is used to paint under the rump.

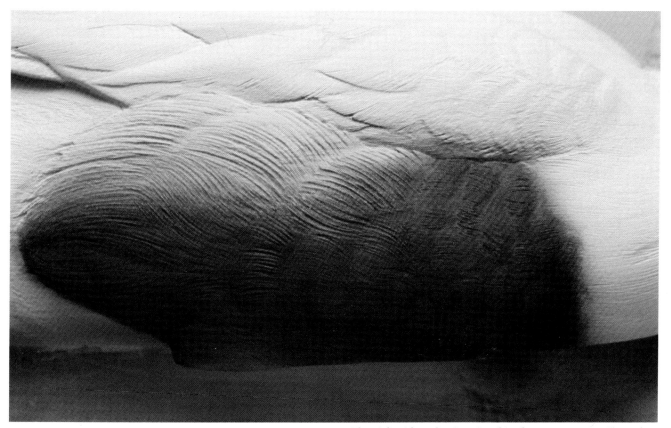

The right sidepocket is painted in the same manner. Jim paints the breast white and creates a transition area between the sidepockets and breast by extending small white feather markings into the chestnut-colored area.

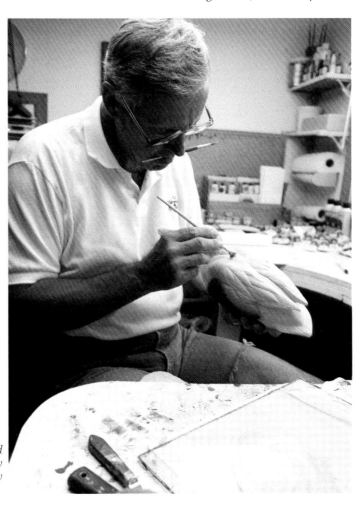

Jim is now ready to add feather detail to the scapulars and breast with a white-on-white painting technique. He begins by painting the scapular feathers on the back with a nimbus gray wash. Two washes are applied.

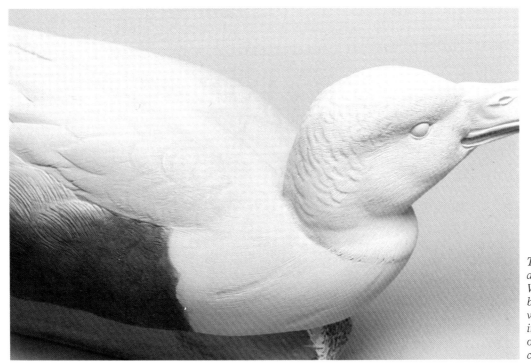

The nimbus gray wash is also applied to the breast. White feather marks will be added, then washes of white will cover the markings, bringing the values of nimbus gray and white closer together.

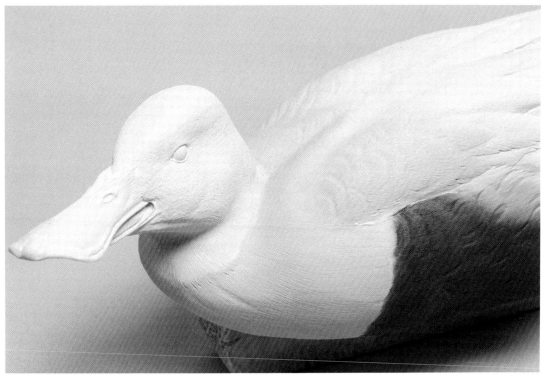

Nimbus gray covers the breast from the collar area, which will be painted green, to the chestnut color of the sidepockets.

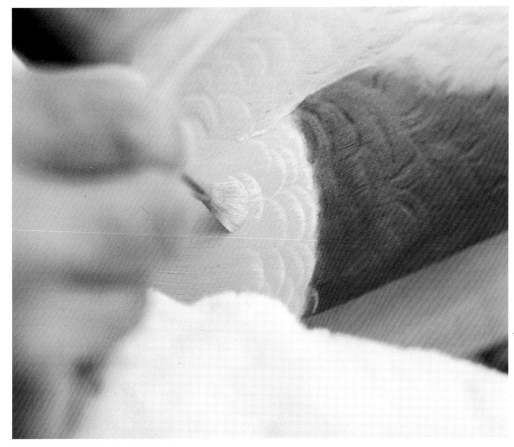

Jim uses a feather-flicking brush (size 6 Liquitex #511 or Raphael #8404) and Liquitex titanium white to apply white feather edges to the breast. The white is painted on the edges of feathers created with the stones and burning tools during the carving process.

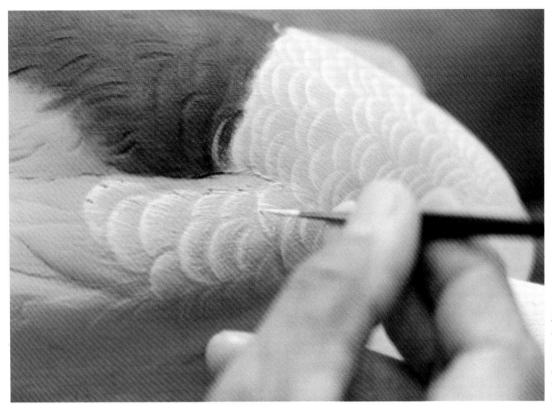

Now the size 1 or 2 Raphael #8220 lining brush is used to further define the feather edges and to pull white feather streaks through the feathers.

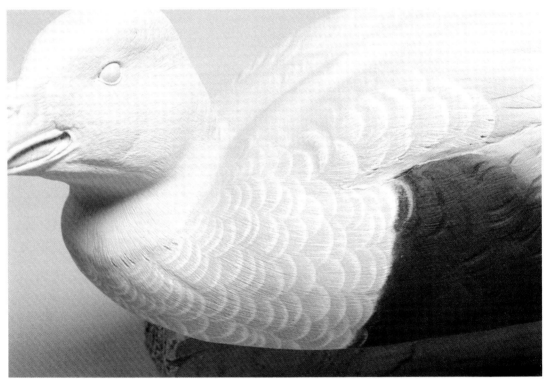

The titanium white feather edges have been applied over the nimbus gray base color but they are too stark, too graphic. Jim will tone them down—bringing closer together the values of nimbus gray and white—with a succession of very thin white washes.

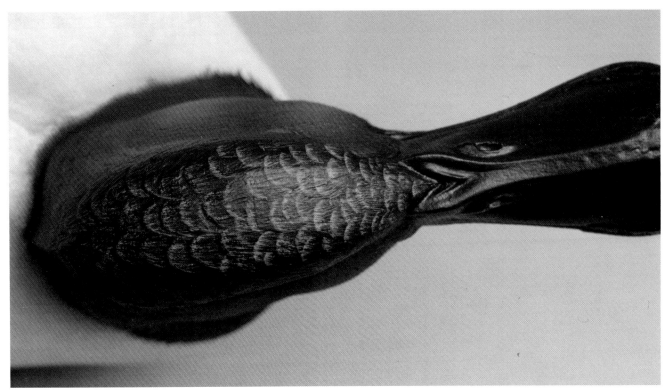

Two washes of burnt umber tone down the feather edges, making them more subtle.

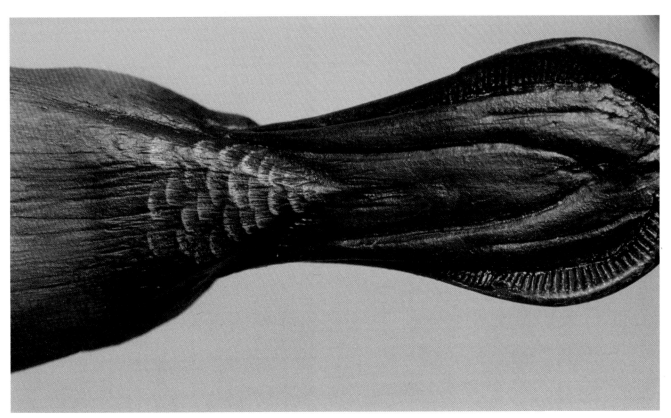

This close-up shows the feather marks under the chin with two washes of burnt umber.

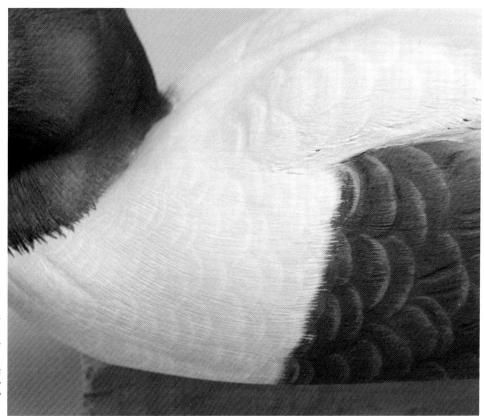

Notice in this close-up the transition areas between the green neck and white breast, and the white breast and the chestnut sidepocket. A size 0 or size 1 lining brush is used to create the tiny irregular feather lines that provide a natural transition.

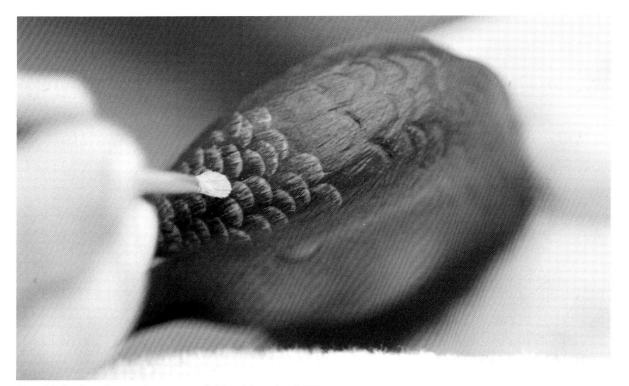

Jim adds feather edges to the crown and chin with a mix of 80% titanium white tinted with 20% raw umber. Here he flicks feather edges on the crown with a size 2 Raphael #8404 brush. The same brush is used under the chin.

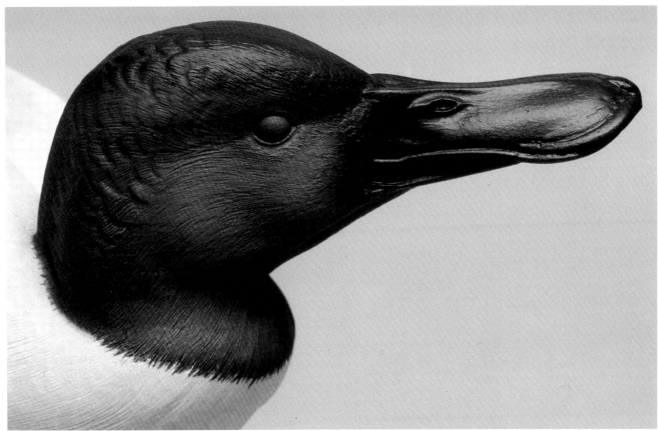

The bill and crown are painted with the standard black mix of 60% Hyplar burnt sienna and 40% Hyplar ultramarine blue. The black is blended to water and applied to the crown, the face directly behind the bill, the chin, and the bill. These Hyplar colors produce a warm black with a slight gloss, which is very lifelike.

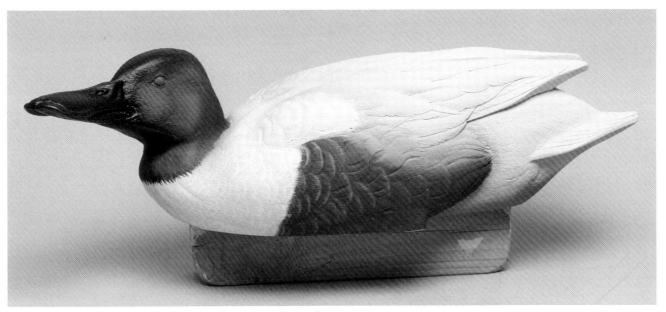

Overall photo of the shoveler at this stage shows the completed breast, sidepockets, and head.

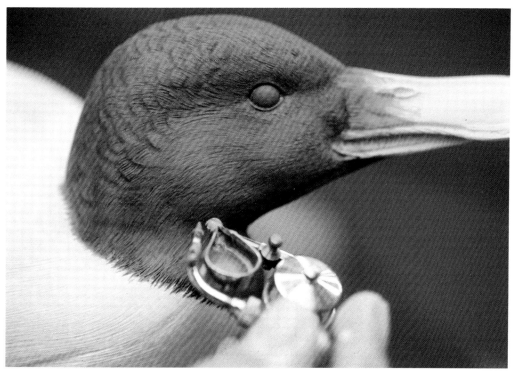

Here Jim adds highlights to the cheeks of the bird by applying a thin wash of yellow oxide with the airbrush. If you prefer to add the highlights with a brush, use a size 6 filbert brush. Dampen the perimeter of the highlighted area with water, then apply color and blend it into the water along the edges. After applying yellow oxide to the general area to be highlighted, lighten just the center of the highlight with a thin wash of yellow light.

To finish, a thin wash of phthalo blue is applied over the entire head. This tones down the highlights, making them more subtle. There should be just enough highlight to emphasize the contours of the face. Finally, one thin wash of carbon black with blue pearl essence powder is blended to water behind the cheek highlight and down the jowl line.

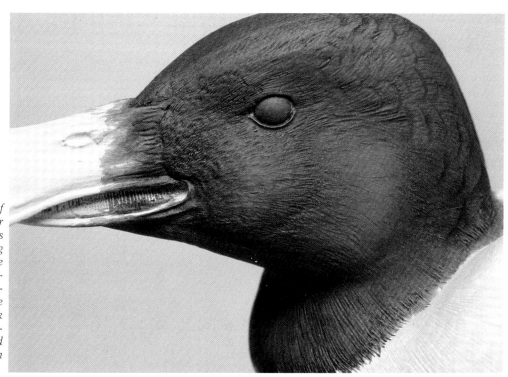

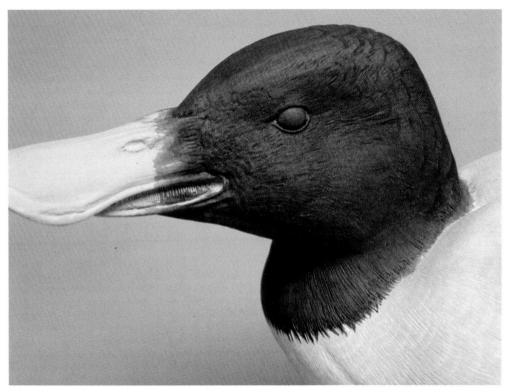

The head is painted with a base color of 45% Jo Sonya phthalo green, 45% pine green, and 10% carbon black (see color chart).

The base color for the head is 45% phthalo green, 45% pine green, and 10% carbon black.

Jim applies four washes of green to the shoveler's head. To the final wash he adds a small amount of green pearl essence to provide iridescence.

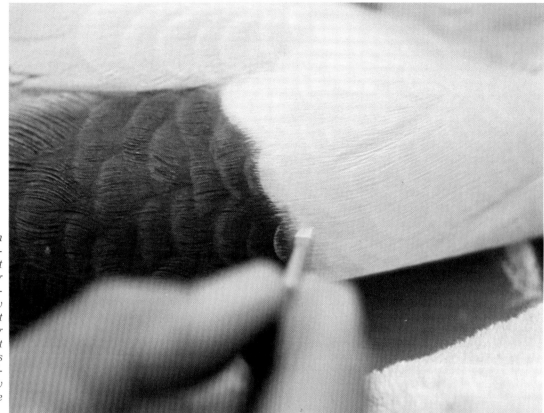

Titanium white with about 15% burnt umber is used to highlight some of the feather edges along the sidepockets. Then a very thin wash of burnt umber is applied over the entire sidepocket area. Here Jim uses the edge of a size 2 filbert brush to pull tiny white feathers into the chestnut area.

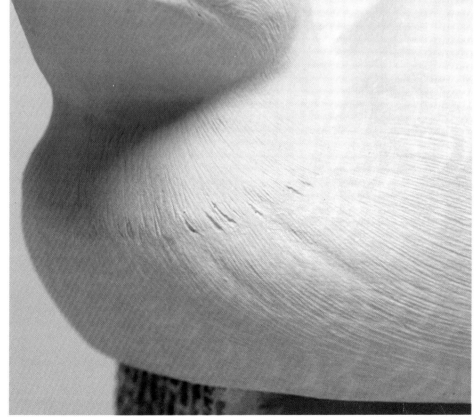

Jim prepares to paint the head by applying a coat of gesso tinted with 10% yellow oxide. The gesso will provide a good base, and it covers any white paint that might have spilled over onto the neck while Jim was painting the breast. Remember, acrylics are a transparent medium and they must be applied over a base of uniform color. Note the transition area here between the neck and breast.

After four washes of thin titanium white the feather edges are still visible, but very subtle. This white-on-white technique provides the illusion of softness and depth.

Next, Jim will paint the transition areas where the breast meets the sidepockets and neck. In this close-up photo of a taxidermy mount it is obvious that the sidepockets have a few white feather edges as well as tiny streaks of white along the margins of the breast and sidepockets. Jim says that the older the bird, the more white markings it is likely to have on the sidepockets.

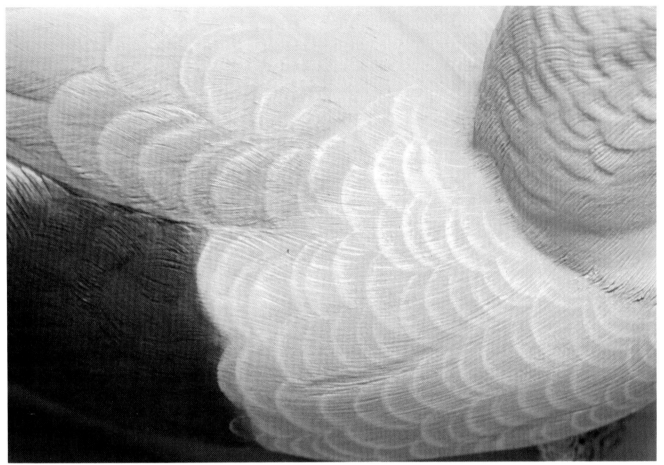

Note in this photograph the pattern and size of feather edges along the back and sides of the breast. Jim extends some of the feather edges into the chestnut area of the sidepockets.

Jim applies three to five thin washes of white over the breast and scapular feathers, drying each with the hair dryer between applications. The goal is to make the area as white as possible but to still retain definition of the feather edges.

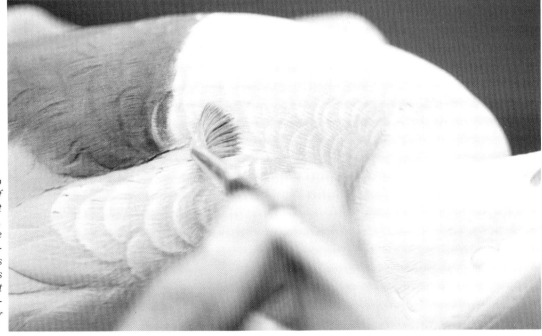

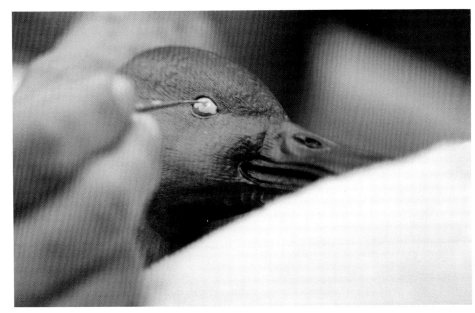

Jim's molded study bird has eyes made of acrylic and must be painted. He applies yellow Testors enamel paint here, then will add black pupils.

The back and upper rump are painted with a base color consisting of 90% raw umber tinted with 10% carbon black.

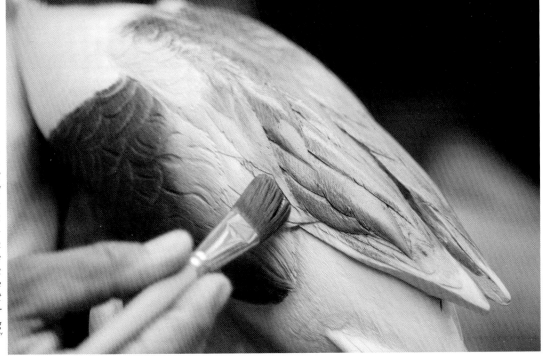

Jim now begins painting the back, including the scapular and tertial feathers and the upper part of the rump. Here he uses a wash of 90% raw umber and 10% carbon black on the back (see color chart). "You don't want to get the area too dark right now because later you'll be painting white feather edges," says Jim.

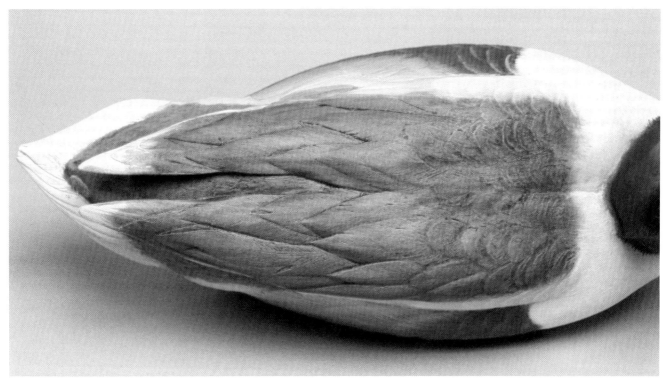

The raw umber/black mix is applied to the upper rump, scapulars, and tertials. The primaries are left white.

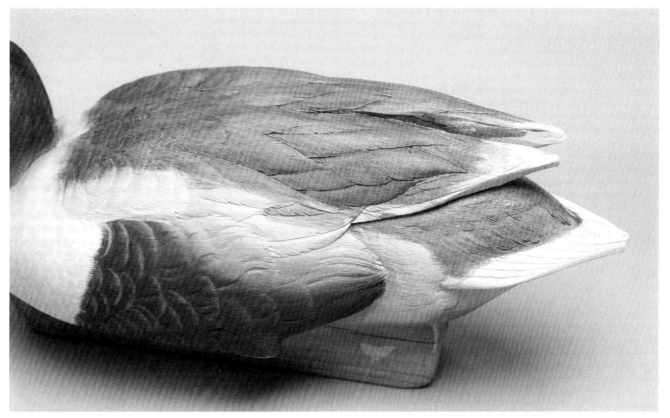

Three washes of color have been applied to the back and rump, and now Jim is ready to add white feather edges.

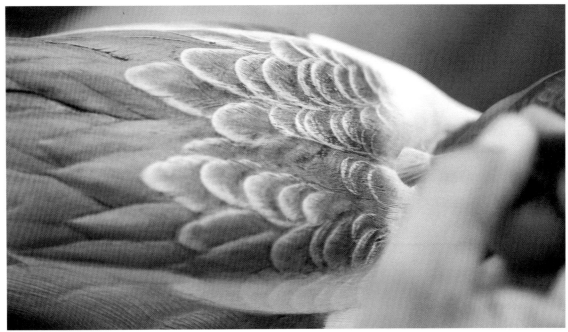

Titanium white tinted with raw umber is used on the feather edges of the scapulars and tertials.

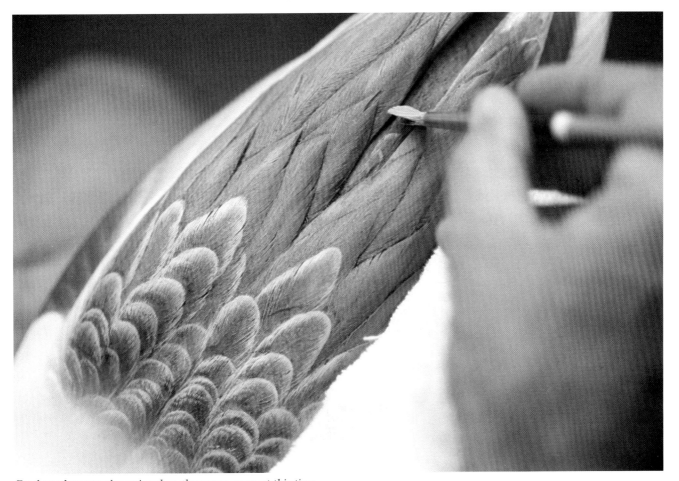

Feather edges are also painted on the upper rump at this time.

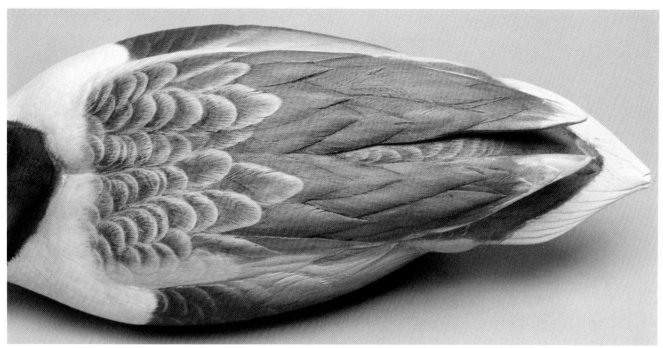

The feather edges are complete, and now Jim will use the raw umber/black mix to darken the bases of each feather.

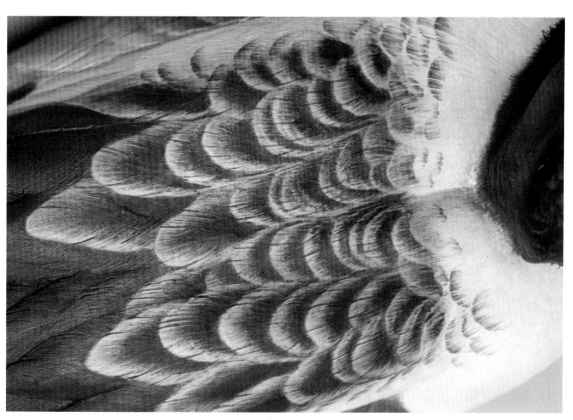

To darken the bases, Jim dampens the white edges and the area just behind them with water, then applies the raw umber/black mix to the base and blends it to the water. This technique produces three values of color on each feather: the white edge, the umber central portion, and the darker base.

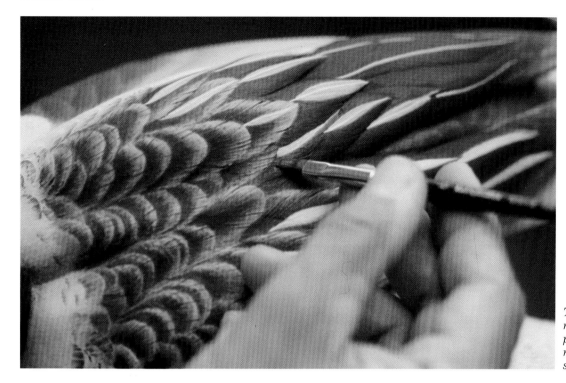

Two thin washes of raw umber are applied over the back, making the color transitions more subtle.

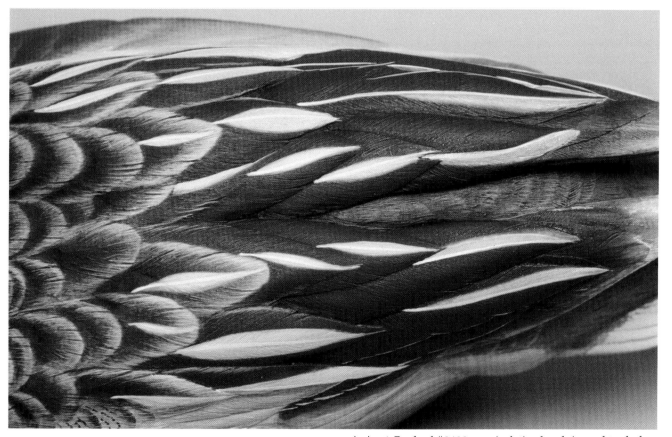

A size 1 Raphael #8408 vermiculating brush is used to darken feather splits with the raw umber/black mix; then the mix is used to darken the tertial and scapular feathers, producing almost a brownish black.

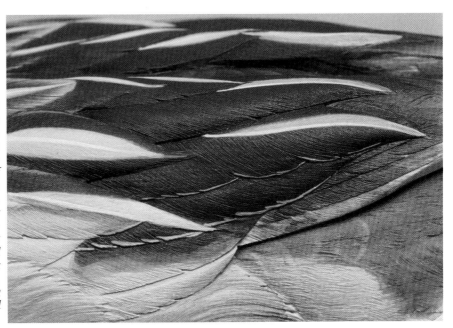

The first row of scapular feathers over the sidepockets has a black edge. Jim paints these with the same raw umber/black mix. Notice here that the lower halves of the scapulars and tertials have a slightly irides-cent greenish cast, which is an equal mix of phthalo green and carbon black to which some green pearl essence has been added. The paint is applied with the color-to-water technique, blending pigment to water. Car-bon black provides shadows in areas that were undercut in the carving process, and white feather centers are added with a mix of 80% white gesso, 15% iridescent white, and 5% raw umber. A size 1 or size 2 lining brush with straight titanium white is used to paint the quills on the white feathers.

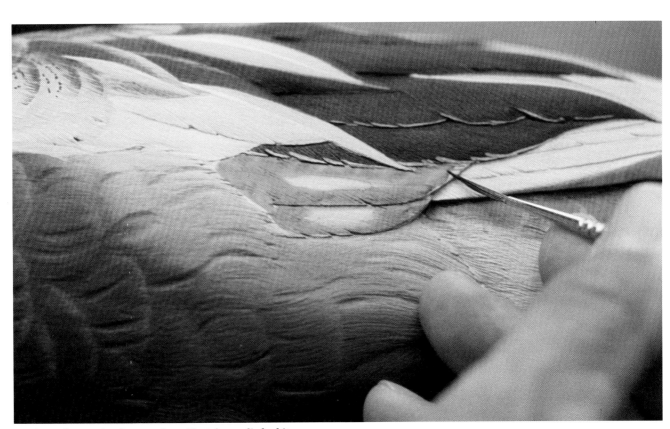

Jim is ready to paint the speculum. First, he applied white gesso with 10% raw umber to cover any paint that may have spilled over while painting the back. Then, two washes of yellow light are painted, followed by a mix of 50% phthalo green and 50% pine green darkened with carbon black goes on. Green pearl essence is sparingly added to the mix. Here Jim has dampened the centers of the feathers and is blending green pigment to water. This technique will provide yellow highlights in the cen-ters of the speculum feathers.

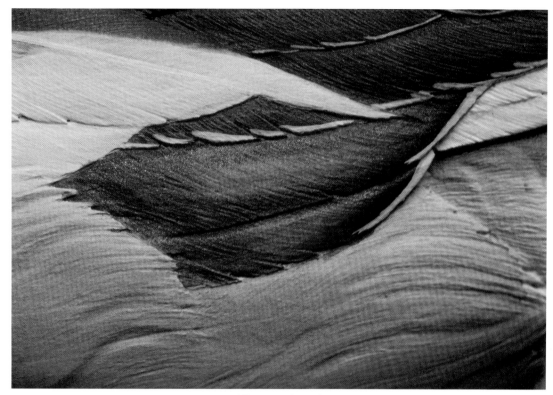

Three washes of green are applied; the third application goes over the entire feather. A final thin wash of carbon black is added to darken the feathers, especially along the trailing edge. A thin line of 70% gesso and 30% raw umber delineates the outer margins of the speculum feathers.

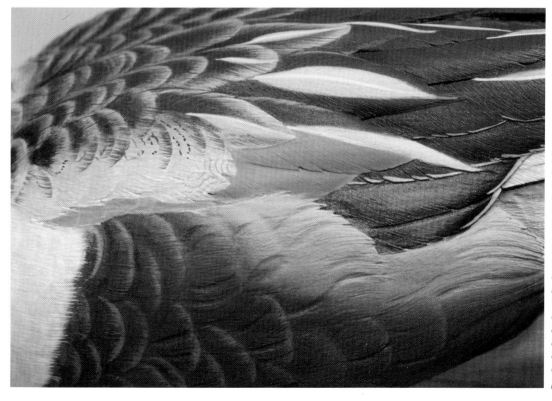

The blue scapular feathers and the long streamer feather above the speculum are painted with a mix of 40% gesso, 30% ultramarine blue, and 30% burnt umber. The lower edges of the scapular feathers are first painted with straight ultramarine blue, then the mix is applied over the entire area, leaving the edges a darker value of blue. A thin wash of burnt umber completes the area.

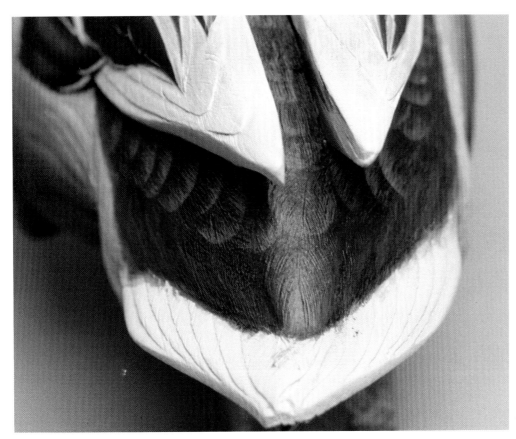

The primaries and the tail feathers are painted with gesso to cover any paint that might have spilled onto them.

The area beneath the rump is painted with the standard Hyplar warm black mix. The same mix is used on the upper rump and on the tail covert feathers. Feather edges have been added with a mix of 80% titanium white and 20% raw umber.

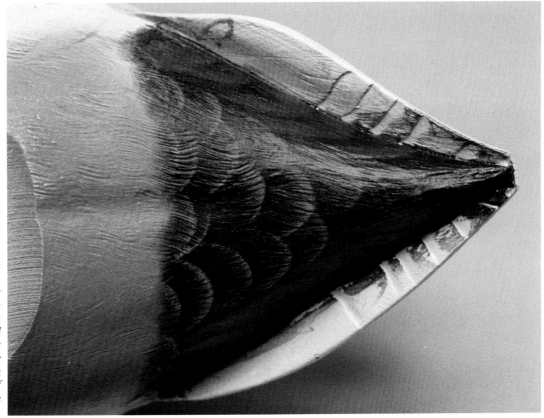

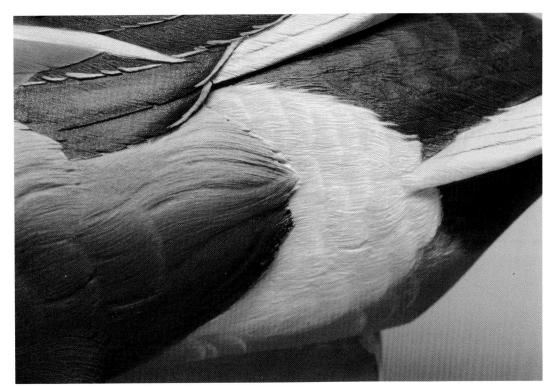

This photo shows the transition areas between the sidepocket, flank, and rump. The white flank is painted with the same white-on-white technique used on the breast. A base coat of nimbus gray is applied, two or three titanium feather edges are flicked on, and then a series of white washes lighten the area but still leave the feather edges visible.

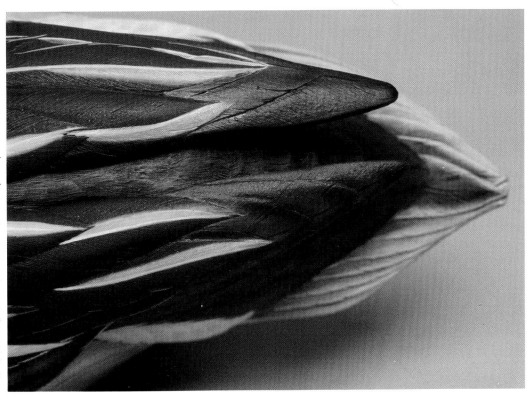

The tops and bottoms of the tail feathers are painted with a mix of 90% nimbus gray and 10% burnt umber. The primaries are painted with a base mix of 85% burnt umber, 10% titanium white, and 5% carbon black. Then Jim uses a mix of 50% carbon black and 50% burnt umber to darken the lower edges of the feathers. A small amount of green pearl essence is added to the inside halves of the primary feathers.

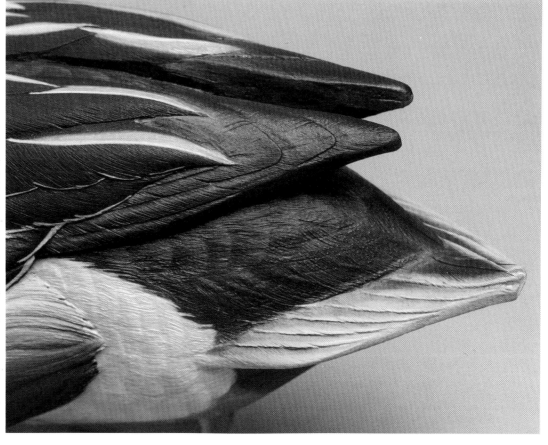

The quills of the primary feathers are painted burnt umber, and the outer edges of the tail feathers and the quills are painted white. A thin wash of burnt umber is applied to the tail to give it a slightly warm tint. The 85% burnt umber mix used on the primaries is used to darken the bases of the tail feathers, with the two center tail feathers being much darker. Jim uses the color-to-water technique, dampening around the area with water, then applying paint and blending to water.

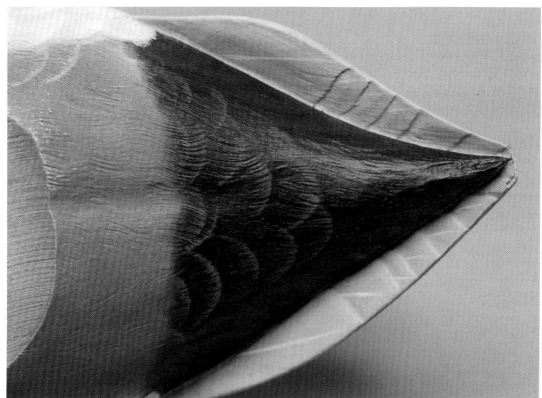

A burnt umber wash is used to darken the underside of the rump, and the quills of the tail feathers are painted white. Matte medium-varnish diluted equally with water is applied to each quill.

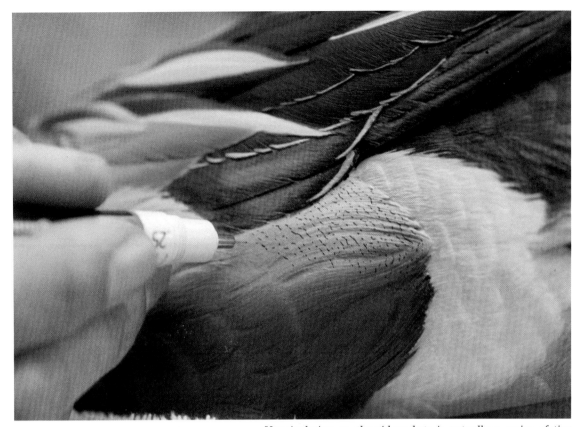

Vermiculation on the sidepockets is actually a series of tiny black dots. Jim uses a Rapidograph pen with a 0.25 tip to apply the dots. For most vermiculation he prefers to use a fine brush, but the dots that constitute the shoveler's vermiculation are so fine that the pen works better in this instance. After applying the dots Jim seals the ink by spraying with Krylon matte finish #1311, masking off surrounding areas before he sprays. If the area is too light, he will darken it with a thin wash of burnt umber.

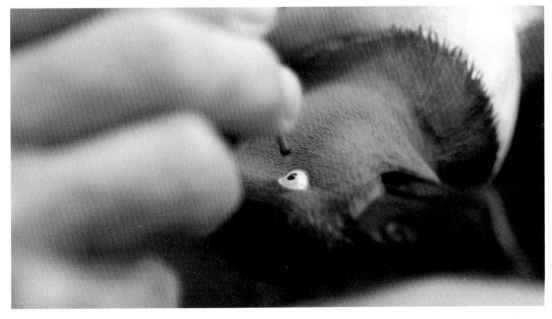

A toothpick is used to dab on the pupil of the eye using Testors black enamel.

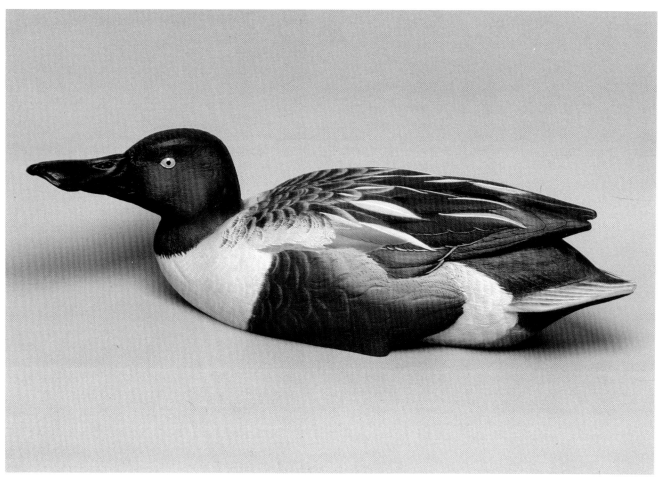

The completed shoveler drake.

8

The Blue-winged Teal Drake

The teal drake is a handsome bird, a combination of bold design and subtle color combinations. The white half-moon on the bird's face is distinctive, as are the blue scapular feathers, the green speculum, and the bold dot pattern along the breast and sidepockets.

You'll get to work on several techniques in this session. The white-on-white painting method used extensively on the bufflehead and shoveler drakes will be used on the teal's flanks and half-moon facial marks.

The speculum will be highlighted with the green-over-yellow technique that was used on the shoveler drake. And the rump, primaries, and tail feathers will be painted subtle earth shades using the color-to-water blending method.

Painting the blue-winged teal with Jim Sprankle's methods shows the incredible versatility and potential of acrylic colors. Because the paints are transparent, the white-on-white technique is fairly easily accom-

MATERIALS & COLORS

Deft Spray Stain, Salem maple
gesso
Hyplar burnt sienna
naphtha red light
raw sienna
raw umber
burnt umber
iridescent white
titanium white

phthalo blue
Hyplar ultramarine blue
Payne's gray
phthalo green
carbon black
yellow oxide
yellow light
pine green
violet pearl essence powder
green pearl essence powder
blue-green pearl essence powder

plished. Ditto the process of building highlights and color depth on the speculum. Acrylics also are excellent for the more subtle tonal challenges, such as providing the gradual shift in color values on the primaries and tail covert feathers.

Again, we should remind you that success in painting depends on good reference material and your ability to study and interpret it. Live birds, taxidermy mounts, or sharp color photographs are essential.

It's also imperative to keep your work area clean and to develop precise, methodical work habits. Painting a realistic bird such as a teal is an exacting task, one that can be ruined when bits of dry paint find their way onto the surface of your painting project. Use a large glass palette and clean water to mix colors, and always discard previous paint mixes before beginning a fresh batch; dried paint left on the glass could come back to cause trouble.

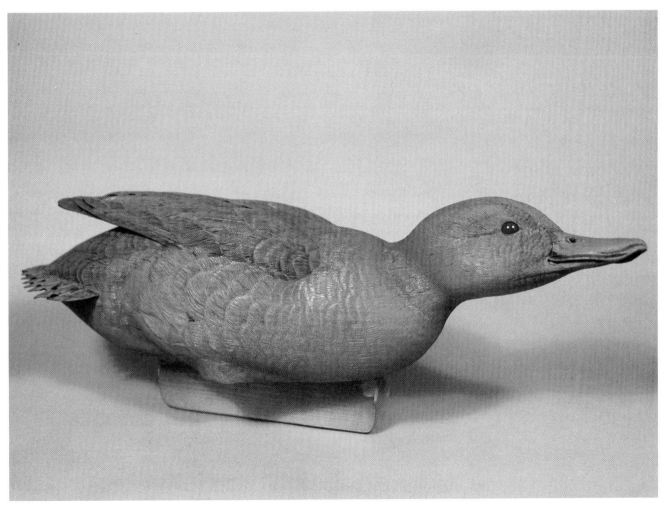

The wooden bird is sealed with Deft Spray Stain in Salem maple color. Jim applies enough sealer to provide a uniform surface over the entire bird, covering any wood filler that might have been used around the neck or eyes.

The base color for the breast and sidepockets is 48% gesso, 15% naphtha red light, 15% raw sienna, 20% burnt umber, and 2% burnt sienna.

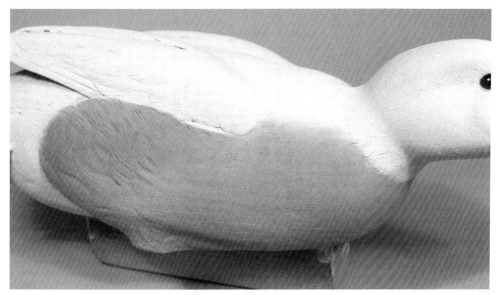

Jim begins painting by applying a base coat of several washes of white gesso tinted with 10% raw umber. Again, enough washes are applied to provide a uniform surface. Jim usually paints three or four coats, allowing each to air dry between applications. Always apply gesso with the flow of the feathers. When the gesso is dry, the base color is applied to the breast, sidepockets, and under the rump. This is a mix of 48% gesso, 15% naphtha red light, 15% raw sienna, 20% burnt umber, and 2% burnt sienna (see color wheel).

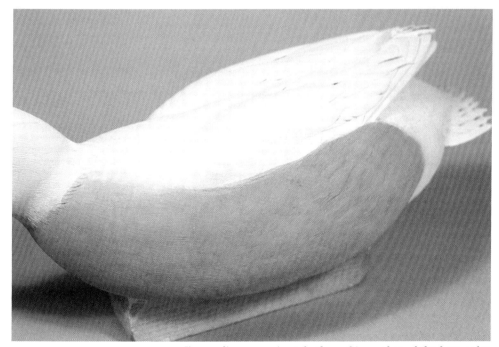

Jim applies approximately three thin washes of the base color mix, then uses a thin wash of straight raw sienna on the breast and the top row of sidepocket feathers. The raw sienna is blended to water along the upper margins of the sidepockets, producing a raw sienna cast in this area. Jim saves the base color mix to use later on the feather markings on the back and cape.

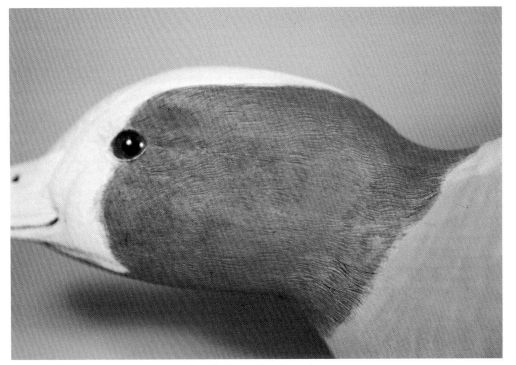

Before Jim paints the head he checks whether paint from the breast might have spilled onto the neck area. If so, he covers it with the gesso/raw umber base coat to ensure an even distribution of color. He then applies four washes of the base color for the head: 75% standard black—60% Hyplar burnt sienna and 40% Hyplar ultramarine blue—10% gesso, 10% burnt umber, 2% phthalo blue, and 3% raw sienna (see color chart).

The base color for the head is 75% standard black (made by mixing 60% Hyplar burnt sienna and 40% Hyplar ultramarine blue), 10% gesso, 10% burnt umber, 2% phthalo blue, and 3% raw sienna.

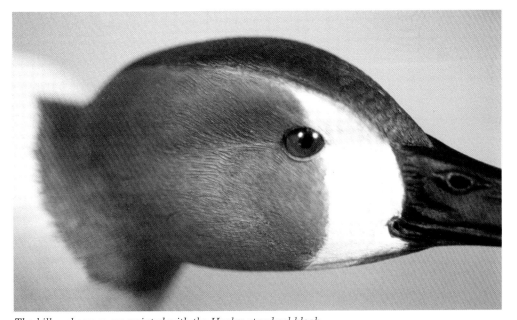

The bill and crown are painted with the Hyplar standard black mix. With the base color applied to the head, Jim blends in two washes of straight Payne's gray behind the eye, under the crown, and down the neck. Then one thin wash of Payne's gray is applied over the entire head, with the exception of the front of the crown and under the chin.

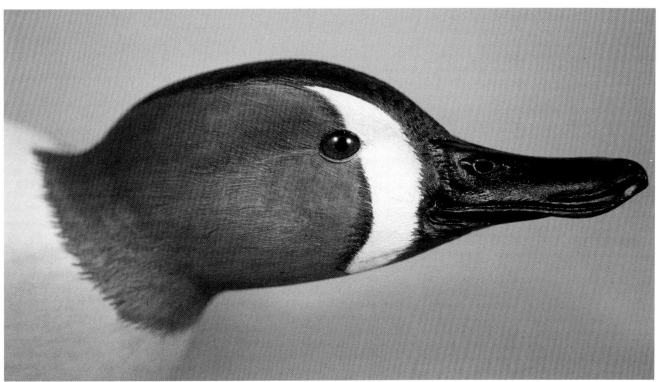

The Hyplar standard black mix is also used under the chin and behind the white half-moon.

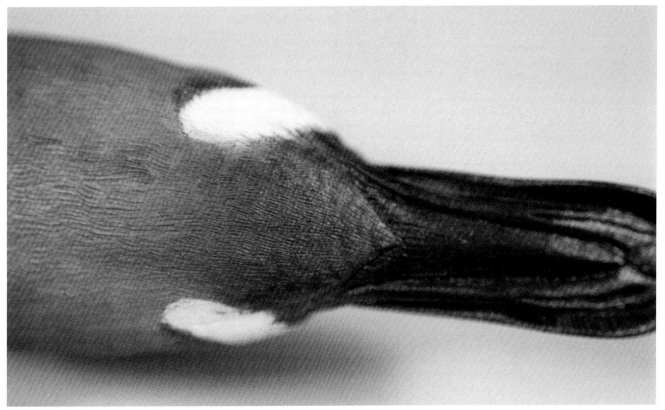

The black mix is applied behind the bill and blended to water under the chin, providing a gradual transition.

Jim uses titanium white tinted with 20% raw umber to flick feather edges on the crown and under the chin. Two thin washes of burnt umber over the crown and under the chin tone down the edges, reducing the contrast.

Iridescence is added above and behind the eye by applying a thin wash of phthalo violet with violet pearl essence powder just behind the eye. Jim dampens the surrounding area and blends the color to water. After the violet dries Jim applies a similar wash of phthalo green with green pearl essence above the violet area, again blending color to water.

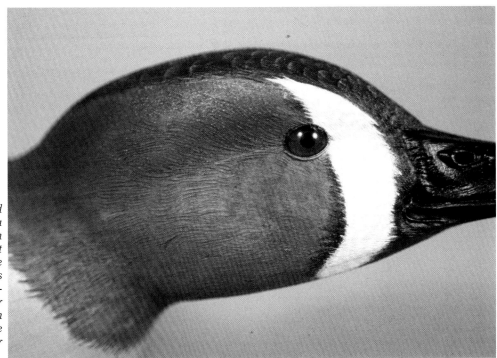

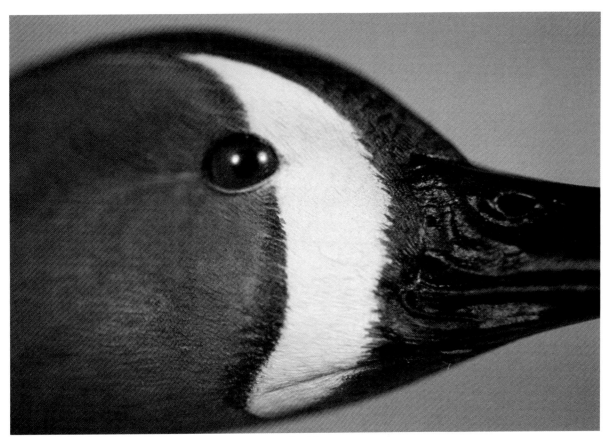

The white half-moon is painted with white gesso tinted with 20% raw umber. Jim then uses a size 2 Raphael #8404 feather-flicking brush to add feather edges to the area with straight titanium white. Feathers were delineated during the carving process; now Jim adds white edges to each.

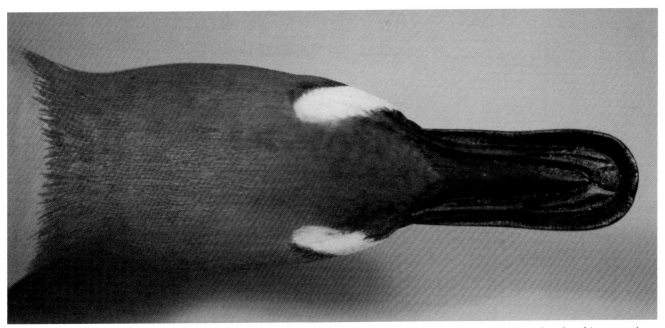

The white half-moons extend well under the chin, sometimes even meeting.

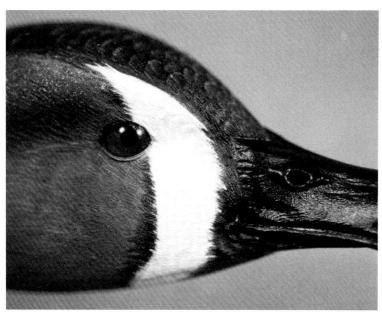

Two or three thin washes of titanium white are applied to the half-moon. The goal is to make the area as white as possible but still have the white feather edges show. Jim finishes the area by using a size 2 Raphael #8220 lining brush to pull fine black feathers into the front portion of the white half-moon. The same brush is used to pull fine white gesso feather lines into the gray area behind the half-moon and along the crown. The addition of these fine feather markings helps soften the margins of the half-moon.

The base color on the back: 85% raw umber, 10% burnt umber, and 5% carbon black.

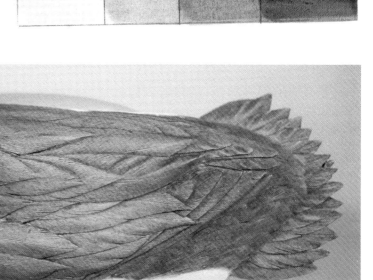

The base color of the back and upper rump is a mix of 85% raw umber, 10% burnt umber, and 5% carbon black (see color chart). Four thin washes of color have been applied in this photo. The color is blended to water where it meets the breast color behind the neck.

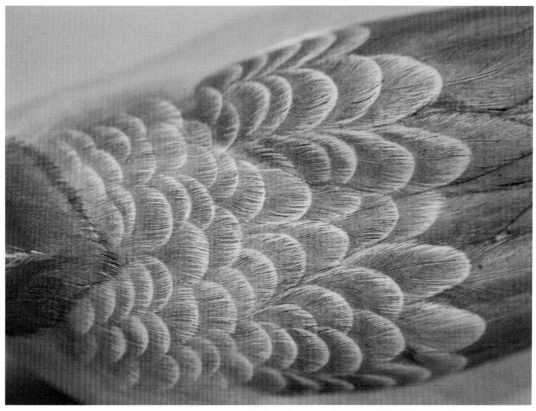

Jim flicks edges on the carved feathers with titanium white tinted with 20% raw umber using a size 6 Raphael #8404 brush.

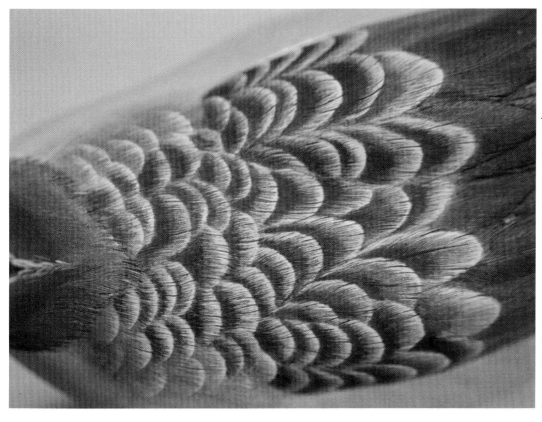

Jim darkens the base of each feather by blending in additional washes of the back base color. To do this, he first dampens the outer edges of the feathers with water, applies paint to the base portion of the feather, then blends the color to water. This produces a deeper color along the feather base and a lighter value near the tip. The technique provides a transition in color value on each feather from deep brown at the base, to medium brown in the center, to warm white along the edges.

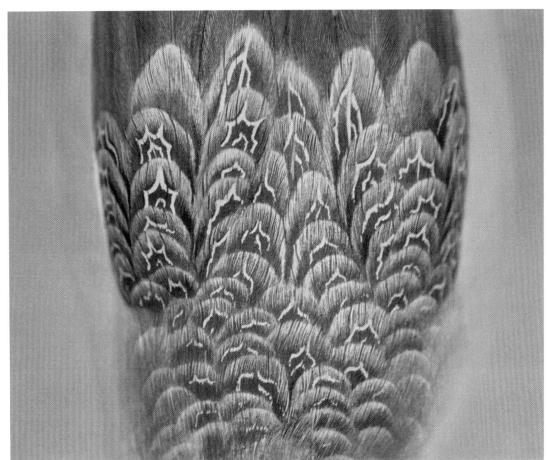

The color mix Jim saved after painting the breast, sidepockets, and under the rump is retrieved, and he now uses a size 2 Raphael #8408 brush to add a vermiculated pattern to the feathers on the back. It's important to have good reference material at this step. A live bird or taxidermy mount is almost essential, but good close-up photos will suffice.

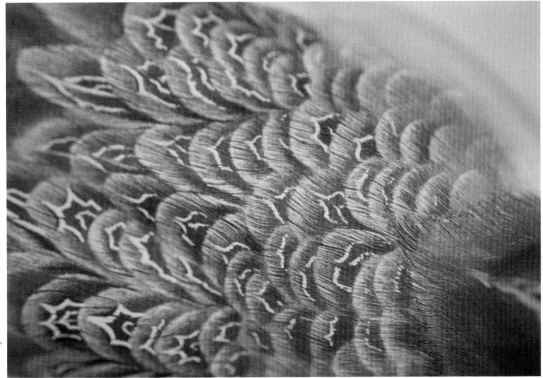

Jim finishes the area by adding a small amount of straight carbon black to random edges of the pattern and in feather splits or other textured areas to enhance the definition. If the entire back seems too light in value, Jim will apply a thin wash or two of raw umber over the entire area.

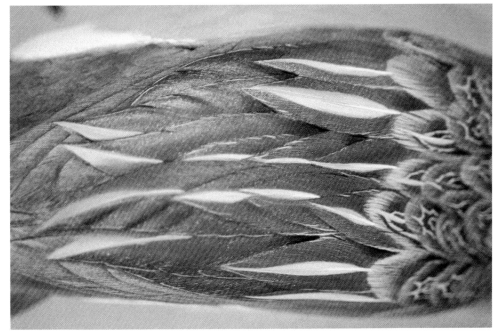

Three tertial feathers on each side of the back will receive a wash of carbon black tinted with green pearl essence, and the centers of the tertials and scapulars are painted a cream color consisting of 75% gesso, 10% yellow oxide, 10% burnt umber, and 5% burnt sienna (see color wheel). A very thin wash of the greenish black pearlescent mix is extended over the scapulars to produce a slight greenish cast and some iridescence.

The centers of the tertials and scapulars are a mix of 75% gesso, 10% yellow oxide, 10% burnt umber, and 5% burnt sienna.

Jim paints the quills by first applying thin raw sienna. Then he adds gesso to the cream mix used in the centers of the tertials and scapulars and blends this color into the raw sienna, beginning at the base of each quill. This same cream mix is used on the lower edges of the tertial feathers and on random scapular feathers. A carbon black wash is used to enhance definition in undercut areas and feather splits. If the back appears too light overall, Jim will apply a thin wash of burnt umber from the neck to the tertials.

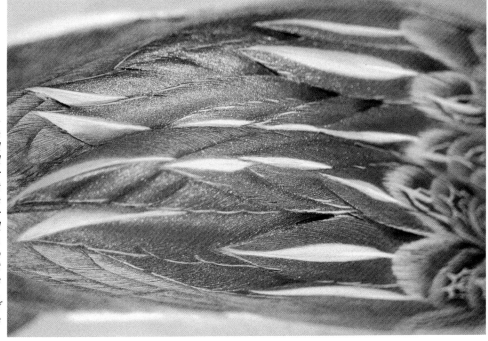

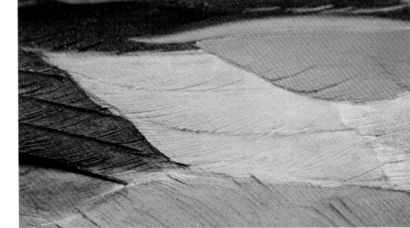

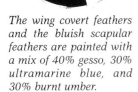

The wing covert feathers and the bluish scapular feathers are painted with a mix of 40% gesso, 30% ultramarine blue, and 30% burnt umber.

Jim begins painting the speculum feathers by first applying gesso to cover any paint that may have spilled onto them while painting the back. Then two washes of yellow light are applied. The blue scapular feather and the wing covert feather are painted with 40% gesso, 30% ultramarine blue, and 30% burnt umber (see color wheel).

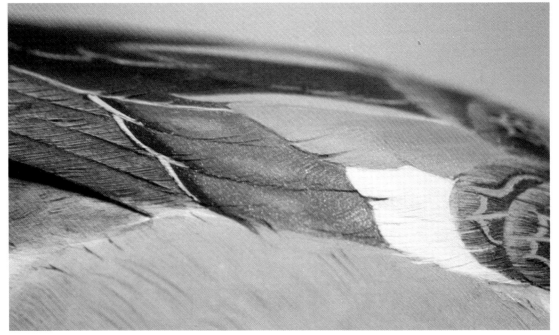

Jim dampens the center of each yellow speculum feather, then blends to it an equal mix of phthalo green and pine green, to which is added about 5% carbon black and some green pearl essence. The green is blended into the dampened centers to produce a yellow highlight in the center of each feather. After two or three similar applications Jim applies a wash of green over the entire speculum to bring the green and yellow values closer together. A thin wash of carbon black darkens the speculum, and buff edges are added to the feather edges with a mix of gesso tinted with 30% raw umber. The blue scapular feathers are finished with a thin wash of straight ultramarine blue applied to the lower edges.

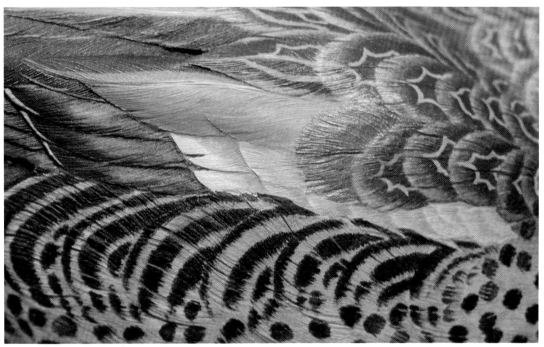

The blue-green feather directly behind the blue scapular is painted with a mix of 60% phthalo green and 40% phthalo blue, with blue-green pearl essence added. Jim uses a size 6 Raphael #8404 brush and applies the color from the feather edge toward the base. A thin wash of burnt umber will darken the feather.

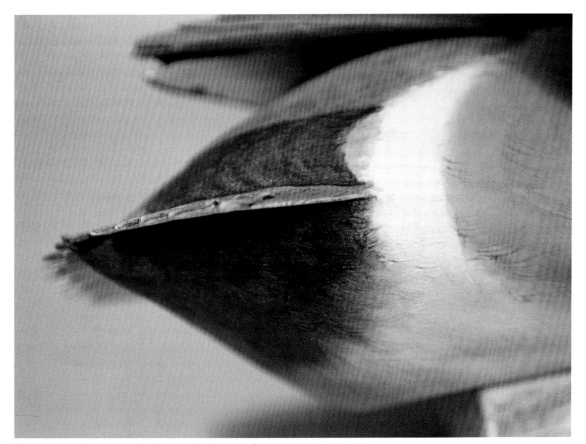

The rump and first row of tail covert feathers on the upper rump are painted black, using the standard Hyplar black mix. Jim applies three or four washes. Some green pearl essence is added to the mix and Jim paints the first row of tail covert feathers under the rump.

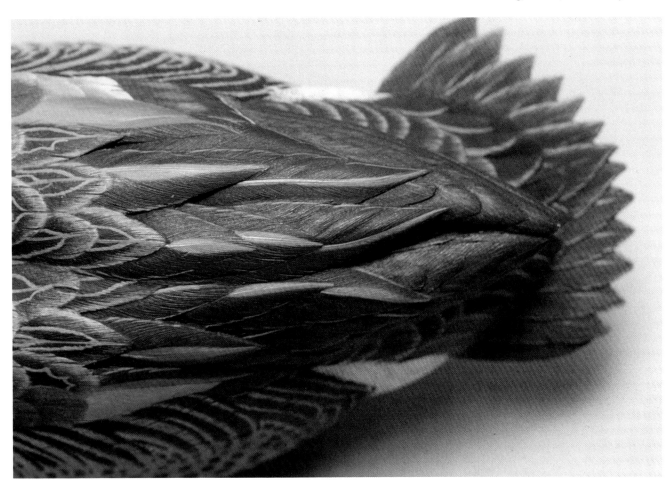

The cream mix used on the centers of the tertials and scapulars is blended into the black along the top edges of the first row of feathers on the upper rump. Then Jim blends to water a thin wash of raw sienna, leaving some of the creamy edge showing. The lower half of these feathers has a green iridescent cast, which Jim applies with a wash of carbon black and green pearl essence powder. The quills are painted with an equal mix of carbon black and burnt umber. The other feathers on the upper rump are painted with a mix of 45% raw umber, 45% burnt umber, and 10% carbon black. Jim blends the color to water from the base out on each feather, producing a darker value at the base. The feather edges are painted with a buff mix of 80% titanium white and 20% raw umber. A thin wash of raw umber with green pearl essence is then applied over the entire area, and the quills are painted with the carbon black/burnt umber mix. Often there is a greenish iridescent cast on the inner halves of the primaries toward the tips. Jim adds some green pearl essence to the mix used to paint the feather edges and applies a thin wash over the inner halves of the upper primaries.

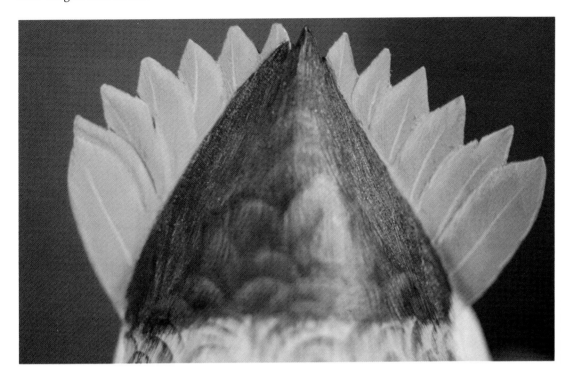

The underside of the tail feathers is painted with gesso to cover paint that might have spilled over.

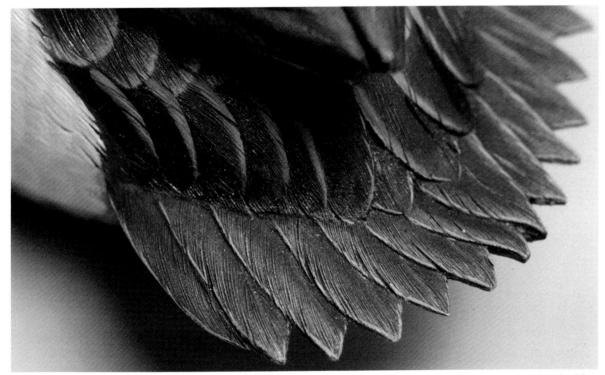

The top sides of the tail and wing feathers are painted with a base color of 60% burnt umber, 35% titanium white, and 5% carbon black. Jim darkens this mix by adding more carbon black, then he dampens the outer edge of the four center feathers and paints the base of each, blending the color to water. The edges are painted a buff made by mixing 20% burnt umber and 80% white gesso, using a size 2 Raphael #8404 brush. The quills are painted the same blackish brown used earlier, and a thin wash of burnt umber darkens the entire area slightly.

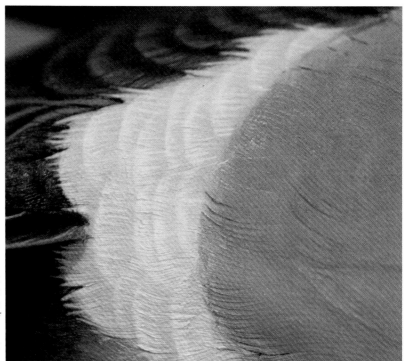

The flank is painted white in the same manner in which the half-moon was painted on the face. Jim first applies a base coat of 80% gesso tinted with 20% raw umber, then he flicks feather edges of titanium white with a size 6 Raphael #8404 brush. Washes of titanium white are applied until the area is white but the feather edges still visible.

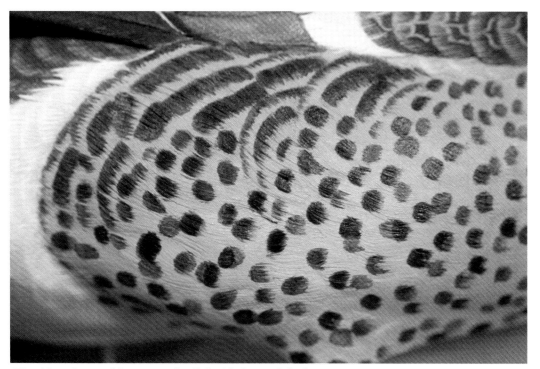

The sidepockets and breast are detailed with dots and feather edges made by mixing 20% burnt umber and 80% carbon black. Along the breast and the forward parts of the sidepockets the marks appear as bold dots, but closer to the flanks they are in the shape of feather edges. Some marks should be bold and others somewhat lighter to provide the illusion of softness and depth. Jim alternates bold and lighter value markings randomly. It's imperative to have good reference photos or, preferably, a mounted bird or study skin when laying out these marks.

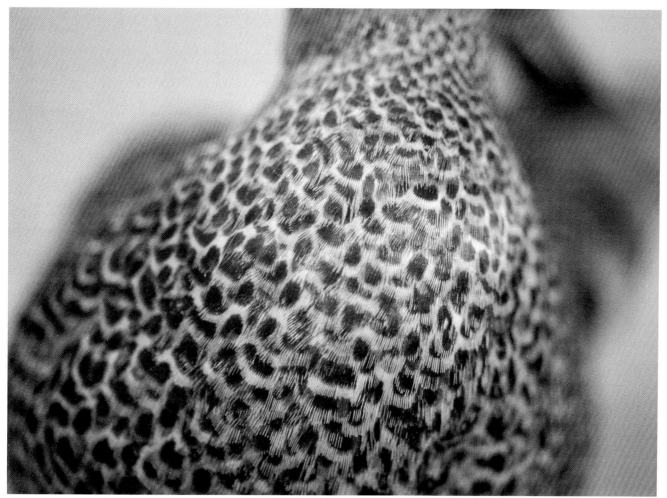

Close-up photo of the breast of a taxidermy mount shows the randomness of the dots. Also note that the dots are smaller and much closer together on the breast than on the sidepockets and flanks.

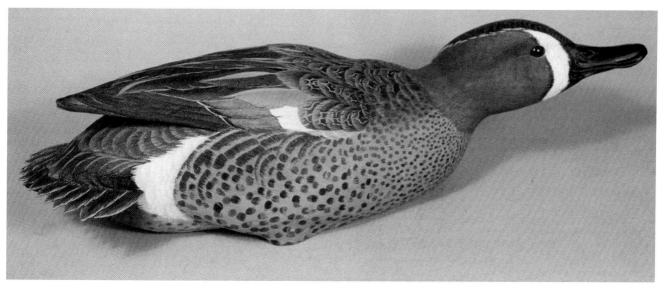

The finished blue-winged teal drake.

9

The Blue-winged and the Cinnamon Teal Hens

The blue-winged teal hen and the cinnamon teal hen are very similar in coloration, the major difference being the shape of the bill. So for this painting session we'll consider them as one. The techniques, coloration, and design used here are appropriate for either species.

Before beginning, it's a good time to reinforce a few painting principles that apply to all species of birds. First, when painting highly realistic birds such as these, it is essential to be neat, to have good housekeeping habits in the painting area. Never let dried paint accumulate on your equipment because sooner or later small bits of it will end up on the bird you're painting, and nasty streaks will result.

Jim uses a sheet of plate glass as a palette, and he places a white paper towel under it to provide a uniform white background on which to mix colors. He keeps a bottle of Windex and a roll of paper towels handy, and the palette is cleaned between each color mix.

In this session Jim is painting one of his molded study birds, so he begins with a base coat of gesso. He uses a stiff bristle brush to apply the gesso and paints with the feather flow of the carved bird. Gesso is a fairly thick medium and if it were applied cross-grain

MATERIALS & COLORS
Hyplar matte medium-varnish
Testors model enamel: dark brown for eye, black for pupil
gesso
Hyplar burnt sienna
raw umber
burnt umber
nimbus gray
carbon black
titanium white
Hyplar ultramarine blue
phthalo green
pine green
raw sienna
yellow light
yellow oxide
green pearl essence powder

to the feather detail, it would obscure the fine detail that has been laboriously etched with stones and burning tools.

This session will provide good experience in building up washes to create the illusion of depth. For example, on the speculum of the hen Jim begins with gesso to provide a uniform surface, then applies yellow, followed by washes of green and burnt umber. The darker colors almost cover the yellow, but still a highlight remains in the centers of the speculum feathers. This technique, once mastered, opens up all sorts of possibilities.

The undercoat and base color for the head, lower sides, and under the rump is a mix of 85% gesso and 15% raw umber.

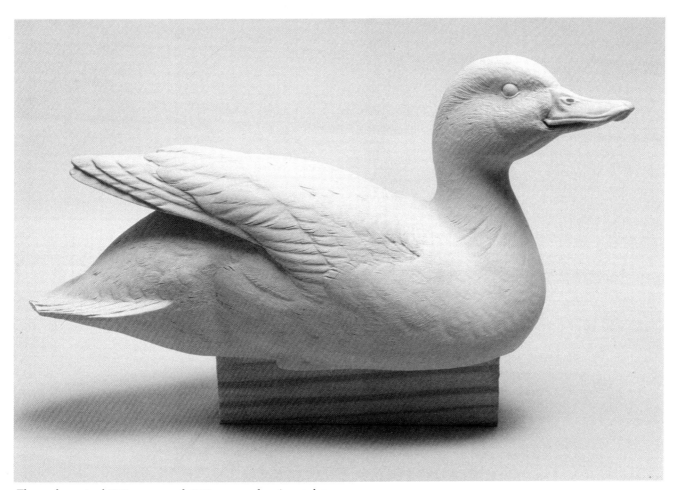

The undercoat of 85% gesso and 15% raw umber (see color wheel) seals the surface of the bird and also serves as the base color for the head, under the rump, and the lower sides. Three washes have been applied and have air dried between applications. Jim saves the gesso mix, which will be used for detailing in future steps.

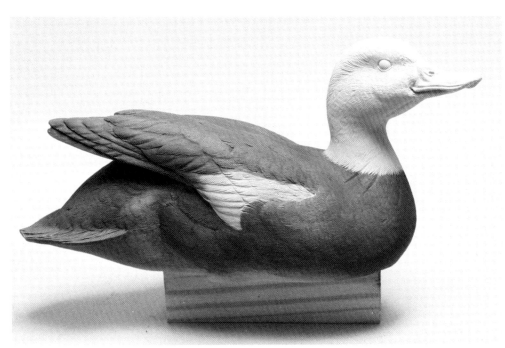

A mix of 55% burnt umber, 35% raw umber, and 10% nimbus gray (see color wheel) is used as the base color of the breast, sidepockets, back, wings, tail, and a portion of the lower rump. Jim mixes more than enough of this color and saves the surplus for a later application. Jim used three washes overall in this photograph, and then applied a fourth wash to the breast, back, and upper rump because he wants the base color slightly darker in these areas.

The breast base color is 55% burnt umber, 35% raw umber, and 10% nimbus gray.

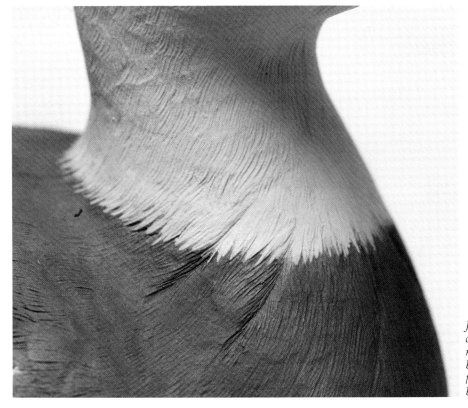

Jim uses the gesso undercoat mix to re-define the area between the head and neck. He carefully uses a small lining brush and the gesso mix to paint fine feather edges along the transition area between the head and neck.

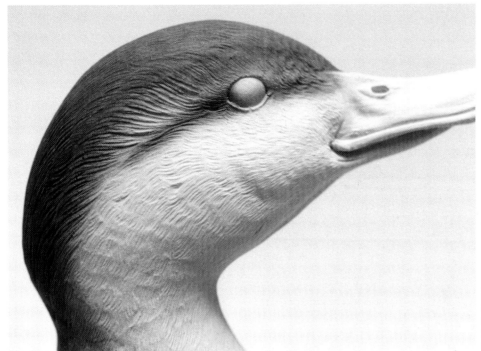

Here Jim adds a small amount of carbon black to the brown base mix and paints an eye line on the head of the teal. He will darken the crown with the same color.

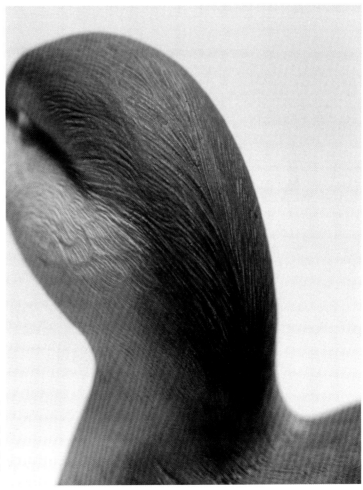

Jim paints the crown using the color-to-water blending technique. He uses two size 6 Raphael #8404 brushes, one for applying clear, clean water and the other for paint. With one brush he dampens the area of the head just below the crown, then with the other he applies paint to the crown and blends it to water along the perimeter. The result is a soft edge, a gradual transition.

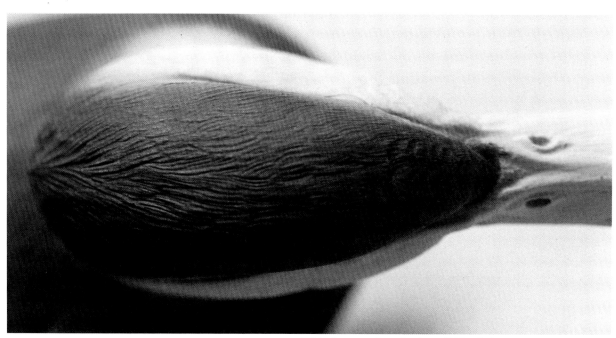

With three washes of color, all blended to water, the crown has the value Jim wants.

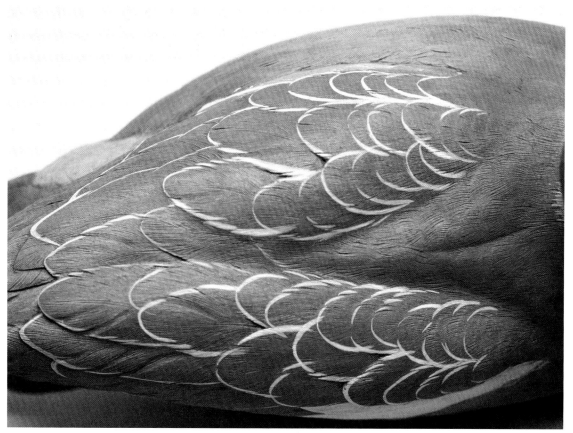

A size 1 or size 2 Raphael #8408 brush is used to cut in the white feather edges along the back of the bird. The color is a mix of 35% titanium white, 35% gesso, and 30% raw umber. This mix will be used for all the white feather edges.

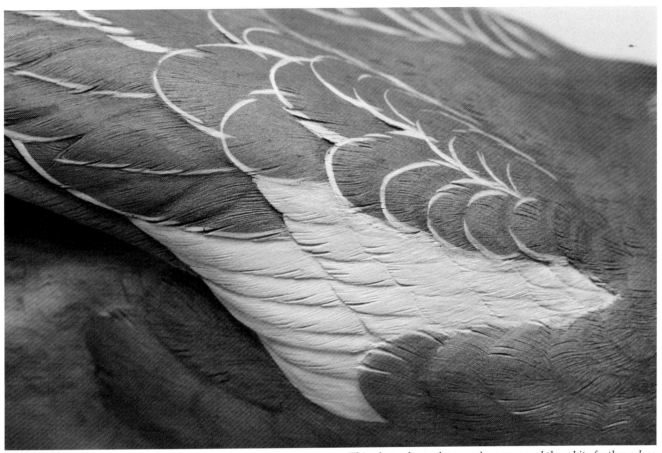

This photo shows the speculum area and the white feather edges along the scapulars.

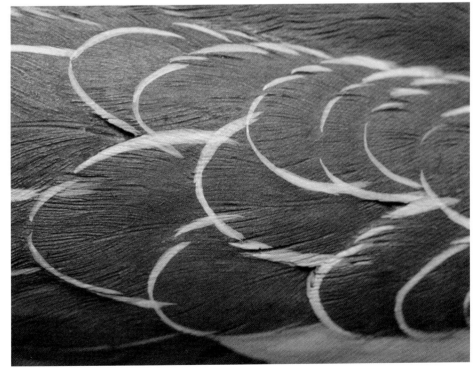

Painting is intended to complement the carving process. Note in this close-up photo that the white edges are applied to feathers that have been carved on the bird; they are not painted at random.

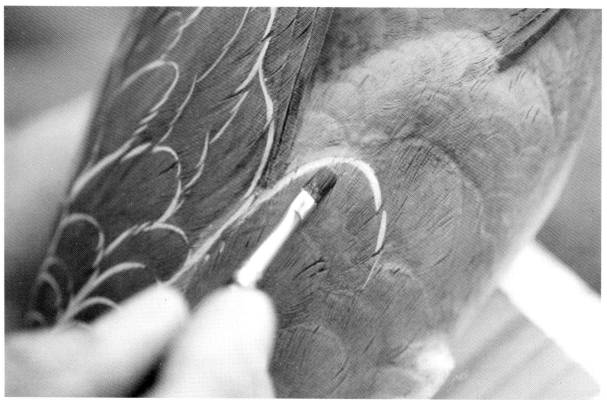

Jim paints the feather edges along the sidepocket area using the color-to-water blending method. Here he uses a filbert brush to dampen the area alongside the edge. The color is blended to water, creating a gradual transition rather than a hard edge.

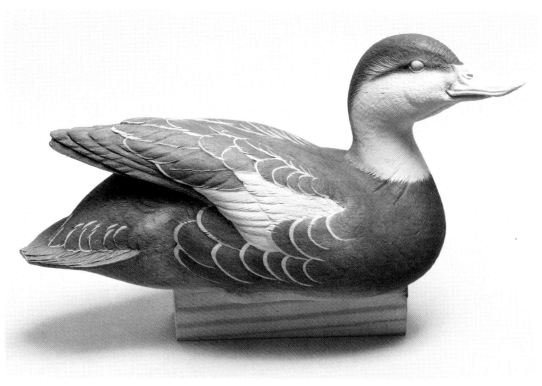

The teal hen with the major feather groups outlined.

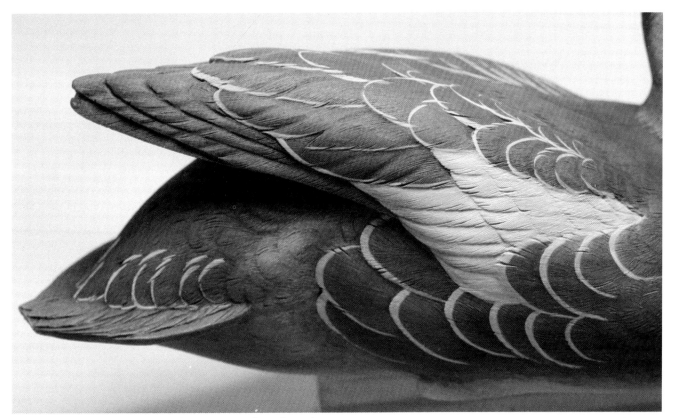

This close-up shows the layout of the feather edges along the wings, rump, and sidepockets.

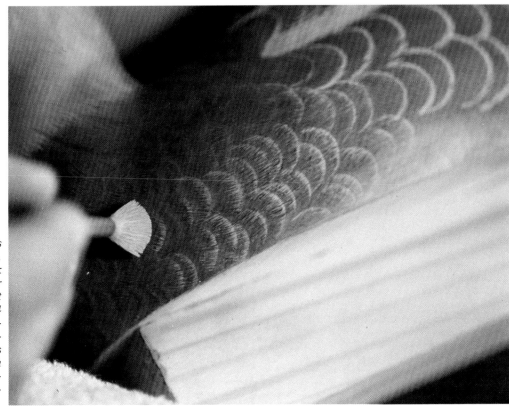

Now Jim begins adding edges to the individual feathers. He uses the same white mix used on previous feather edges and applies the paint with a size 6 Raphael #8404 or Liquitex #511 feather-flicking brush. The fan-shaped brush is ideal for this job. Jim coaxes the brush into the proper shape by flattening the bristles with a palette knife after each use.

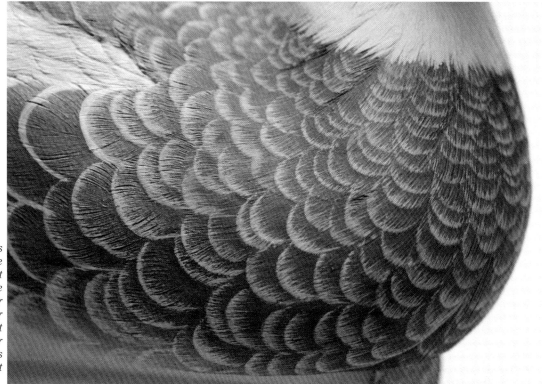

Individual feathers are added to the breast and sidepocket areas. Note that the feathers are smaller and closer together higher on the breast and larger and farther apart along the sides and on the lower part of the breast.

With the feather edges painted, Jim refines their shape with a size 0 or size 1 lining brush. The idea here is simply to elongate some of the white lines, to extend the white of the feather edges, making them realistically irregular. This technique is especially valuable along the upper rump and under the primaries, where it is difficult to reach with the feather-flicking brush.

This close-up photo shows a combination of feather-edging techniques. The bolder edges were applied with the feather-flicking brush, and the small lining brush was used to elongate some of the random white lines.

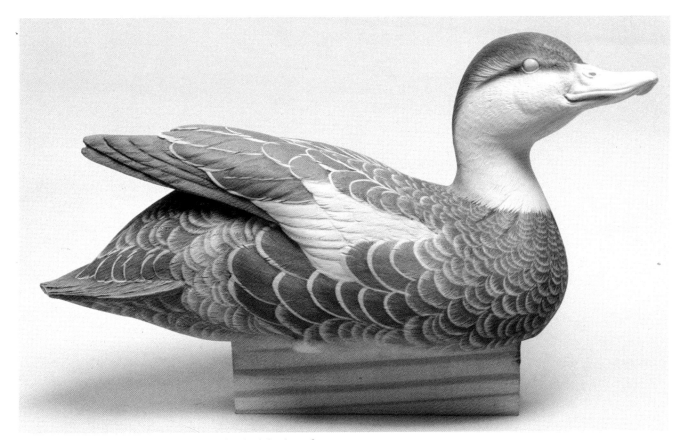

The feather groups have been outlined, individual feather edges have been painted, and now Jim is ready to darken the centers of the flight feathers along the hen's back.

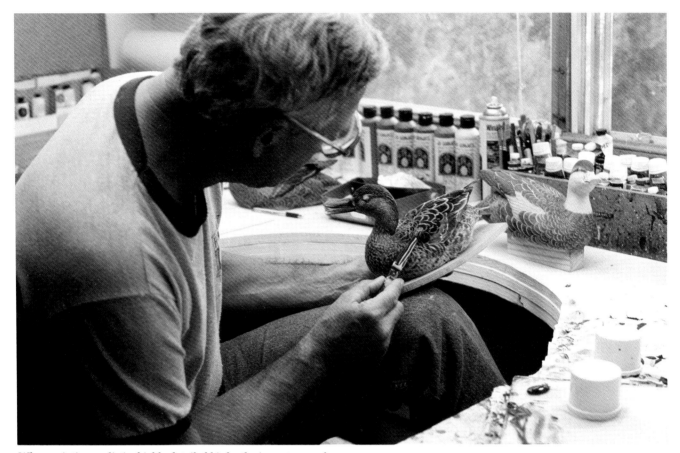

When painting realistic, highly detailed birds, the importance of good reference material cannot be overstated. Jim has cinnamon teal and blue-winged teal hens in his aviary, and he keeps a taxidermy mount in his painting studio.

Here Jim mixes color for the dark centers of the feathers, comparing the value of the acrylics with the actual color of the taxidermy specimen. The color is the brown base mix used in the beginning, which can be darkened if necessary with carbon black. He will use this color to darken each feather beginning at the base and lightening the value toward the edge. Again, this is done with the color-to-water blending technique. Jim dampens the outer perimeter of each feather with water, applies paint to the base of the feather, then blends the paint to the water, creating a gradual edge.

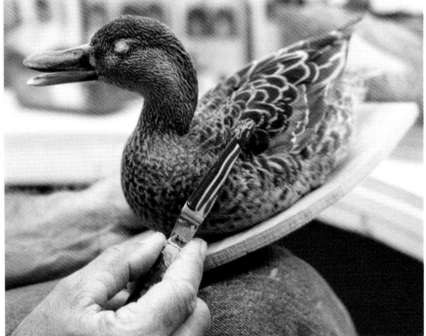

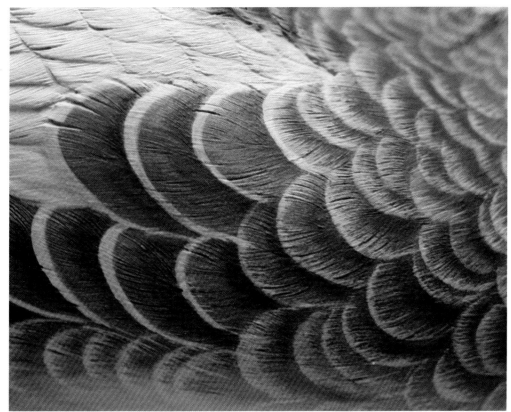

This close-up demonstrates the effect. Each feather has three values: the white tip or edge, the brown base color, and the darker brown at the center or base of the feather. Along the sidepockets shown here, the bases of the feathers are darkened with an additional wash of the brown base mix; carbon black is added to the base mix when darkening the bases of the tertials, scapulars, primaries, and tail feathers because those feathers are darker.

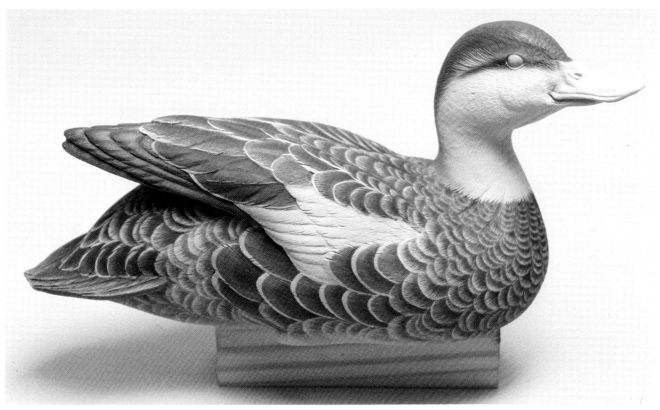

Darkening the bases of the feathers enhances the shape and contours of the bird, and it provides depth and definition.

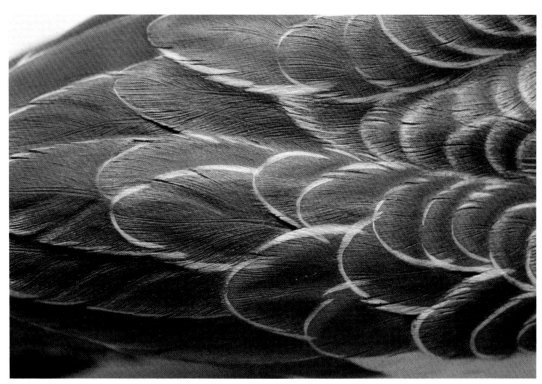

Jim adds a small amount of phthalo green and green pearl essence to the tertial feathers and the inside edges of the primaries. Note the pattern here of the darkened areas of the individual feathers.

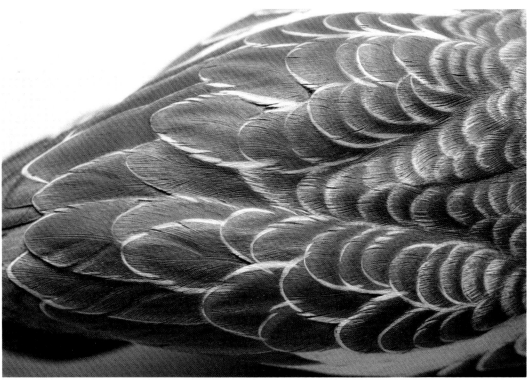

The feather areas can be darkened with brushes, using the color-to-water blending technique, or they can be done with an airbrush, as in this photograph. Jim prefers the former method.

Now Jim uses the dark brown mix used on the bases of the feathers to add feather splits to the feathers on the breast. A small brush is needed, and Jim uses either a size 2 Raphael #8220 or a size 0 or size 1 Raphael #8408.

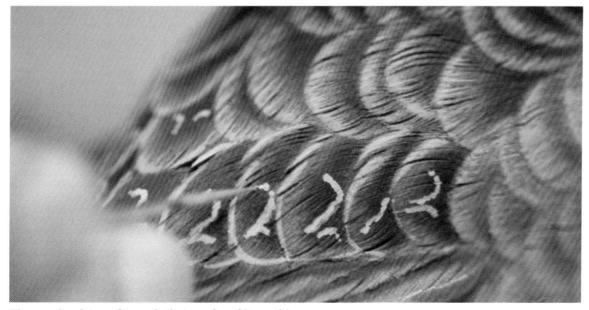

The same brush is used to apply the irregular white markings on the feathers along the tail covert feathers. The color is the same mix used previously on the feather edges. Consult your reference material for configuration of these marks.

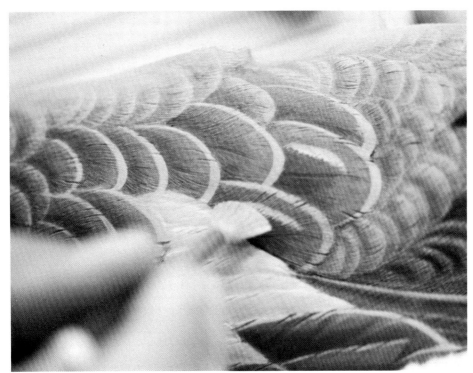

The feather-flicking brush is used with the white feather-edge mix to add these markings to the sidepocket feathers. Jim adds a small amount of raw sienna to the mix to warm it slightly. A thin raw sienna wash is then applied to the entire area. Again, study your reference material.

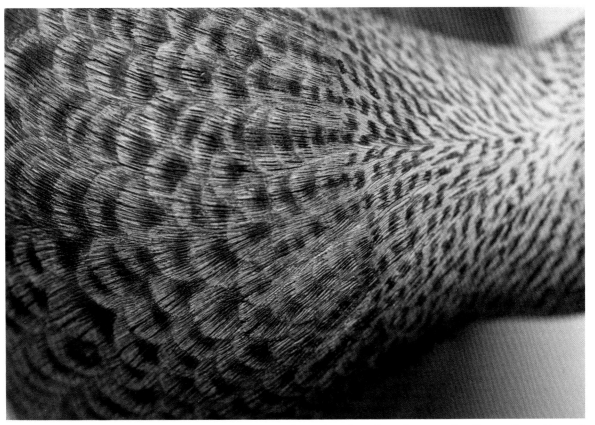

To bring the color values closer together Jim applies a thin wash of raw umber over the entire bird except for the head and neck. The flanks, cape, sidepockets, and breast have a slightly gold cast, so he applies two thin washes of raw sienna.

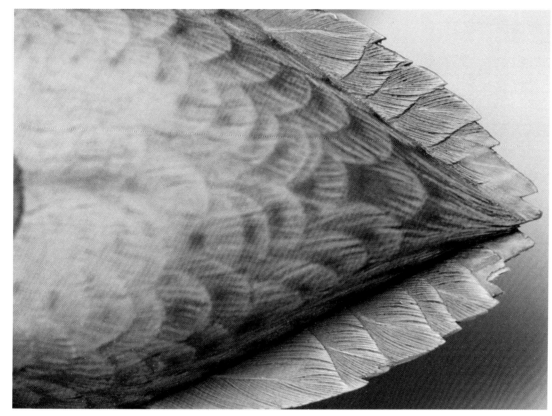

Two washes of raw sienna are also applied to the area under the tail.

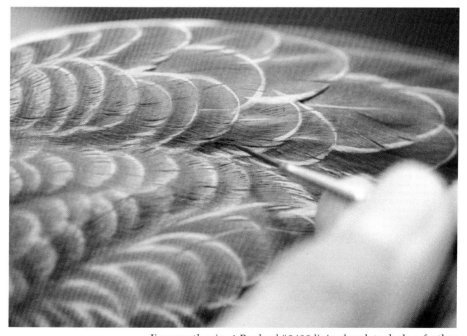

Jim uses the size 1 Raphael #8408 lining brush to darken feather splits and various corners and crevices with carbon black. "You want to do this in only two or three places," he says. "It breaks up the monotony a little and adds some shadows and depth." The quills are painted with a buff mix of 70% gesso and 30% burnt umber, applied with the fine lining brush. "Study your reference closely," Jim says. Finish with a wash of matte medium-varnish.

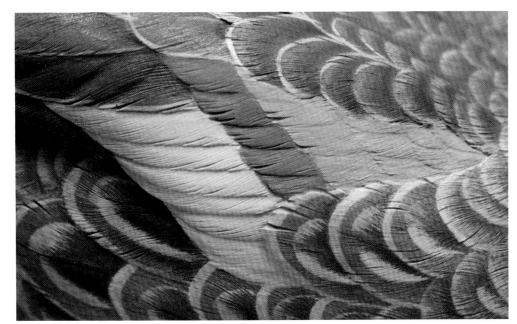

A mix of 40% gesso, 30% ultramarine blue, and 30% burnt umber is used on the middle and lesser covert feathers.

Jim does the wing covert feathers next. If paint has spilled onto these feathers, he covers them with gesso to provide even distribution of color. Remember, acrylics are transparent. The speculum feathers are painted a base coat of yellow light, and the middle and lesser covert feathers are a mix of 40% gesso, 30% ultramarine blue, and 30% burnt umber (see color wheel).

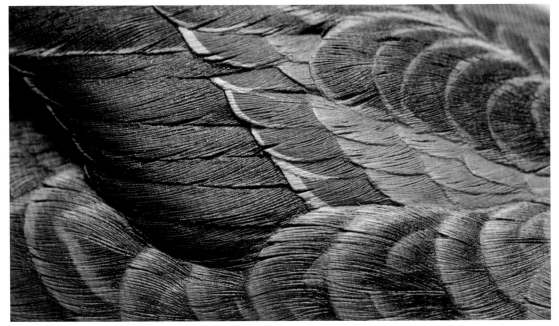

Jim dampens the centers of the speculum feathers, then blends to water a mix of 45% phthalo green, 45% pine green, and 10% carbon black, with green pearl essence powder added. Three or four washes are applied, the last of which goes over the entire feather. The result is a green speculum feather with a yellow center highlight. Carbon black blended to water darkens the trailing edges of the speculum, then a cream mix of 70% gesso and 30% burnt umber is applied to the extreme rear edges. A thin wash of carbon black darkens the entire area.

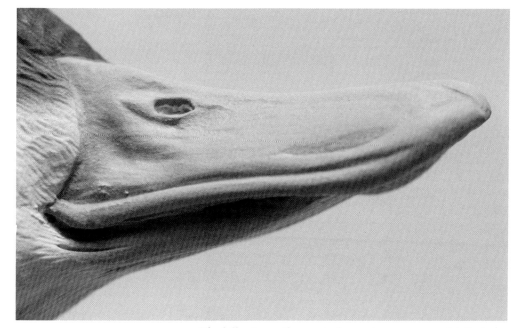

The bill is painted with a mix of 40% gesso, 35% yellow oxide, and 25% burnt umber.

The bill gets another coat of gesso to cover any paint that may have spilled onto it. The gesso also provides a slightly textured surface that makes blending easy. Then Jim paints the bill with a yellow base coat of 40% gesso, 35% yellow oxide, and 25% burnt umber (see color wheel).

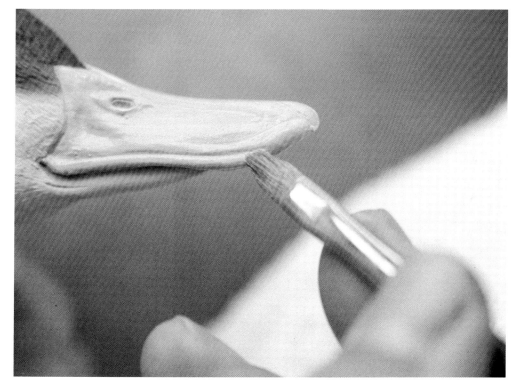

The top two-thirds of the upper mandible is a dusky color that Jim makes by mixing 50% carbon black, 25% gesso, and 25% burnt umber (see color wheel). Here he uses a filbert brush to dampen with water the lower portions of the bill. The black is applied to the top of the bill and blended to the water, creating a soft edge.

A mix of 25% gesso, 25% burnt umber, and 50% carbon black is used for the upper mandible.

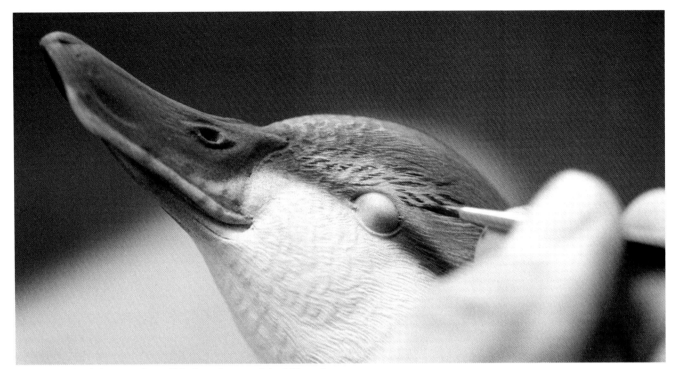

Jim has applied three washes of black to the top of the bill, and
he now uses the lining brush to paint small feather streaks along
the head using a mix of 45% burnt umber, 45% raw umber, and
10% carbon black.

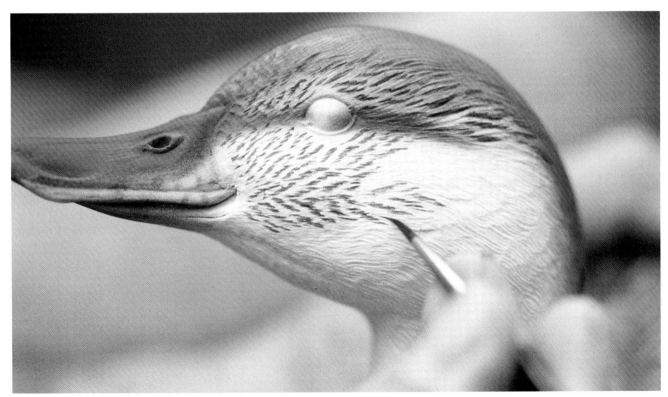

A size 0 or 1 Raphael #8408 brush is used to apply the streaks.
Consult your reference material for accurate depiction of these
lines. Note that they break downward beneath the eye.

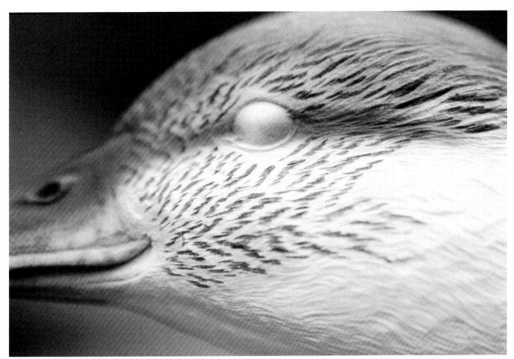

The area behind the bill, under the chin, and around the eye has a more open, buff color, so don't paint feather lines in these areas. Compile good, accurate reference material and consult it often when painting.

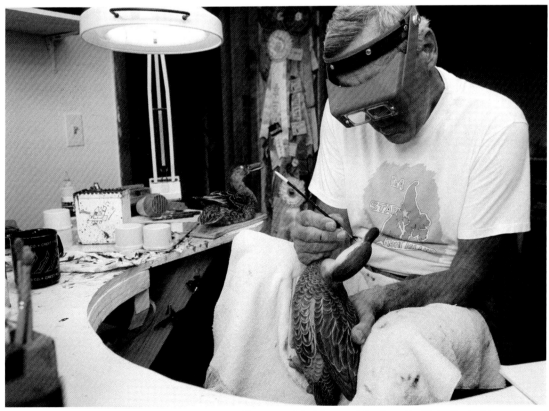

Jim at work in his Kent Island studio. Note the taxidermy mount close at hand as he paints the head of the carved bird.

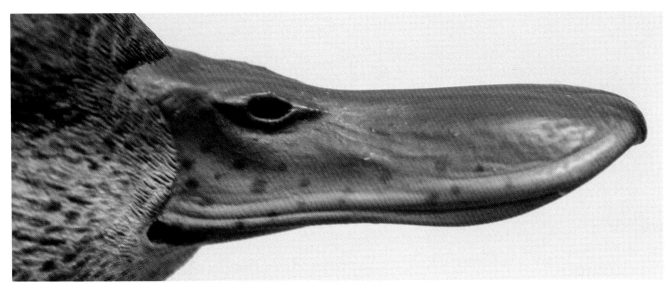

Jim finishes the bill by applying random black dots, then two thin washes of matte medium-varnish diluted equally with water. This gives the bill a realistic, waxy look.

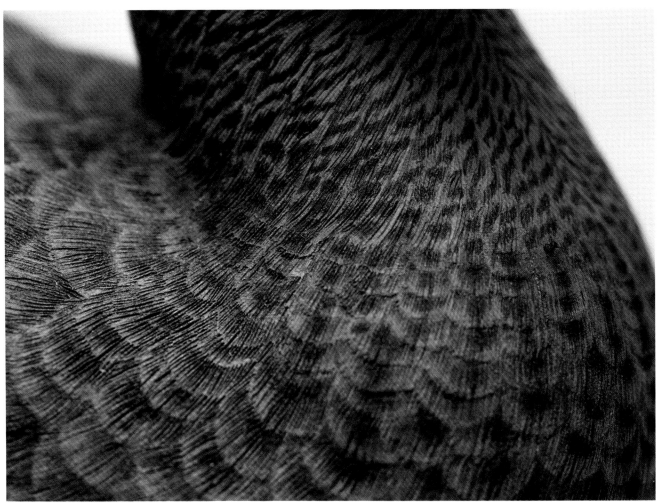

Close-up shows feather detail along breast. A thin wash of burnt umber darkens the upper part of the breast.

Two overall washes of burnt umber darken the head. The eye is dark brown, which Jim paints with high-gloss Testors enamel, followed with a gloss black enamel for the pupil. Note the cream area under the eye.

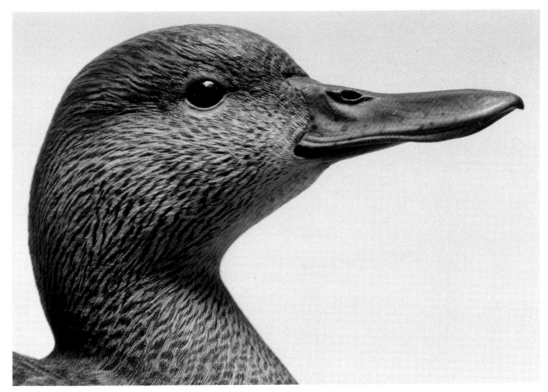

The finished head and bill.

Close-up shows detail of the crown.

10

America's Classic:
The Mallard Drake

The ubiquitous mallard drake is the most commonly recognized duck of North America. The mallard is a handsome bird with its deep green head, yellow bill, white collar, chestnut breast, and smoky flanks.

The drake presents a challenging painting project because it incorporates many of the Sprankle methods discussed in this book. You can take full advantage of the transparent qualities of acrylics in painting the green head, where a base coat of gesso and yellow oxide will create subtle depth that will show through the predominant green. This will be accentuated by thin washes of yellow to be added later, creating highlights that will emphasize the cheek contours.

MATERIALS & COLORS

gesso
nimbus gray
raw umber
burnt umber

burnt sienna
raw sienna
titanium white
phthalo green
pine green
carbon black
yellow light
yellow oxide
dioxazine purple
ultramarine blue
phthalo blue
cobalt blue
naphtha red light
green pearl essence powder
blue pearl essence powder
purple pearl essence powder
violet pearl essence powder

Feather edges will be flicked onto the back, cape, and breast, and the sides of the bird will be painted with fine vermiculated lines.

The mallard, however, is not a difficult bird to paint. Just take it one step at a time, and do your very best at each step. Never compromise on quality or settle for your second-best effort.

As in all painting sessions, work in a clean, orderly environment. Don't let dried paint accumulate on your palette, mix paints thoroughly and carefully, and apply colors in thin consecutive washes. Remember, "When in doubt, thin out." It's easy to build color through washes, but if you get it too dark, it's very difficult to correct.

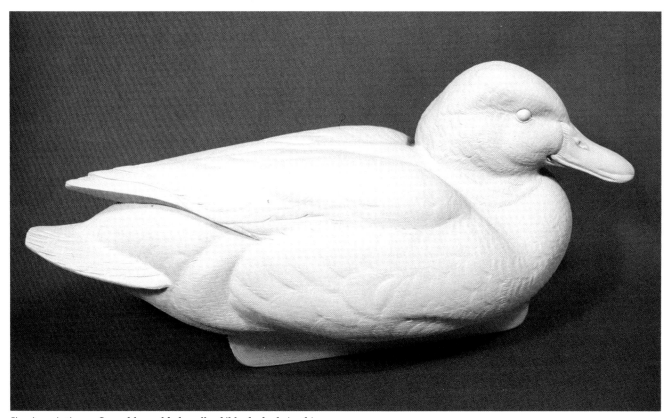

Jim is painting a Sprankle molded mallard/black duck in this session so he applies a base coat of 40% gesso, 50% nimbus gray, and 10% burnt umber (see color chart). Three applications are made using a size 18 Raphael #355 stiff bristle brush. As always, brush on the undercoat with the flow of the feather detail and allow it to air dry between coats. The undercoat also serves as the base color for the sides, back, scapulars, tertials, and the area under the rump. It's a good idea to make a sufficient quantity of this mix and save it for use later on the tertials and scapular feathers.

The base mix, or undercoat, is 50% nimbus gray, 40% gesso, and 10% burnt umber.

Using good reference material is essential in painting any bird, especially one with a bold design. Consult a live bird or taxidermy mount and determine exactly where the breast color meets the sidepockets and where it extends behind the neck. Lightly mark this area with a soft lead pencil and paint with successive washes of 40% burnt umber, 40% burnt sienna, 10% cobalt blue, and 10% dioxazine purple (see color chart).

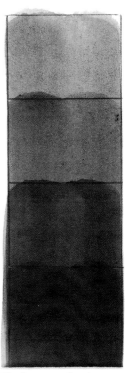

The breast color is 40% burnt umber, 40% burnt sienna, 10% cobalt blue, and 10% dioxazine purple.

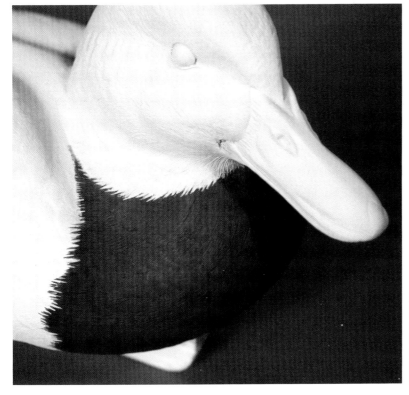

Here Jim has applied four washes with a one-inch Raphael #8250 brush. Use the widest brush practical for any given application, he advises. The wider the brush, the more evenly the color will be distributed and the less likely you'll be to get streaks. Note the feathered transition areas along the margins of the breast color.

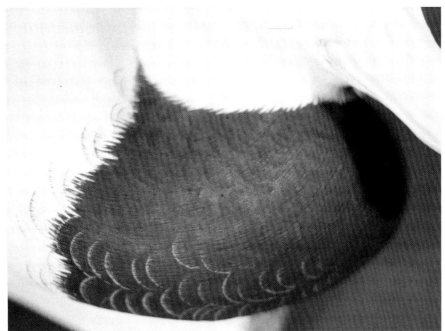

Next, Jim uses a size 2 Raphael #8408 brush to cut in the feather tips from the breast to the sidepockets, using the base-color mix. On the lower part of the breast he flicks on very fine buff feather edges using a size 6 Raphael #8404 with a mix of 80% titanium white and 20% raw umber. On the remaining feathers of the breast Jim flicks on straight burnt umber edges, then applies two very thin burnt umber washes over the entire area.

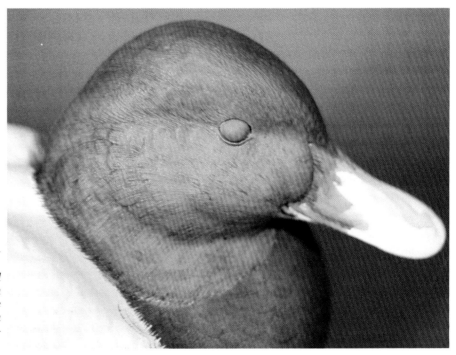

The head is first painted with an undercoat of 85% gesso and 15% yellow oxide. A one-inch Raphael #8250 brush is used to apply a green wash to the head, which is a mix of 45% phthalo green, 45% pine green, and 10% carbon black, with a small amount of green pearl essence powder (see color chart).

The head is painted with a mix of 45% phthalo green, 45% pine green, and 10% carbon black, with a small amount of green pearl essence added.

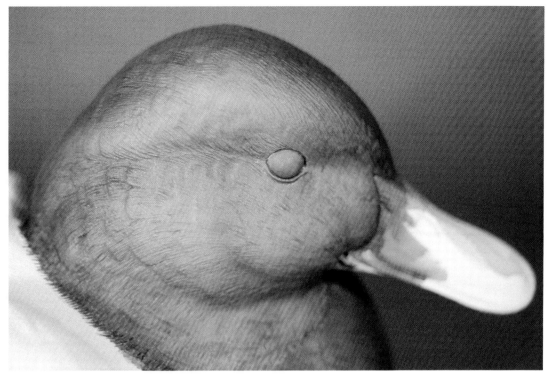

Three washes of green have been applied, and Jim wants to add more highlights to the cheek and brow ridge to emphasize the contours of the head.

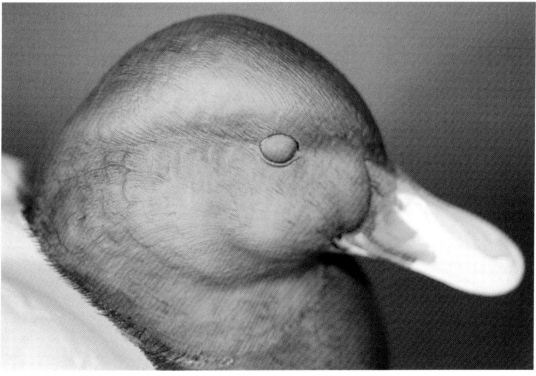

These highlights can be applied either with an airbrush or with the color-to-water blending method. Jim first applies a thin wash of yellow oxide to the highlighted area, then follows with another thin wash of yellow light.

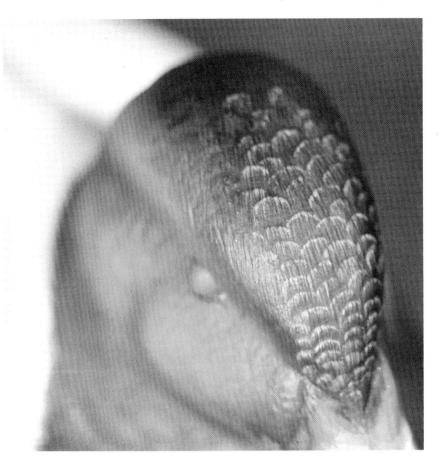

The crown, the area behind the bill, and the back of the neck are painted a blue-black color made by mixing 60% burnt sienna, 35% ultramarine blue, and 5% phthalo blue with blue pearl essence. Jim dampens the area outside where the paint will be applied with water, then adds the paint and blends to water, creating a soft transition. The small feather edges are flicked on with a size 2 Raphael #8404 brush loaded with 75% titanium white and 25% raw umber.

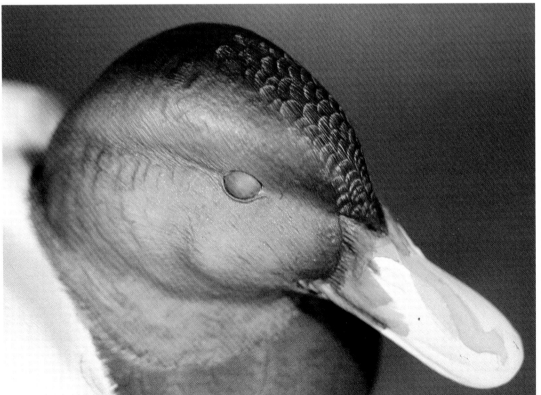

The head is finished by first applying a thin wash of phthalo blue over the entire head except the crown. The crown is then darkened by two washes of burnt umber. The white neck band can be painted now. Jim uses 85% gesso and 15% raw umber, applied with a size 2 filbert brush. A size 2 Raphael #8220 lining brush is used to extend tiny white feather lines into the head and breast area, creating a soft edge for the band.

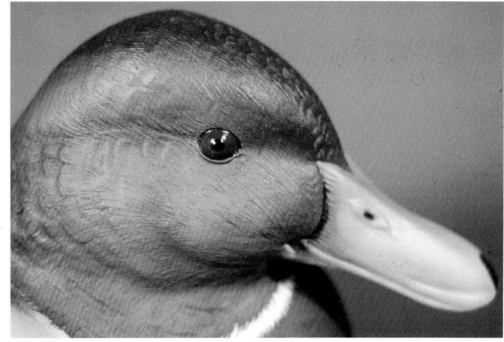

The base color of the mallard bill is 60% yellow oxide, 30% pine green, and 10% yellow light.

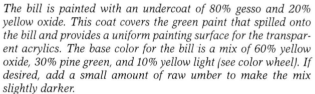

The bill is painted with an undercoat of 80% gesso and 20% yellow oxide. This coat covers the green paint that spilled onto the bill and provides a uniform painting surface for the transparent acrylics. The base color for the bill is a mix of 60% yellow oxide, 30% pine green, and 10% yellow light (see color wheel). If desired, add a small amount of raw umber to make the mix slightly darker.

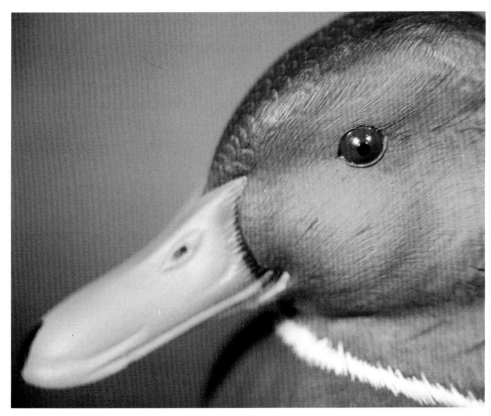

After two washes with a sable brush Jim finishes with a light glaze using his airbrush loaded with raw umber. This slightly darkens the base of the bill and the area along the lower edge of the upper mandible. The same effect can be accomplished with the color-to-water blending method. The bill has a very subtle red highlight on the sides of the upper mandible. Jim adds this with a very thin wash of naphtha red light applied with either a brush or airbrush.

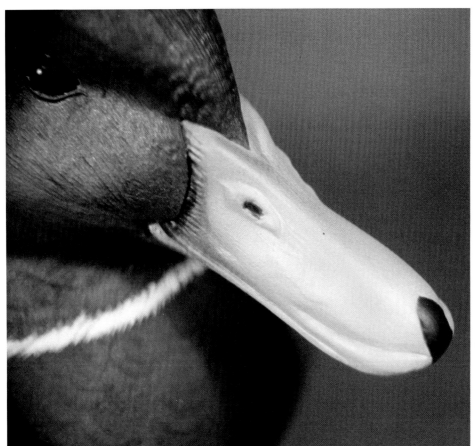

The adult drake has a slight off-white cast at the tip of his bill, and Jim adds this with a thin wash of 80% titanium white and 20% raw umber. Then the nail and the margin where the bill meets the head are painted the standard Hyplar black (60% burnt sienna and 40% ultramarine blue). The bill is finished with two washes of matte medium-varnish diluted equally with water.

The tertials and scapular feathers are painted with the same color used on the breast, to which about 20% burnt umber has been added. Check your reference closely before painting this area.

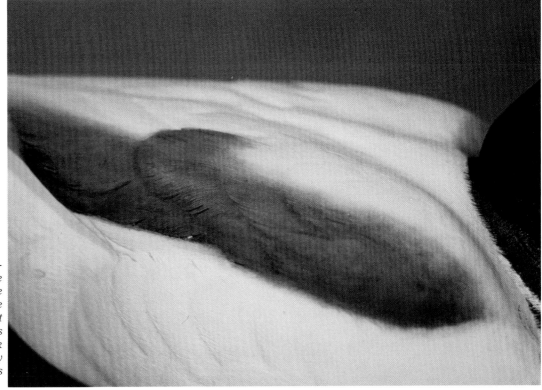

Jim paints these feathers with the color-to-water blending method, dampening the area around them and then blending the paint into the water to create a gradual transition of color. After two or three washes of color Jim darkens the lower edges of the scapularq and tertials by applying thin washes of carbon black. The tertial feather directly over the speculum has a subtle purple value, so Jim mixes some purple pearl essence with the black and applies a wash to that feather.

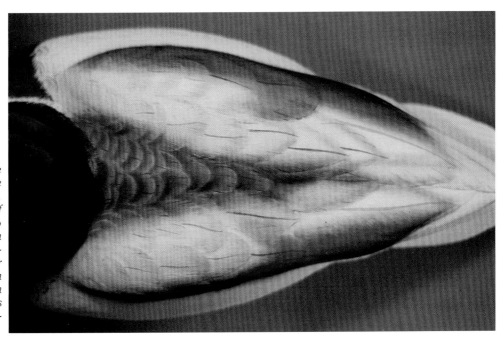

Jim uses the same color on the cape area that he used on the lower scapulars and tertials, then flicks on feather edges of 80% titanium white and 20% raw umber. The bases of each feather are darkened with another wash of the same feather color. Thin washes of carbon black or burnt umber darken the area after the feather edges are applied and the bases darkened.

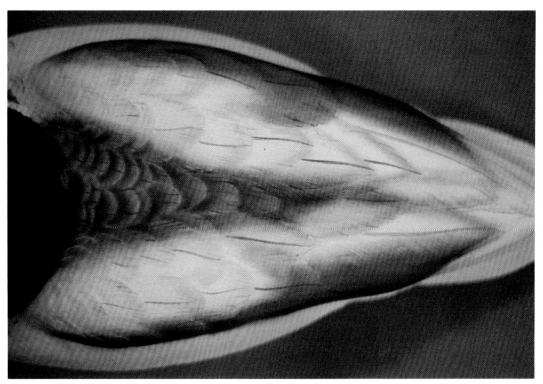

A size 6 Raphael #8404 brush is used to flick very thin burnt umber feather edges along the back. The quills on the tertials are a watery mix of 50% raw sienna and 50% burnt umber; the scapular quills are burnt umber.

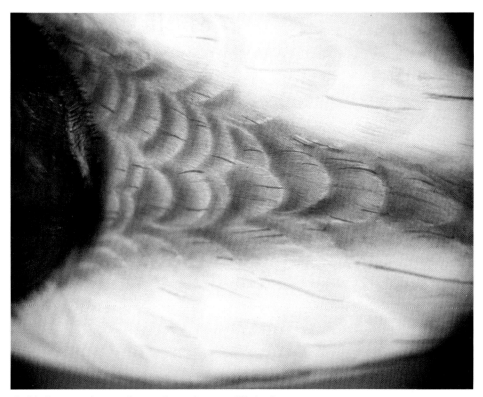

A thin burnt umber wash over the entire area fills in the texture lines and increases definition.

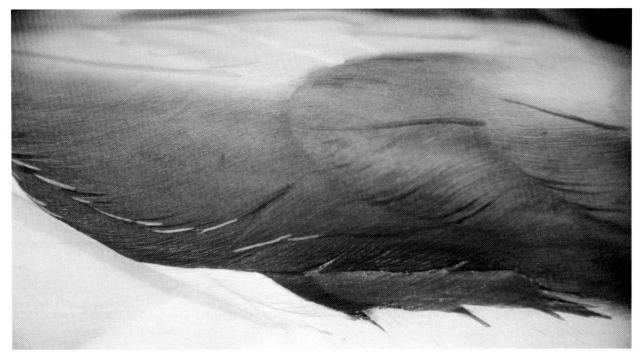

The speculum first gets a coat of gesso to cover paint that might have spilled onto it. Then Jim applies a mix of 60% dioxazine purple, 35% ultramarine blue, and 5% carbon black, plus blue pearl essence powder. Next, he adds violet pearl essence powder to the above mix and blends it from at least one-half the feather edge forward. The black edge is Jim's standard black mix of 60% Hyplar burnt sienna and 40% Hyplar ultramarine blue. The white edge is 85% gesso with 15% raw umber. The area is finished with a thin wash of carbon black.

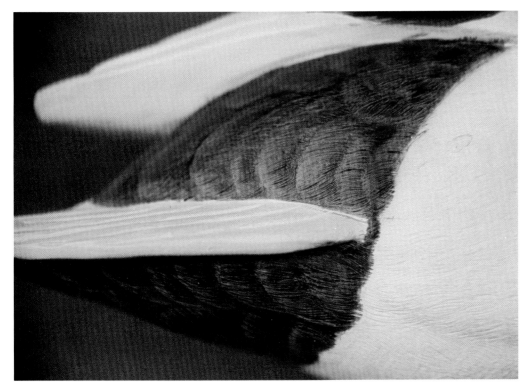

The upper and lower rump is painted with the standard Hyplar black mix. Buff edges are flicked on the feathers on the lower rump with the 80% titanium white and 20% raw umber mix, followed by thin washes of burnt umber.

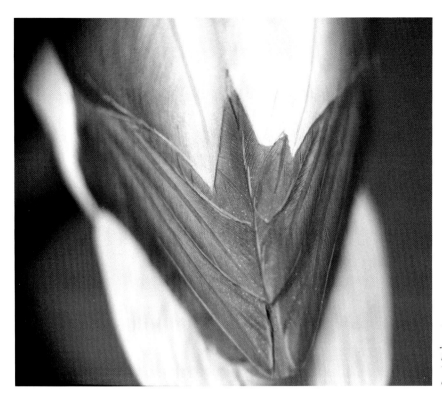

The upper rump has a greenish iridescent cast. Jim flicks yellow oxide feather edges on the first row of tail covert feathers, then follows with a wash of carbon black with green pearl essence powder added for iridescence.

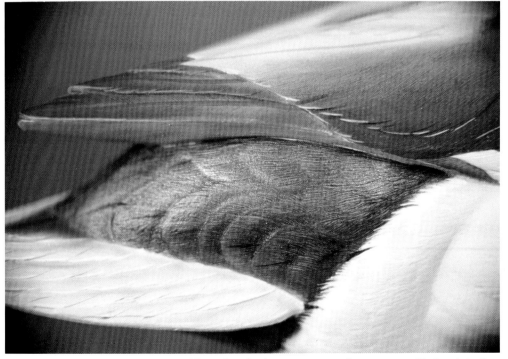

The wing feathers are gessoed to cover spilled paint, then washed with 85% burnt umber, 10% gesso, and 5% carbon black. The edges are painted with a brownish black mix of 70% burnt umber, 30% carbon black, with green pearl essence. The inner halves of the wings are painted with the same color but with pearl essence used sparingly. The quills are a mix of 80% burnt umber and 20% raw sienna. A faint cream color runs along the edges of the wing feathers. Check your reference material.

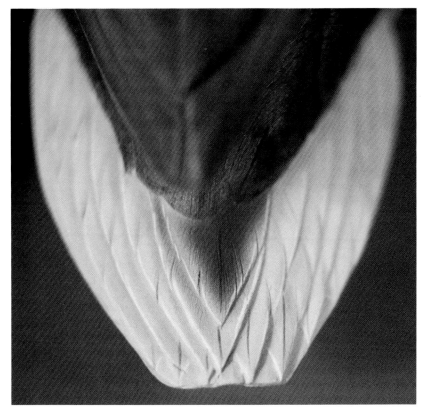

The tops and bottoms of the tail feathers and the area under the wings are painted with a mix of 75% gesso, 20% burnt umber, and 5% carbon black. The centers of the tail feathers on the top side have a very faint burnt umber value, with the two center feathers somewhat darker. Add some carbon black to the burnt umber for these feathers.

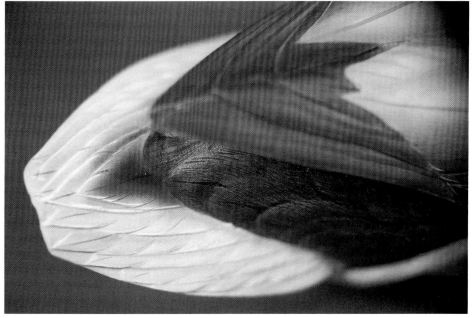

The quills on the top side are painted with a mix of 80% burnt umber and 20% black. The feather tips are 90% gesso and 10% raw umber. One thin wash of burnt umber completes the area. The gesso/raw umber mix is used on the feather edges under the tail, and the quills are white. Finish with a burnt umber wash. Under the wings the tips and edges are painted with a mix of 80% burnt umber and 20% carbon black, blended to a dampened surface. The quills are the same color as under the tail. Finish with one wash each of burnt umber and carbon black.

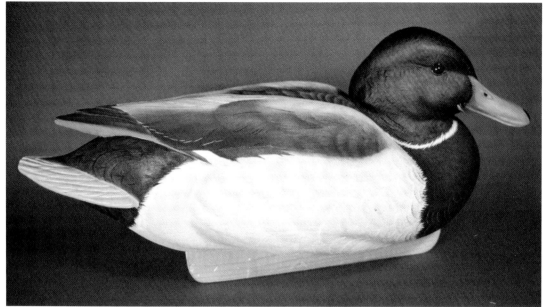

The mallard drake, complete except for vermiculation. The white band between the black upper and lower rump areas is 85% gesso and 15% raw umber, the same mix used on the neck band.

Jim adds the vermiculation on the sides with a mix of 65% burnt sienna, 33% ultramarine blue, and 2% gesso. The back is vermiculated with the original sidepocket mix to which is added 3% to 5% gesso. Then the total mass is tinted with 10% burnt umber for the vermiculation. The photo here shows the vermiculation pattern on a taxidermy mount.

The vermiculation directly behind the breast.

A view of the tertial and scapular feathers on the back.

Note that the vermiculation on the sidepocket is much bolder
than in other areas.

11

Case Study: The Green-winged Teal Hen

These painting notes for the green-winged teal hen were taken from a journal I kept while I was painting the *Red River Rockets* during the winter of 1989–90. Rarely have I ever finished painting a bird and not had something I would change on the next bird of the same species. But the flying green-winged teal hen met with my approval. I wouldn't change a thing.

This painting project includes showing the wings extended, so we can discuss the color mixes and procedure. The iridescent colors of the speculum add a point of interest, and in painting the hen of any species I try to show the speculum and open wing for that reason.

Undercoat

Because this is a wooden carving – the body and head of tupelo, the wings of basswood – I first sealed the bird with Deft Spray Stain in Salem maple color. Then I applied an undercoat of 85% gesso and 15% raw umber, which is the base color of the lower side-

pockets, lower breast, and undertail coverts (photos 3, 10). This mix is applied to the entire bird, including the wings.

Upper Sides, Breast, Back, Upper Rump, and Upper Tail

These areas were painted with a base color of 55% burnt umber, 35% raw umber, and 10% nimbus gray. The sides should be lighter in color, so I applied one less wash of paint in those areas. The important thing here is to strive for even distribution of color; you don't want dark spots caused by thick, uneven applications of paint. I use the largest brush I can handle comfortably in any given area.

With the base color applied, I next painted the white feather edges with a mix of 55% titanium white, 20% raw umber, 10% burnt umber, and 15% nimbus gray. I used a size 2 Raphael #8408 brush for the sidepockets, tertials, scapularq, and upper rump areas (photos 8, 9, 13, 14). I painted the edges with the

MATERIALS & COLORS

Deft Spray Stain, Salem maple

gesso

raw umber

burnt umber

raw sienna

brown earth

carbon black

titanium white

nimbus gray

Payne's gray

smoked pearl

iridescent white

opal

ultramarine blue

phthalo blue

phthalo violet

naphtha red light

yellow light

phthalo green

pine green

Jo Sonya pale gold or
gold pearl essence powder

blue pearl essence powder

green pearl essence powder

white pearl essence powder

Hyplar matte medium-varnish

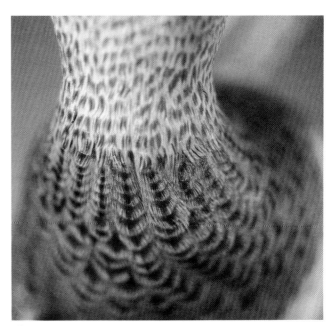

Photo 1

distinct values of color from the tip to the base: the white edges, then the base color, then the darker value at the base (photos 2, 8, 9, 13, 14) of the feather. The darker value is made by adding a small amount of carbon black to the base mix.

I painted the feather detail (photos 8, 9, 13, 14, 15) with a mix of 85% titanium white and 15% raw umber, then applied thin washes of raw sienna to produce a slight golden value on the sidepockets, scapulars, and some breast feathers. Photos 8, 13, 14, and 15 show where I used brown earth and carbon black to accentuate some of the feather markings.

All quills are a mix of 50% carbon black and 50% burnt umber.

The Head

Look closely at photos 4, 5, and 6 of the head and you will notice dark feather markings on the face and gold markings on the crown. My first step in painting the head is to create a base, or background, for these markings. The crown and the streak running from behind the bill through the eye channel are painted with a mix of 45% burnt umber, 45% raw umber, and 10% ultramarine blue. I used the color-to-water blending method to create a soft, gradual edge where these colors were applied. I used two size 6 Raphael #8404 brushes, one to dampen the margins of the area with

color-to-water blending method, first dampening the area outside the feather edges with water using a size 4 or 6 filbert-type brush, then applying the color with the #8408 brush and blending it to water. This method avoids creating an abrupt edge where the color is applied. The transition is smooth and realistic.

The remaining feather edges (photos 1, 2, 3, 8, 14) were painted with size 2 and 6 Raphael #8404 brushes. Each feather was darkened at its base, with the darker value gradually merging with the base color approximately one-third of the distance from the tip. In other words, each feather should have three

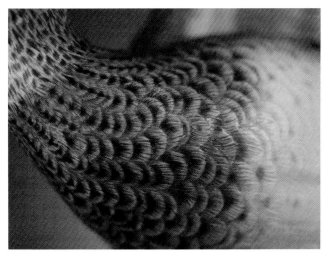

Photo 2

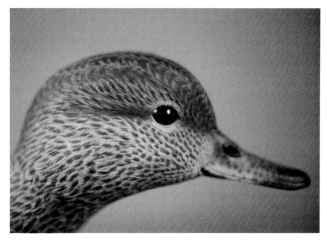

Photo 4

Photo 3

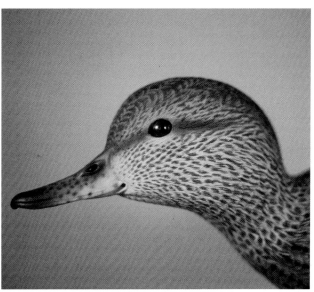

Photo 5

water and the other to apply paint and blend it to water. The small feather marks were applied with a size 2 Raphael #8408 brush using the same color mix. Directly behind the bill and under the eye and chin is a lighter buff area (photo 7) where the dark streaks should not be applied.

After painting the dark feather markings, I followed with a few small streaks of titanium white and raw sienna, which you can see if you look carefully at the close-ups of the head.

The crown has a definite feather pattern, as seen in photo 6. These feathers were detailed with a mix of 80% gesso and 20% raw umber, followed by a wash of raw sienna. The overall color of the head is deepened by very thin washes of either burnt umber or carbon black. These washes create a rich overall value and emphasize the carved feather detail by darkening the tiny crevices left by burning and stoning tools.

Photo 6

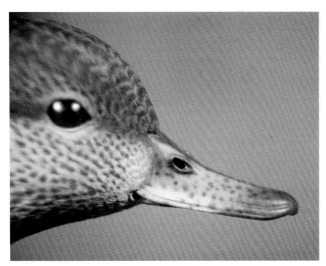

Photo 7

The Bill

The bill is first gessoed to cover any paint that might have spilled onto it while painting the head. Gesso provides a uniform painting surface for transparent acrylic paints, and it has a slight texture, which makes blending easier.

I first applied a purple color to the lower corner of the upper mandible and the center rear of the lower mandible. This is a mix of 85% opal, 10% phthalo violet, and 5% Payne's gray. The color was blended to water at the margins using two size 6 filbert brushes. An airbrush could be used here.

Next, I mixed 85% Payne's gray and 15% smoked pearl and painted the remainder of the upper and lower mandibles (photos 4, 5, 7). The spots were applied with the same mix. I finished the bill with two thin washes of matte medium-varnish diluted equally with water. This protects the bill and gives it a very realistic waxy look.

Undertail Feathers

The underside of the tail feathers is painted with a mix of 90% nimbus gray and 10% burnt umber. I added approximately 10% iridescent white (or white pearl essence) to this mix to produce a slight iridescence (photo 10). The feather edges, quills, and other markings are 90% titanium white and 10% raw umber, followed by a thin wash of carbon black and one wash of burnt umber to emphasize carved detail. The sidepocket base color was used to paint the feather markings under the rump.

The Legs

I first gessoed the legs for even distribution of color. For the scales and webbing I used heavy, thick gesso applied with a size 2 Raphael #8408 brush to create each little scale. It usually takes a couple of applications. The entire leg and foot (photo 19) were painted with a mix of 65% gesso, 25% Payne's gray, 5% raw umber, and 5% carbon black. The webs are darker, so some carbon black or burnt umber was added to the above mix for these areas. This mix was also used for

Photo 8

the shadows and spots on the sides of the legs. The nails are straight black—I used carbon black and burnt umber mixed equally. A faint flesh color can be seen on the legs. I used a very thin wash of naphtha red light for this. It could be airbrushed on, if you are so inclined. I followed with one thin wash of burnt umber, then two coats of matte medium-varnish diluted with equal parts water. This gives the feet and legs a realistic waxy look.

The Wings, Top Side

I started by painting the primaries and primary coverts (photos 11, 15, 16) a base color of 60% burnt umber, 30% titanium white, 5% raw sienna, and 5% carbon black, to which I added 15% iridescent white. I used a one-inch Raphael #8250 brush. For the outer edges and tips of the primaries and the centers of the primary covert feathers I added burnt umber and carbon black to the base mix instead of the iridescent white. The tips are a little darker, so I blended to water a mix of 50% carbon black and 50% burnt umber.

The quills are painted first with a mix of 70% raw sienna and 30% burnt umber. Then the area of the quills from the tip back is darkened with an equal mix of carbon black and burnt umber. From the base of the quill out I used a mix of 75% titanium white and 25% raw umber.

The greater, middle, and lesser covert feathers (photo 11) are painted first with a base-color mix of 80% nimbus gray, 10% raw umber, 5% carbon black, and 5% burnt umber, to which I added 15% iridescent white. The feather edges are painted a grayish white made of 80% nimbus gray and 20% iridescent white. I applied the paint with a size 2 Raphael #8404 brush, then used a size 2 Raphael #8408 to pull individual feather lines.

I then darkened the base mix by adding a small amount of raw umber and carbon black and painted the bases of the individual feathers. This mix was also used on the quills.

The lower portions of the greater coverts, next to the secondaries (the speculum), have a goldish value, and some feathers near the primaries have a white edge. I applied the white edges first with a mix of 75% titanium white and 25% raw umber, then added the gold value with a mix of 50% raw sienna, 35% titanium white, 10% burnt umber, and 5% burnt sienna.

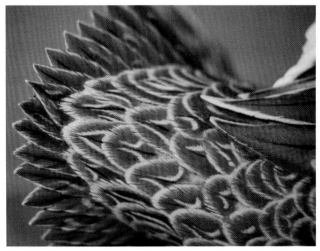

Photo 9

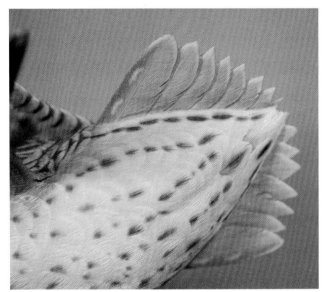

Photo 10

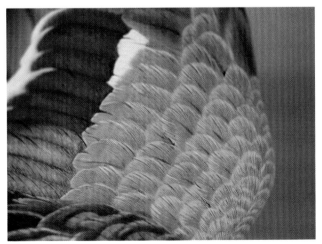

Photo 11

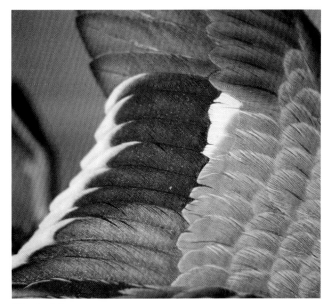

Photo 12

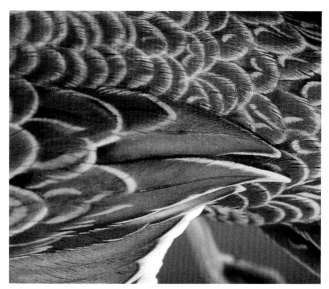

Photo 14

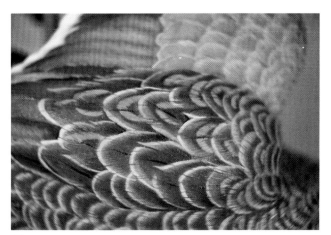

Photo 13

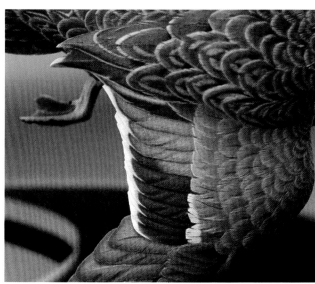

Photo 15

The secondaries, or speculum, are first gessoed, then the green feathers are painted. I begin with a base of yellow light, then apply a mix of 45% phthalo green, 45% pine green, and 10% carbon black, with green pearl essence powder added. I dampen the center of the speculum with water, apply the green paint around the dampened area, and blend the color to water. This leaves a slight yellow highlight in the center of the speculum. The speculum is then darkened overall by a wash of the green mix over the entire area.

If you look closely at photos 12, 14, and 15, you can see two different values of color on the feathers next to the buff-colored edges. Adjacent to the buff edges I blended carbon black, then blended phthalo blue with

blue pearl essence powder into the green area. One very thin wash of carbon black darkened slightly the entire area.

The black speculum feathers are an equal mix of carbon black and burnt umber. I dampened the centers of the black feathers and blended the original mix with a small amount of blue pearl essence powder, which added iridescence. Last, I blended to water the buff-colored edges on all ten secondary feathers. This was a mix of 75% gesso, 15% raw umber, and 10% burnt umber. I used a size 2 Raphael #8220 brush to carefully paint the black feather splits on the white and gold edges of the greater covert feathers.

The Wings, Underside

I started by creating a base mix of 70% nimbus gray and 30% burnt umber, then added 15% iridescent white to the base mix and painted the undersides of the primaries and secondaries (photo 17). Equal parts carbon black and burnt umber were then added to the base mix to darken the edges of the primaries. The tips of the secondaries and the first row of underwing lining feathers were lightened with a mix of 70% titanium white and 30% raw umber.

The edges were painted with the color-to-water blending method using two size 6 filbert-type brushes, one to apply water and the other to apply pigment.

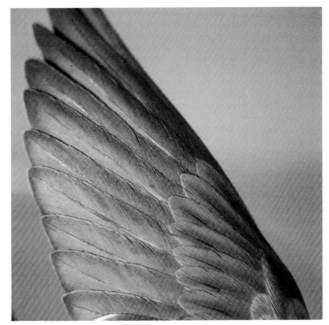

Photo 16

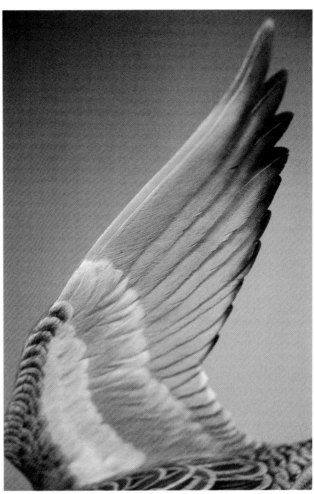

Photo 18

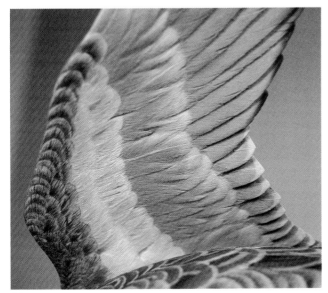

Photo 17

Photo 19

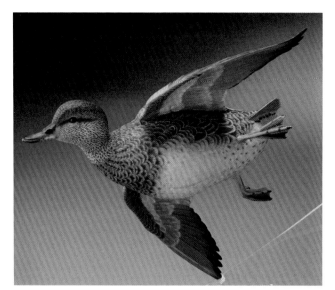

Photo 20

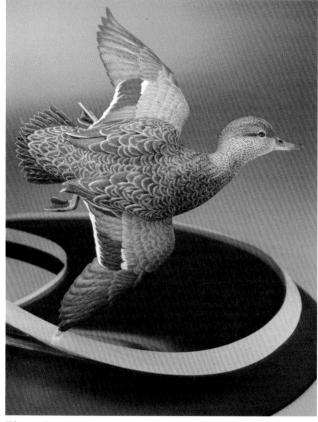

Photo 21

The quills are a bone color, a mix of 70% titanium white, 25% raw umber, and 5% raw sienna.

The third and fourth row of underwing lining feathers (photos 17, 18) are off-white, a mix of 70% titanium white and 30% raw umber, to which is added either 15% to 20% iridescent white or some white pearl essence powder. I saved this mix to use later on feather edges. The very edges of the feathers are white, so I blended straight titanium white there.

I applied a watery burnt umber color from the quill outward toward the edges of each feather.

The brownish area was painted a mix of 70% burnt umber, 27% titanium white, and 3% carbon black, to which a small amount of white pearl essence was added.

I used a size 2 Raphael #8404 brush to flick the feather edges on the brown feathers, using the same mix as on the third and fourth row of underwing lining feathers. Two size 2 filbert brushes were used to

blend to water a thin wash of burnt umber on each feather, beginning at the base and going outward. The quills on these feathers were painted burnt umber.

The underwing area was finished by applying one thin wash of burnt umber overall. Then the primaries got another burnt umber wash to which was added a small amount of Jo Sonya pale gold, followed by a very thin wash of carbon black.

All quills were then painted with matte medium-varnish diluted equally with water. This adds a waxy, realistic look to the quills.

12

Case Study: The Pintail Drake

Painting a pintail drake is a challenging project, even for an experienced carver/painter. The pintail to me is a very sleek and highly stylish bird. This project will give you an opportunity to blend color to water, flick feather edges, and do some vermiculation.

The bird used in this case study is the same carving that appeared on the cover of my book *Waterfowl Patterns and Painting* published in 1986 by Greenwing Enterprises.

Undercoat

Before putting on the undercoat, I seal my carvings with Deft Spray Stain in Salem maple color. I apply enough coats to get a uniform color over the entire bird. Then, after the lacquer dries, I put on an undercoat that serves as the base color for the sidepocket areas, breast, neck stripe, and the white area under the rump. The base color on this pintail is 90% nimbus gray and 10% gesso.

With the base color on, I began a white-on-white painting technique by applying white feather tips with straight titanium white on the breast, neck stripe, lower sidepockets, and under the rump. It's important to lay out the vertical neck stripe accu-

rately, so I consulted reliable reference material (live birds, taxidermy mounts, good photos) and lightly sketched the area with a #2 pencil.

The goal with the white-on-white method is to create subtle definition in a predominantly white area of the bird. The area should be white, yet white feather edges should show, providing the illusion of depth and softness. This is done by applying a light gray base coat, then white feather edges, followed by successive washes of white, which eventually bring the gray base color very close to the value of pure white. I apply enough washes to make the area appear white yet still allow the feather edges to look well defined.

I paint the feather edges with a size 6 Raphael #8404 brush, then put on thin washes of titanium white. Depending upon where they have been feeding, some pintail drakes will have a rusty color on the breast and belly. This can be applied with a thin wash of raw sienna.

On this pintail I carved feather splits and similar detail in wood, so I added definition to these areas while painting by darkening them with a wash of nimbus gray, which I blended to water. A wash of matte medium-varnish diluted equally with water produced a slightly waxy look (photo 1).

MATERIALS & COLORS

Hyplar matte medium-varnish
Deft Spray Stain, Salem maple
gesso
nimbus gray
titanium white
raw sienna
burnt umber
raw umber
Hyplar burnt sienna
carbon black
Hyplar ultramarine blue
phthalo green
phthalo violet
yellow oxide
yellow light
Payne's gray
phthalo blue
naphtha red light
iridescent white
slate gray pearl essence powder
green pearl essence powder
violet pearl essence powder
blue pearl essence powder

The Head

The white vertical neck stripe had been painted, so in painting this pintail my next step was to lightly sketch in pencil where the head and neck join the breast. Then I made the brown color for the head by mixing 45% burnt umber, 45% raw umber, and 10% titanium white, and painted the head according to my layout.

The head is not simply brown; it has many tiny feather edges of burnt umber. So, with three washes of brown on the head, I began flicking burnt umber feather edges with the size 2 Raphael #8404 brush (photo 4). These were applied to the area beginning behind the bill and extending back toward the neck and under the chin. The pintail's crown is darker (photo 3) than the sides of the head, so I added a small amount of carbon black to the base color and applied a wash, blending the color to water along the margins of the darker area.

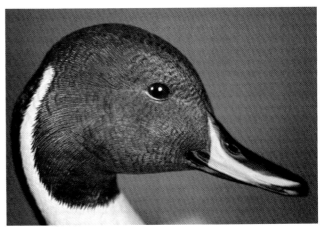

Photo 2

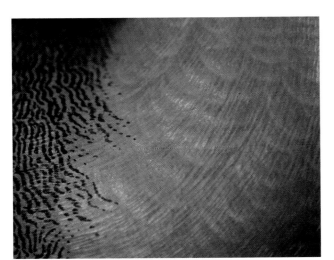

Photo 1

Photo 3

The white vertical stripe, or horn (photos 3, 6), has a black trailing edge, which I painted with my standard black mix of 60% Hyplar burnt sienna and 40% Hyplar ultramarine blue. In this instance, I added a small amount of slate gray pearl essence powder to provide some iridescence.

The small feathers of the crown get tiny buff-color feather edges, which are a mix of 70% titanium white and 30% raw umber. I used a size 2 Raphael #8404 brush, followed by two thin washes of burnt umber to darken and give some richness to the area.

If you look closely at the head of a pintail, you will notice subtle green and violet highlights (photos 3, 4). I applied them to this bird in a series of washes to which I added pearl essence powder for iridescence. I began with a green wash, which consisted of straight phthalo green with green pearl essence. I applied the color with the color-to-water blending method, first dampening the perimeter of the highlight with water, then blending the color to the water, creating a soft, gradual transition that is almost imperceptible.

Next, I applied a violet wash, mixing a bit of violet pearl essence with phthalo violet. Again, this highlight was applied with the color-to-water blending method.

The final detail on the head is the series of tiny buff feathers between the dark crown and the sides of the head. This buff color, which is different from the one painted on the feather edges of the crown, is a mix of 55% gesso, 25% yellow oxide, and 20% burnt umber, and I applied it with a small lining brush.

The Bill

My first step in painting the pintail bill (photo 5) was to gesso it, covering any paint that might have spilled and providing me with a uniform surface for painting. I then applied a base color consisting of 90% gesso, 5% phthalo blue, and 5% Payne's gray. At this point the bill could be darkened, if desired, by applying a wash or two of burnt umber.

Next, I applied the standard Hyplar black color using the color-to-water blending method. Studying my reference, I determined the area that I wanted black, then dampened the outside of that area with water. I then applied the black paint with a size 6 filbert brush, blending it to the water to create a soft edge. I finished the bill with two thin washes of matte medium-varnish diluted equally with water. This pro-

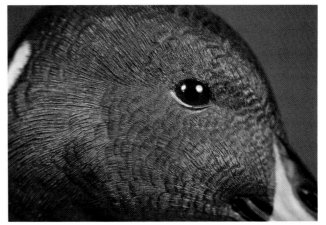

Photo 4

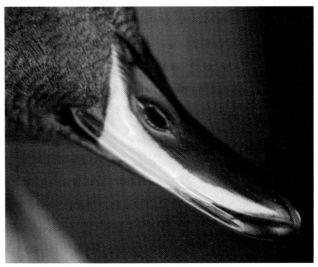

Photo 5

Photo 6

vides a lifelike waxy look. Should the bill become too glossy, I would buff it very gently with #000 steel wool.

This case-study pintail has a closed bill, but if I were to carve an open-billed bird, I would paint the pink tissues of the inner portions with gesso tinted with 5% naphtha red light. The tongue is whiter than the other areas, so I would add a small amount of titanium white to the base mix.

The Tertial and Scapular Feathers

The tertials and scapulars form a key area of the carving, so you should consult all the good reference material you can muster before you paint. When I painted this pintail I had a live drake in the aviary that's attached to my studio, and I kept a taxidermy mount on my workbench. I also keep a reference file on each species of waterfowl that I do, which includes photos, clippings from magazine articles, notes from previous projects, and anything else that might help me.

The base color for these wing feathers is the same base color I used on the top side of the tail feathers and upper rump—a mix of 85% gesso, 10% raw umber, and 5% Payne's gray. I added 10% iridescent white to this mix and painted the entire tertial and scapular area.

With the base coat on, I then painted the dark centers of the applicable feathers (photos 7, 8, 11) using the color-to-water blending method. This mix consisted of 50% carbon black and 50% burnt umber. Some of the scapular feathers had a greenish cast, so I added a small amount of green pearl essence powder when I painted these areas. The carbon black/burnt umber mix is also used for vermiculation, so I mixed a sufficient quantity and saved it.

When blending color to water I use a size 6 filbert-type brush in combination with a size 6 Raphael #8404 brush. The Raphael is used to dampen the area around the painted area with water, then the filbert is used to apply pigment and blend it to water.

The tertial feather next to the speculum (photo 7) has a whitish streak near the quill that I painted with 65% titanium white, 25% raw umber, and 10% iridescent white. The same mix is used with a lining brush to paint the appropriate feather tips (photos 7, 8, 10, 11). On some pintail drakes you will see small white dots on some of the scapular feathers, and the same mix can be used to paint them. The quills are straight carbon black, and I put a thin wash of burnt umber over the entire area to enhance the barb definition.

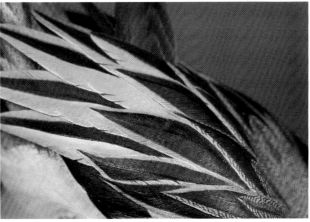

Photo 7

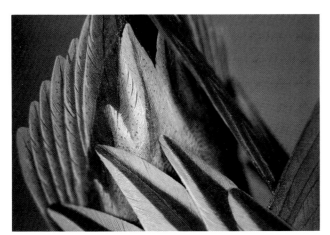

Photo 8

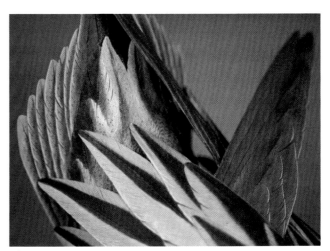

Photo 9

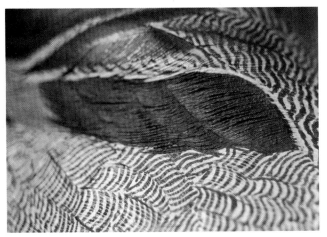

Photo 10

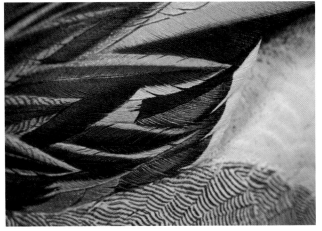

Photo 11

Photo 12

The Upper Rump

On the first row of tail covert feathers, directly behind the tail feathers, the lower half of each feather is painted using the standard Hyplar black, and on this bird I added a small amount of green pearl essence. The upper halves of these feathers are painted brown from about one-eighth inch from the quill toward the tip. Also, the upper halves have a series of brownish dots, which I painted with a mix of 90% burnt umber and 10% titanium white. I used the brown mix to vermiculate the remaining feathers on the upper rump. My favorite brush for vermiculating is a size 1 Raphael #8408, which maintains a sharp, tight point yet holds an adequate amount of paint.

The Flanks

By using gesso in my base-color mix I can cover any dark paint that may have spilled onto the flank area. When painting with acrylics it's important to keep in mind that they are transparent and that you need to paint over a uniform surface.

The base color of the flanks is 80% gesso, 15% yellow oxide, and 5% raw umber, applied in three or four washes. I used a size 6 Raphael #8404 brush to flick on the feather tips, using very thin, watery raw sienna. The raw sienna marks are somewhat darker toward the tail. Some vermiculation marks could be sparingly added at this time, if desired. Check your reference. A final wash of burnt umber completes the area (photos 11, 12, 15).

Under the Rump

The black area (photos 2, 13) was painted with my standard Hyplar black mix. The white areas adjacent to the tail feathers are the inner halves of the first row of feathers next to the tail. When applying the black paint I blend it to water along the margins of the area to be painted white, creating a soft edge. After the black dries, I paint the white, which is the same color (nimbus gray and gesso) used earlier on the side-pockets and breast. Again, the white is applied with the color-to-water blending method, creating a soft transition between the white and black.

I flicked small feather edges in the white area with titanium white, then used a mix of 70% titanium white and 30% raw umber to add feather edges in the black area (photo 2). I applied several washes of burnt umber over the black area, bringing the white feather

edges and the black base color closer together in value. Basically, it's a black-on-black technique; the goal is to bring the feather edges close to the value of the base color but to still retain definition.

The Undertail Feathers

A base color of 85% gesso, 10% burnt umber, and 5% carbon black goes on the underside of the tail (photo 13). Then white feather edges are painted with a mix of 90% titanium white and 10% raw umber, which is also used on the quills. The area is finished with a very thin wash of burnt umber, then carbon black. The operative word here is "thin."

The Tail Feathers, Top Side

I painted these feathers along with the tertials and scapulars (photo 8). The centers of the feathers, along the quills, are considerably darker than the outer edges. I use 90% burnt umber, 5% titanium white, and 5% iridescent white to darken the centers, applying the paint with the color-to-water blending method. On these feathers I use a size 6 filbert brush to dampen the margins of the painted area, then I use a size 4 filbert to apply the paint, blending it to water.

The tips of the feathers are painted a light buff color and the quills a dark brown, a mix of 70% burnt umber and 30% carbon black. The two long sprig feathers are painted carbon black with green pearl essence powder added. The quills are painted straight carbon black.

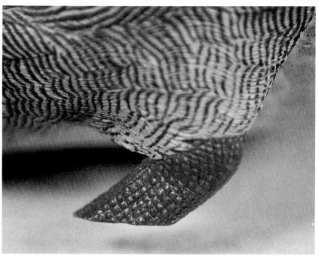
Photo 14

The Wings, Top Side

The tops of the wings are painted with a mix of 85% burnt umber, 10% titanium white, and 5% carbon black. The darker edges, a mix of 70% burnt umber and 30% carbon black, are applied with the color-to-water blending method (photo 9). The same mix is used for painting the quills.

There is a very subtle, thin buff edge along the inner halves of the wing feathers. I use a mix of 65% titanium white and 35% burnt umber. The entire area then gets a wash of thin burnt umber or carbon black to emphasize carved feather definition.

The Speculum

First, I apply gesso to the speculum and the gold feather edge in front of the speculum (photo 11). The colors here are difficult to achieve because on a real bird they seem to change with the angle at which you view them. I begin by painting the speculum feathers yellow light, then apply a mix of 60% phthalo green and 40% carbon black, adding a little green pearl essence powder. The colors are applied with the same method used on the shoveler and blue-winged teal drakes. I dampen the center of the speculum, apply green around it, and then blend color to water. The result is the green speculum with a yellow center

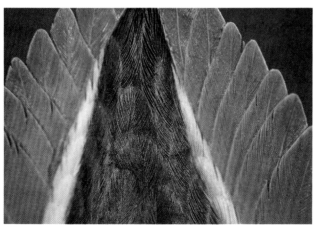
Photo 13

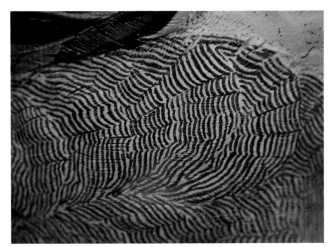

Photo 15

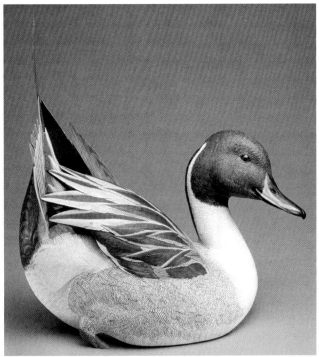

Photo 16

highlight. A final wash of green goes over the entire speculum and, if needed, I could darken it further with a wash or two of burnt sienna or carbon black.

With the pintail drake there is a hint of violet in the speculum, which I add with a wash or two of carbon black tinted with violet pearl essence powder. I apply it with a nearly dry brush, and paint in only one direction. This makes the color change value slightly depending upon the angle from which it is viewed—just like the real bird.

In photo 11 you will see black, then white, outer edges on the speculum. I paint the black first using straight carbon black, then the white, which is a mix of 85% gesso and 15% raw umber.

The gold feather edge in front of the speculum is a mix of 70% titanium white, 25% burnt sienna, and 5% yellow oxide. These feathers have very fine buff tips, which are painted with 85% titanium white and 15% raw umber. A thin wash of burnt umber then goes over these feathers.

In front of the gold feather edge is a black area, which actually is a scapular feather. It is painted with my standard Hyplar black formula. Then I add some blue pearl essence powder to the mix and flick faint feather edges using a size 6 Raphael #8404 brush. These should be very subtle (photo 10).

Vermiculation

I always do the vermiculation last, and on this bird I used a size 2 Raphael #8408 brush with a mix of 50% burnt umber and 50% carbon black.

It's important to remember that vermiculation patterns vary from bird to bird, so it's a good idea to have good reference material and to refer to it often. I use photos and taxidermy mounts, and sometimes even bring in a live bird from the aviary and have it on my work table as I paint.

I start vermiculating with the feathers adjacent to the flank, so I work from back to front. This gives me a good view of the previously painted lines, and I can control spacing and design better this way because my hand is not covering my work as I paint.

Photo 1 shows the transition area between the breast and sidepockets. The transition area is similar along the lower sidepockets and belly. Once the vermiculation lines are painted, I smooth the transition by applying some titanium white with an airbrush.

If there are feather separations on the sidepockets with the base feathers showing through, you can lighten those areas with a mix of 80% titanium white and 20% raw umber blended to water. I did that on this bird. The separated feather shows in photo 15.

The vermiculation can be darkened overall if desired by applying a thin wash of burnt umber or carbon black.

The final step is to put a couple of coats of matte medium-varnish diluted equally with water on each quill.

13

Case Study: The Cinnamon Teal Drake

Over the years I have carved and painted more cinnamon teal drakes than probably any other species of waterfowl. In more than twenty-three years I have made a variety of changes in my painting methods, but the method described here is my latest, and, I believe, my best.

The cinnamon teal drake has a handsome red color on its sidepockets, breast, neck, and head, and has orange-red eyes. The species is closely related to the blue-winged teal and shoveler.

The Undercoat

I use three thin coats of Deft Spray Stain, Salem maple color, to seal the wooden bird. After this dries, I apply a base of 85% gesso and 15% yellow oxide. Gesso is a fairly thick, opaque medium, so you always want to apply it in the direction of the feather detail. If you paint across the finely carved feathers the gesso will obscure them. Let it air dry between coats. I usually put on three coats, enough to produce a uniform surface with no glossy spots showing through.

The Sides, Breast, Head, and Under the Tail

I paint the entire area with a mix of 85% burnt sienna and 15% cobalt blue. The burnt sienna is equal parts Jo Sonya and Hyplar. I mix more than I need and save the excess to later paint feather markings on the back. This base coat is applied with a one-inch Raphael #8250 brush. I like to use the widest brush practical when putting on base colors such as this. A wide brush distributes color evenly and avoids streaks.

The burnt sienna/cobalt blue mix can be fine tuned by the addition of yellow oxide or burnt umber. I add a little yellow oxide if I want to lighten the color, or burnt umber to darken it.

Before painting on the feather tips, I lighten the sidepocket areas with a wash of cadmium orange and I darken the breast and head with a wash of dioxazine purple. Then I use yellow oxide to paint the feather tips on the sides and breast and the highlights on the cheeks and behind the eye.

The crown and the area under the chin are darkened with washes of my standard Hyplar black mix.

MATERIALS & COLORS

Deft Spray Stain, Salem maple
gesso
Hyplar burnt sienna
Jo Sonya burnt sienna
burnt umber
raw umber
cadmium orange
dioxazine purple
titanium white
carbon black
yellow light
yellow oxide
Hyplar ultramarine blue
cobalt blue
phthalo blue
phthalo green
pine green
blue-green pearl essence powder
green pearl essence powder

Photo 1

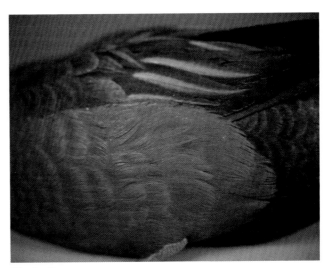

Photo 2

Photo 3

Then I flick on buff feather edges using a mix of 80% titanium white and 20% raw umber. I also flick reddish feather edges on the crown using the original base mix. The standard black mix is used to flick a few feather edges along the edges of the crown, behind the eye, and directly behind the bill (photo 4). I use the size 2 Raphael #8404 brush. Larger black feather edges are applied to the area between the breast and the upper sidepockets and scapular feathers (photo 1).

With all the feather edges painted, I follow with a wash of the original base color over the sidepockets, then a thin wash of burnt umber over the remaining areas.

The Bill

First, I gesso the bill to provide a uniform painting surface. The center of the underside of the lower mandible is painted a brownish red color that I make

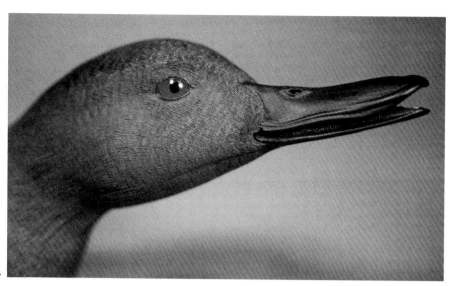

Photo 4

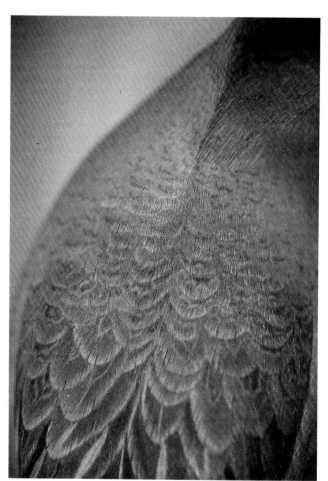

Photo 5

washes of matte medium-varnish diluted equally with water finish the bill, providing a lifelike, waxy look (photo 4).

The Back and Upper Rump

Both areas are painted with a mix of 90% raw umber and 10% carbon black using a one-inch Raphael #8250 brush. The paint is applied in a series of washes, which allows the color to build up gradually.

Photos 5 and 8 show that the feathers along the rump and back have three values of color: light tips, base-color central portions, and darker bases. I paint these feathers by first applying the base color of 90% raw umber and 10% carbon black, which is the same used on the shoveler drake back. You might want to consult the color chart in that chapter. Then I use the size 6 Raphael #8404 brush to paint the feather edges with 80% titanium white tinted with 20% raw umber.

The bases of the feathers are darkened by adding a small amount of carbon black to the base color, then applying the paint using the color-to-water blending method. I use two filbert brushes, a size 4 for the color, and a size 6 for the water. The color-to-water method provides a gentle gradation in color value, from dark at the base of each feather to light at the tip.

Next, I paint the rusty red markings on the back and scapular areas. Using a size 1 Raphael #8408 brush I carefully apply thin washes of the color saved from

by adding a small amount of burnt umber to the reddish base color. This is applied only to the center of the lower mandible; the rest of the bill is painted with the standard Hyplar black mix. A couple of thin

Photo 6

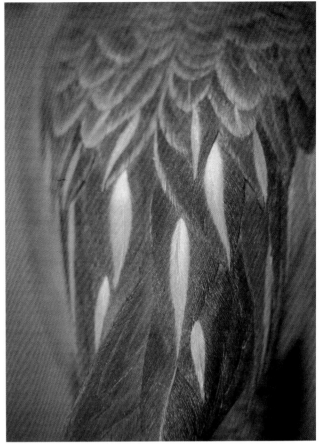

Photo 7

painting the sides, breast, and head. For feather splits I use the same darker mix that I used on the bases of the feathers.

Notice in photos 10 and 11 the two scapular feathers next to the long blue scapular directly behind the tertials. These two feathers have a blue-green cast, which I apply with a thin wash of 60% phthalo green and 40% phthalo blue, to which I added a very small amount of blue-green pearl essence. A couple of washes of raw umber then darken the area overall.

The Tertial Feathers and Long Scapular Feathers

On the tertials and long scapulars I use the same mix I used to darken the bases of the feathers on the back and upper rump. These feathers are fairly dark, almost a blackish brown in some instances. The lower halves of the tertials have a greenish cast, which can be added with a thin wash of 75% carbon black, 25% phthalo green, and some green pearl essence powder.

Before painting the centers of the feathers, I darken any undercut areas with carbon black. This deepens the natural shadows created during carving and adds definition. It's important always to coordinate your carving and painting techniques; let one complement and build upon the other.

I use two filbert brushes and the color-to-water blending technique to paint the centers of the tertials and scapulars using a mix of 75% gesso, 10% yellow oxide, 10% burnt umber, and 5% burnt sienna. When painting these feathers it's vital to check your reference material closely to determine the exact shapes of the cream areas, and whether the color extends on

both sides of the quill or only on the inner portions of the tertial feathers.

I paint the quills with the size 1 Raphael #8408 brush, using a watery mix of raw sienna. The quills are lighter in value toward their bases (photo 7).

The cream mix previously used in the centers of the feathers is used to edge the first row of feathers directly behind the scapulars, which provides a softer transition between the two areas. The same mix is used to put on the lower edges of the tertial feathers.

Blue Scapular and Wing Covert Feathers

I always gesso these feathers first to cover paint that might have spilled onto them and to ensure an even distribution of color. Then I apply thin washes of 40% gesso, 30% ultramarine blue, and 30% burnt umber. On the wing covert feathers I flick white—80% titanium white and 20% raw umber—feather edges, followed by a thin wash of burnt umber. The scapular feather has a blended area of ultramarine blue (photos

10, 11). I dampen the lower part of the feather and apply straight ultramarine blue from the base out, then follow with one thin wash of burnt umber.

The Speculum

Again, I apply gesso before painting to ensure even distribution of color. The first wash applied is yellow light, followed by a mix of 45% phthalo green, 45% pine green, and 10% carbon black, with some green pearl essence powder added. (This is the same speculum illustrated on the blue-winged teal drake in Chapter 8.) I dampen the center of the speculum, then apply green around the dampened area, blending the color to water. This leaves a yellow highlight in the center of the speculum. The final wash of green goes over the entire speculum and, if needed, it could be darkened with a thin wash of carbon black.

The edges of these feathers are usually darker on the rear margin. I darken this area with carbon black, blending it to a dampened surface to create a gradual edge. The extreme edge of the speculum has a buff edge, which was painted with a mix of 80% gesso and 20% burnt umber.

The Tail Covert Feathers, Flank, and Under the Rump

The black area under the rump (photo 9) is painted with my standard Hyplar black mix. I used 80% titanium white and 20% raw umber on the white feather tips. I put a couple of burnt umber washes under the rump to bring the values of the feather edges and the base closer together.

The upper edges of the first row of tail covert feathers have a gold color, while the lower edges have a greenish cast. I paint the upper edges by blending to water the same cream-color mix used on the centers of the tertials and scapulars. This mix is blended back toward the quill approximately one-eighth inch. I then blend a thin wash of raw sienna to the cream color just applied. For both of these blending jobs I use two filbert-type brushes, a size 2 for paint and size 4 for dampening the surface painted into.

On the lower halves of the feathers I add a small amount of green pearl essence to the standard Hyplar black mix. One wash suffices.

A lining brush or a size 1 Raphael #8408 brush is used to apply carbon black to the feather splits and quills.

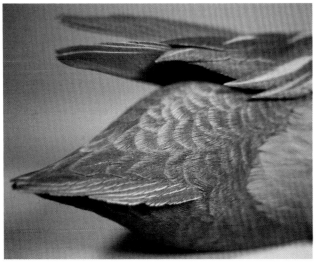

Photo 8

Photo 9

The Wings and Tail

The tops of both the wings and the tail are painted with a mix of 85% burnt umber, 10% titanium white, and 5% carbon black. On the wings the edges are the standard Hyplar black mix blended to water (photo 6). The inner halves have a greenish cast, so I add a small amount of green pearl essence powder to the black mix and apply it as I did on the tail covert feathers. The quills are brownish black.

The top side of the tail is painted with the base mix to which I added a small amount of carbon black. I darken the base of each feather, blending the color to water (photo 11). The buff-color tips are a mix of 70% gesso and 30% burnt umber. The quills are the same color as on the wings. A thin wash of burnt umber finishes the wing and tail feathers.

Photo 10

Photo 11

Photo 12

Under the Tail and Wings

I paint these areas with a mix of 90% nimbus gray and 10% burnt umber. The feathers beneath the tail have edges and quills of straight titanium white. After painting them, I follow with a thin wash of burnt umber and then one of carbon black.

Under the wings I darken the edges of the feathers with a mix of 70% burnt umber and 30% carbon black, blending this mix to a dampened surface. The quills are a buff white.

The Legs

If the legs show, I paint them with gesso. I use thick gesso and a lining brush to apply tiny dots that suggest scales. The legs are then painted with a mix of 60% gesso and 40% yellow oxide. After three washes of that color, I apply a couple of thin washes of burnt umber. To provide a realistic look I'll apply two washes of matte medium-varnish diluted equally with water. This should also be applied to the quills.

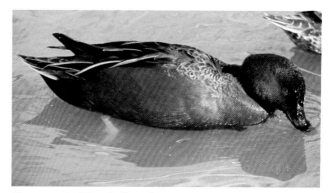

Cinnamon teal hen in the aviary.

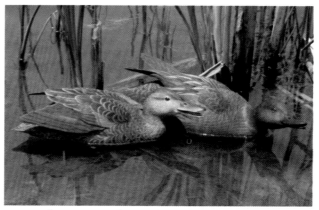

A pair of cinnamon teals carved in 1985.

14

Case Study: The American Wigeon Drake

The American wigeon drake, sometimes referred to as the baldpate, is a very distinctive and graceful duck. Observing them here in my aviary, I've found them to be very active, very nervous birds, and I often photographed them in a scolding position, which prompted me to do this wigeon carving in 1987.

The real challenge in making this scolding wigeon came when the carving was completed and it was time to paint. It really put me to the test. It was a successful project, though, and the wigeon was selected for the 1987 Leigh Yawkey Woodson Art Museum Birds in Art exhibition. Currently it's in the collection of A. James Clark.

If you're planning to paint a wigeon drake, my advice would be to first put together a good collection of photographs or, better yet, get a study skin, taxidermy mount, or live bird. The ornithological departments of colleges and universities often have study skins that you can look at, or perhaps even borrow. Zoos usually have good collections of wildfowl in their aviaries. I built an aviary attached to my studio several years ago, and it has been a great investment. It's a real luxury to go out and pick up a live bird to study when you're painting a complicated specimen such as this wigeon drake. Sometimes I'll tether a bird on my work table while I'm painting so I can have it right in front of me.

My first step in painting the wigeon is to seal the wood with lacquer. I have used Deft Spray Stain, Salem maple color, for several years with good results.

The Undercoat

The entire bird is painted with a mix of 85% gesso and 15% raw umber using a stiff bristle brush and always applying the paint with the carved feather flow. I use a size 18 Raphael #355 brush, and I allow each coat of gesso to air dry. Gesso is a thick medium and if you dry it quickly with a hair dryer or other heat source, it can shrink and pinholes can develop. It doesn't take long to air dry, so don't rush it. I usually apply three or four coats, just enough to produce a uniform surface with no transparent or glossy spots. I always save some of my gesso mix in case I need it later for touch-ups.

MATERIALS & COLORS

Deft Spray Stain, Salem maple

gesso

raw umber

burnt umber

burnt sienna

raw sienna

titanium white

pine green

phthalo green

naphtha red light

ultramarine blue

cobalt blue

phthalo blue

yellow oxide

yellow light

nimbus gray

iridescent white

white pearl essence powder

The Breast, Sides, and Back

The gesso undercoat provides the base color for the lower sides, flank, and the white area under the rump. The purple-pink colors in these areas challenge even the best of painters. On this bird I first painted the breast, which has more of a purple value than the sides. I applied the paint with the color-to-water blending method, first dampening the margins where the breast color blends with the colors of the sides and back. I then applied the paint, blending it to the water to provide a soft edge. The basic color mix is 70% naphtha red light, 25% cobalt blue, and 5% gesso. I added about 10% iridescent white to this color to paint the breast. It can be darkened with a small amount of burnt umber if necessary. I saved this base-color mix for later use.

I used the same basic mix for the sidepockets and the area behind the neck, but instead of iridescent white I added a small amount of raw sienna (photos 1, 2). Then feather tips were added with a mix of 85% titanium white and 15% raw umber, followed by very

thin washes of the original base color. I like to apply washes to broad areas such as this with as large a brush as is practical – in the case of this wigeon a one-inch Raphael #8250. A wide brush reduces the possibility of getting streaks. Washes also should be applied sparingly; too much paint applied at one time will puddle and dry with a very distracting gloss.

The Head

Study closely the photos showing detail in the head (photos 8, 9). On this bird I began by applying a base-color mix of 85% gesso, 10% raw umber, and 5% carbon black. I pulled little feather tips down into the breast area with a size 2 Raphael #8408 brush to

Photo 1

Photo 2

Photo 3

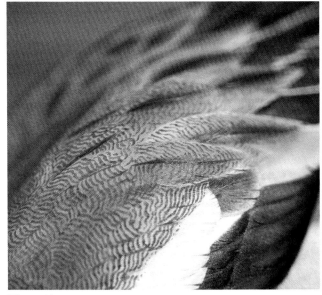

Photo 5

Photo 4

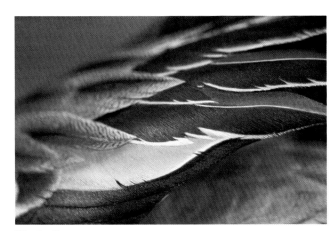

Photo 6

create a soft transition. Then I applied a wash of raw sienna to the crown to give it a slightly golden hue.

Feather tips are painted on the crown with a size 2 Raphael #8404 feather-flicking brush, which has a fan shape ideal for this job. The color is a mix of 85% titanium white and 15% raw umber. The crown is then lightened by a couple of thin washes of straight titanium white in what amounts to a white-on-white painting method.

The green area is painted with a mix of 90% pine green and 10% carbon black. It's important to study your reference material closely before painting this to determine the exact layout. I very lightly sketch in the outline with a soft lead pencil, dampen the area around it with water, then apply the green color and blend to water along the margins.

The nape and the area in front of the eyes are darkened with a wash of 80% carbon black and 20% phthalo blue.

The green area has some subtle yellow highlights, and I paint them by blending to water a wash of yellow oxide. Then I put a wash of yellow light onto the yellow oxide. These are then toned down with washes of the green base mix to which I added a little green pearl essence powder.

Study closely the black feather markings on the head to determine the size, shape, and direction of flow. These are painted with a mix of 75% carbon black and 25% burnt umber and are applied with a size 2 Raphael #8408 brush. I usually darken the area after applying these markings with a thin wash of carbon black.

The Bill

As always, I gesso the bill before painting to prevent any paint that may have spilled earlier from bleeding through. The entire upper mandible is painted with a blue mix of 90% gesso, 8% cobalt blue, and 2% burnt umber (photo 12). On this drake I airbrushed straight titanium white on top of the bill and along the lower edge of the upper mandible before painting the black areas along the tip of the bill, the base, and along the lower mandible.

The black is my standard mix of 60% Hyplar burnt sienna and 40% Hyplar ultramarine blue. I apply it to the bill with the color-to-water blending method, first using a size 4 filbert brush to dampen the outer margins of the area, then applying the black paint with a size 2 filbert brush and blending it to water.

This wigeon has an open mouth, so I paint the mouth tissues a pink color made by mixing 95% gesso, 4% naphtha red light, and 1% burnt umber. The tongue and the roof of the mouth are somewhat whiter, so I omit the burnt umber and add titanium white instead.

I finish the bill with two thin washes of matte medium-varnish diluted equally with water. I always apply the matte medium-varnish at this stage of painting because it helps protect the bill while the bird is being handled during subsequent painting steps.

The Tertial and Scapular Feathers

I like to paint the scapular feathers first (photos 4, 5, 6). This grouping has a pinkish brown cast that I make by adding a little burnt umber to the base color used on the sidepockets.

The tertial feathers are gray-brown on the inner halves and an iridescent green color along the outer, or lower, halves. These colors are separated by a bone-color quill.

I paint the inner halves first with a mix of 85% burnt umber, 10% carbon black, and 5% gesso or titanium white. A little iridescent white or white pearl essence powder can be added.

The lower halves are painted with 60% burnt sienna and 40% carbon black, with a trace of green pearl essence powder added. On the quills I start with a burnt umber color and graduate to bone while working closer to the speculum.

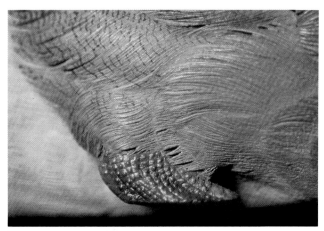

Photo 7

The lower edges of the feathers have a thin white margin – a mix of 85% titanium white or gesso tinted with 15% raw umber – applied with a lining brush.

The Speculum

As always, I gesso first to cover spilled paint, then paint the entire grouping with yellow light. The green feathers are a mix of 45% phthalo green, 45% pine green, and 10% carbon black, with some green pearl essence powder added.

After the yellow dries, I dampen the center of the speculum with water, apply the green around the dampened area, and blend the color to the water. After about three washes applied in this fashion, I add a fourth, this time covering the entire speculum grouping. This method leaves a subtle yellow highlight in the center of the green speculum – the advantages of transparent acrylic paints (photo 3).

The leading edge of the speculum is dark on the wigeon drake, so I add a wash or two of my standard Hyplar black mix and blend it to water over the green color. I use the same black mix to paint the first row of greater wing covert feathers.

The White Wing Covert Feathers

These are painted with the white-on-white method described throughout this book. I begin with a base coat of 90% nimbus gray and 10% titanium white, then flick on straight titanium white feather tips with my size 2 fan-shaped Raphael #8404 brush. If you

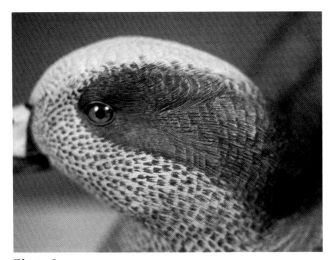

Photo 8

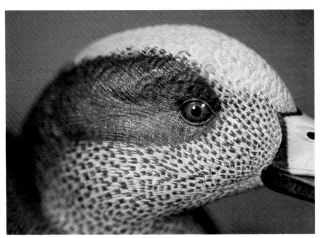

Photo 9

Photo 10

have trouble flicking feathers with this method, you can paint them with a small lining brush. I often use one of these small brushes to touch up the flicked feathers, extend feather markings, and add other little details like that. This type of brush also is used to pull tiny feathers from the white area into the edge of the black, providing a smooth transition (photo 3).

With the feather edges on, I then add washes of straight titanium white, bringing the values of the base color and the feather edges closer together. The area should appear white, but subtle detail such as the feather edges must show or the feather grouping will appear washed out and have no depth or definition. By retaining the white feather edges against a white background, you provide the illusion of softness and lift.

The Black Areas

The first row of tail covert feathers and the area under the rump are painted black (photos 13, 14, 20) using a mix of 60% Hyplar burnt sienna, 35% Hyplar ultramarine blue, and 5% carbon black.

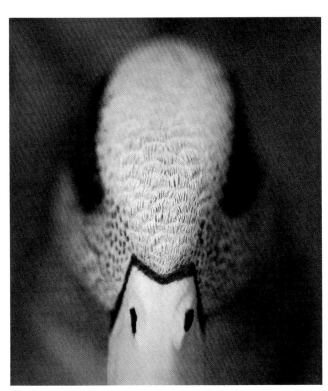

Photo 11

After perhaps three washes of black, I add another thin wash of phthalo green with a small amount of green pearl essence powder.

The feather tips under the rump are extremely faint. I use 70% titanium white and 30% raw umber and apply them with a very light touch using the size 6 feather-flicking brush. Then I follow with a couple of thin washes of the black base color.

Photos 13 and 14 provide a close look at the tops of the tail covert feathers, which have a silver-white band that becomes buff as it nears the black area. When painting these feathers, I begin by applying the silver-white color and blending it to the black. I use a mix of 90% titanium white, 5% burnt umber, and 5% carbon black. Then I very lightly blend some burnt umber between the silver and black areas, thus creating the buff zone.

I finish by darkening the centers of the upper rump feathers, blending to water a mix of 80% burnt umber, 10% carbon black, and 10% gesso. The quills are painted straight carbon black.

The Wings

The tops of the wings are painted first with a base color of 85% burnt umber, 10% titanium white, and 5% carbon black. I mix plenty of this color and save it to later paint the tail feathers.

The edges of the wing feathers have a darker value (photo 19), which I add by blending to a dampened surface 70% burnt umber and 30% carbon black. This can also be used to paint the quills. Along the inner halves of the feathers, toward the tips, I apply a thin wash of phthalo green with a little green pearl essence powder added.

If the feathers need to be darker, or if you need a smoother transition where colors were blended, you can put on a thin wash of carbon black or burnt umber.

Remember, you can't get in trouble with thin washes, but you can ruin a good carving by applying paint too heavily. Believe me, I've done it!

The Tail Feathers, Top Side

I saved the base mix that I used earlier on the wings, and I apply the same color to the tops of the tail feathers. The bases of these feathers are darkened slightly

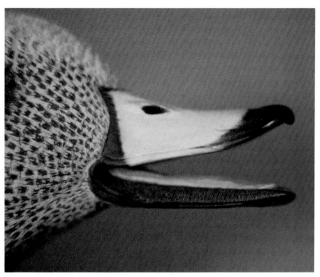

Photo 12

Photo 13

Photo 14

Photo 15

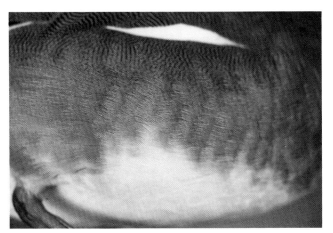

Photo 17

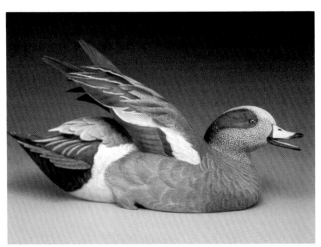

Photo 16

by adding a small amount of carbon black to the base color and blending it to water along the lower portions of each feather. The four center feathers are darker from the quill out, so I add a little more carbon black to the mix and again blend to water, using size 4 and size 6 filbert brushes.

The buff margins on the edges of these feathers are painted with 70% gesso and 30% burnt umber. The quills are brownish black. The area is finished with a thin wash of burnt umber.

Wings and Tail Feathers, the Underside

I begin by making a base slate-color mix consisting of 75% gesso, 15% raw umber, and 10% carbon black. I add 10% iridescent white to this mix to paint the

underside of the tail feathers. The feathers here have white edges and bone-color quills, which is a mix of 90% titanium white and 10% raw umber. A single thin wash of burnt umber completes the area (photo 20).

The feathers under the wings are painted with the same base mix as the tail. I darken the inner halves and tips of these feathers with a thin wash of 90% burnt umber and 10% carbon black. The quills are painted the same as under the tail. The area is finished with successive thin washes of carbon black and burnt umber.

Vermiculation

I always save the vermiculation for last, not necessarily because it's the most fun of all painting procedures but because I like to handle the bird as little as possible once these fine lines go on.

Photos 2 through 5 show the design and density of vermiculation. On the wigeon drake the vermiculation lines are darker and larger at the top and rear of the sidepockets. Vermiculation differs from bird to bird, so you will need reliable reference material when painting these areas.

I have used several methods of vermiculation, but for the wigeon I go with the size 2 Raphael #8408 brush. It keeps a sharp point and holds a sufficient quantity of paint.

The mix used on this bird is my standard Hyplar black formula to which I add a very small amount (about 1%) of titanium white.

Study your reference carefully when you're doing the vermiculation on your carving. Keep in mind that the vermiculated lines are much heavier on the scapu-

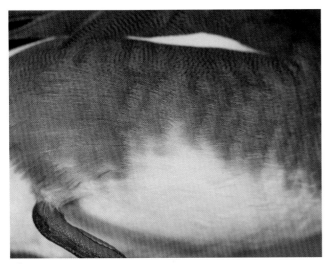

Photo 18

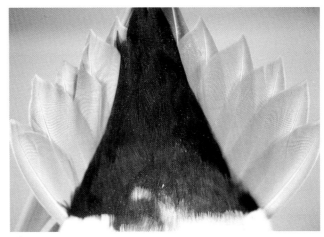

Photo 20

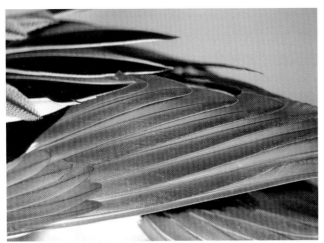

Photo 19

Photo 21

lar feathers than on the sidepockets, and don't forget the vermiculated areas on the rump and on the white flank (photo 15).

The Legs and Feet

The drake's legs and feet are painted a slate gray color with a slight greenish cast. The webs are black, as are random spots on the feet and legs.

To Finish

Mix a solution of equal parts matte medium-varnish and water and paint each quill with a small lining brush.

15

Case Study: The Gadwall Drake

It seems to me there are three critical areas to consider when painting the gadwall drake. First, there is a tricky transition area between the cupped feather tips on the breast and the vermiculated areas on the side-pockets. The second critical area is the head, in particular the very distinctive dark streaks that create the pattern on the face. Third would be the tertial and scapular feathers, where you have to blend a subtle range of colors.

I've carved and painted a lot of gadwall drakes in my career, but I've often said that I hope the people who own my drakes don't decide they want me to do a hen for them so they'll have a pair. The gadwall drake is a beautiful, elegant bird—one of my favorites.

The carving illustrated in this case study is one of my favorite gadwalls. It was done in 1987 and is in the collection of Dr. Bill Amoroso.

Sealing the Wood

This is a bird carved from tupelo gum, so I seal the wood before painting with several applications of Deft Spray Stain, Salem maple in color. I put on enough coats to give a uniform surface with no glossy or flat spots.

The Undercoat

The undercoat is applied over the entire bird, and it serves as the base color for the head, lower sides, and the rump. It's a mix of 85% gesso and 15% raw umber. I apply it with a stiff bristle brush, and as always I apply the gesso in the same direction as the carved feather flow. I usually put on three coats, allowing each to air dry before the next goes on. Resist the temptation to use a hair dryer. It will speed up the drying time, but the intense heat can shrink the gesso and cause tiny pinholes that will ruin the paint job. Gesso dries quickly enough without help, so have patience and do it right.

The Sides, Breast, Upper Back, and Back of Neck

I paint all of these areas at the same time with a mix of 65% Hyplar burnt sienna and 35% Hyplar ultramarine blue, which is a slightly warmer version of my standard black formula. It is essential to study your reference material before painting these areas. I paint the back with the color-to-water method, dampening the scapular area and then blending the black mix into

MATERIALS & COLORS

Hyplar matte medium-varnish
Deft Spray Stain, Salem maple
gesso
raw umber
burnt sienna
burnt umber
raw sienna
ultramarine blue
nimbus gray
carbon black
titanium white
iridescent white
yellow oxide
phthalo green
dioxazine purple
phthalo violet
green pearl essence powder
white pearl essence powder
violet pearl essence powder

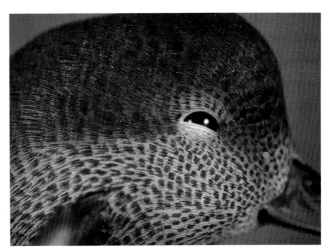

Photo 1

While I have this color mixed, I apply it to the tops and bottoms of the tail feathers and under the wings. I then add some carbon black and burnt umber to the original mix and paint the tertial feathers adjacent to the scapulars and the tertial feather next to the white speculum. Again, I blend color to water to create a gradual transition.

The tips of the gray tertial feathers have a lighter shade of white, which can be blended to water with brushes or airbrushed. This is a mix of 90% titanium white and 10% raw umber. Iridescent white (about 10%) can be added. The quills here are painted a thin, watery raw sienna. The very thin white feather edges shown in photo 4 are painted with the mix of titanium white and raw umber.

The Scapular Feathers

These feathers have a color that I call old gold. I mix 75% raw sienna, 10% gesso, 10% burnt umber, and 5% burnt sienna, then blend this color into the back area as shown. The centers of these feathers are darker (photos 5, 7, 8), so I mix 85% burnt umber and 15% titanium white and blend it to water along the centers of each feather. The quills are straight burnt umber.

The scapular feathers have a very fine buff edge where they meet the gray tertials. I paint this with a lining brush using 90% gesso tinted with 10% raw umber.

The lower edges of the scapular feathers next to the sidepockets have a gold color. I apply a raw sienna wash over this area, blending it to water at the edges.

it. The lower halves of some scapular feathers are brown, so I increase the proportion of burnt sienna. The breast has a cooler, blacker value, so I increase the ultramarine blue.

When painting these areas, I use the largest brush I can handle. Fewer brush strokes means less chance of getting streaks—a common problem.

I save painting the breast cups and sidepocket and back vermiculation until last. I don't want to handle the bird any more than necessary once the vermiculation is painted.

The Tertial and Scapular Feathers

The five gray feathers on each side are painted with a mix of 75% nimbus gray and 25% burnt umber. If I need to make it darker, I can add a little carbon black. I apply the paint with the color-to-water blending method, merging color to water along the margins of the painting area (photos 4, 5, 6).

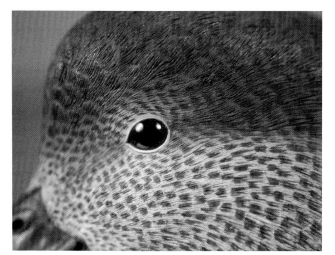

Photo 2

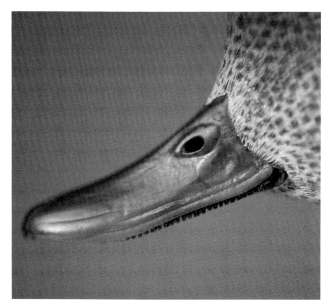

Photo 3

Photo 4

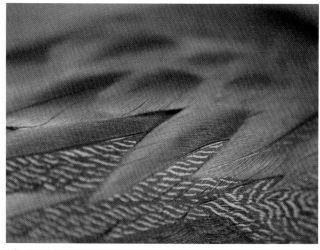

Photo 5

Photo 6

The Rump

The rump is painted a deep black (photos 13, 14). It's a mix of 60% Hyplar burnt sienna, 35% Hyplar ultramarine blue, and 5% carbon black. I apply the color with a size 6 feather-flicking brush, first dampening the margins of the area that will be painted, then blending the color to water to create a soft edge.

There is a slight green iridescence on the first row of tail covert feathers and on some of the feathers next to the base of the tail on the underside. I flick on some small feather tips with yellow oxide here, then go over the area with a thin wash of phthalo green with a small amount of green pearl essence powder.

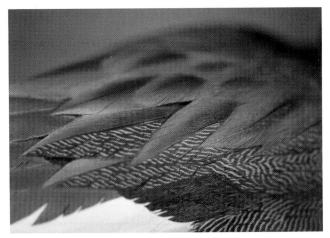

Photo 7

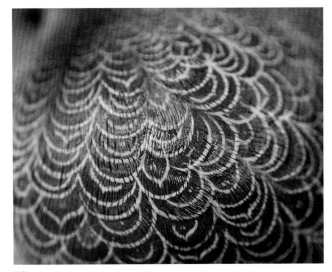

Photo 9

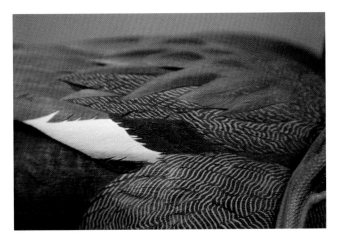

Photo 8

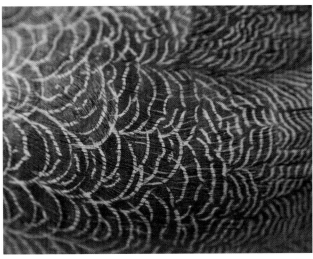

Photo 10

The remaining feather tips should be flicked ever so lightly with a mix of 70% titanium white and 30% raw umber, then a wash or two of the black base color is applied (photos 13, 14).

The Tail Feathers

Before painting the tail feathers I always check to ensure that no black paint spilled onto them while I was painting the rump. If the tail feathers do have spilled paint, I'll gesso the area to cover it. Remember, acrylics are transparent; if you put them over spilled paint, it will likely bleed through.

A base coat of 75% nimbus gray and 25% burnt umber was put on the tail feathers when the gray tertials were painted. On the bottom of the tail the feathers are much like those of the pintail drake, a light buff with bone-white quills (photo 14). The

feather edges are a mix of 90% titanium white and 10% raw umber, which also is used on the quills. The color should be blended to water. The feathers can be darkened by adding a thin wash overall of carbon black or burnt umber. The burnt umber will lend a brownish cast, while the carbon black is a more neutral value.

The centers of the top tail feathers are darker than the outer edges, so I dampen the area around the center and apply a mix of 90% burnt umber, 5% titanium white or gesso, and 5% iridescent white, blending it to water.

The feather tips are a buff color, made by mixing 80% gesso or titanium white with 20% burnt umber. The quills are a mix of 75% raw sienna and 25% burnt

umber, and they are darker toward the tips of the feathers. I usually finish the area with a thin wash of carbon black.

The Wings

The top sides of the gadwall's wings are painted just like those of the pintail drake, with the exception that the inner halves have a greenish cast. I first paint the entire wing with a mix of 85% burnt umber, 10% titanium white, and 5% carbon black. The edges are a darker value, a mixture of 70% burnt umber and 30% carbon black. I paint the edges with the color-to-water blending method, first dampening the area around where the paint will be applied with water, then blending the color to the water to create a soft edge. The burnt umber/black mix is also used for the quills.

To add the greenish cast, I put a thin wash of phthalo green with green pearl essence over the inner halves toward the tips of the feathers. To darken the area, I apply a thin wash of carbon black or burnt umber.

The Speculum

I always paint the white speculum, the black greater covert feathers, and the rusty middle covert feathers at the same time, beginning with the white speculum (photos 8, 11).

If you look closely at photo 8, you can see that the black feather just beneath the white speculum gives the lower edge of the speculum a gray cast; otherwise the speculum is totally white. I paint it with a mix of 90% titanium white and 10% raw umber, adding some iridescent white or white pearl essence. I'll add a little carbon black to the mix to come up with the light gray used along the lower edge of the speculum. I apply the gray with the color-to-water blending method to avoid having a hard edge where the gray joins the white.

On the other side of the gadwall, the speculum is different in that a single sidepocket feather overlaps the speculum. To paint this feather, I add titanium white to my sidepocket mix. Because it is a single feather, it is transparent, so it should be lighter in value than the normal sidepocket color.

Small details such as this make a carving successful. Although you want to accurately depict each bird you carve and paint, it's important to remember that birds

differ in appearance just as people do. They are not all stamped from the same mold. It helps to spend a lot of time watching birds, reading about them, and studying photographs and taxidermy mounts.

The black feather group in front of the speculum (photo 8) is painted with my standard black formula of 60% Hyplar burnt sienna and 40% Hyplar ultramarine blue. The rusty wing covert feathers are a mix of 85% burnt sienna, 10% dioxazine purple, and 5% ultramarine blue. These colors are applied in thin washes.

The Head

Before beginning the head, study your reference material closely and look carefully at photos 1 and 2. Before I add the dark feather streaks, I lighten the

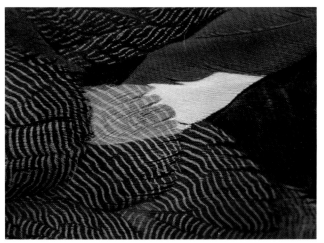

Photo 11

Photo 12

area directly behind the bill and under the chin with a wash of 85% titanium white and 15% raw umber.

I apply the dark feather streaks with a size 2 Raphael #8408 brush using an equal mix of carbon black and burnt umber. These streaks go over the entire face, crown, and neck. Good reference material is vital in capturing the design, density, and placement of these marks.

The crown has a rusty color, becoming almost black toward the neck and down the nape. I use a rusty red mix of 80% burnt sienna and 20% burnt umber and blend it onto the crown, leaving the white area directly behind the bill. I use the black mix that I painted the feather streaks with to darken down the nape of the neck to the back.

The face can be lightened by adding small feather streaks of 90% titanium white and 10% raw umber. To darken the face, apply a thin wash of carbon black or burnt umber with a size 6 feather-flicking brush.

When hunting gadwalls in Arkansas, I noticed that adult drakes in that area have a faint purple cast behind the eyes. You can add this with a thin wash of phthalo violet with violet pearl essence powder.

The Bill

As always, apply gesso first to cover any paint that might have spilled onto the bill, and to produce a good surface for blending color.

The lower part of the upper mandible of an adult drake in breeding plumage has a yellow-orange color (photo 3), which is a mix of 75% raw sienna and 25% burnt sienna applied in thin washes.

The top of the upper mandible and the lower mandible are painted with my standard Hyplar black mix, which is blended into the orange area. I sometimes use an airbrush to create a nice soft transition between the black and orange areas. The airbrush is ideal for this job, but I am leery of overusing it. It seems to me that it produces an unrealistic ceramic look that certainly isn't proper on a carved bird. Used for occasional tasks such as this, however, it is a handy tool.

Vermiculation

The gadwall drake is the only bird on which I apply white vermiculation lines, and the reason is the tran-

Photo 13

Photo 14

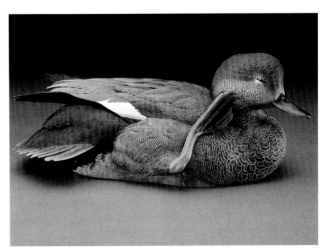

Photo 15

sition area where the cup-shaped feathers of the breast meet the vermiculated areas of the sides (photos 9, 10, 11).

It helps to lightly lay out the cupped feather tips and the transition area with a soft lead pencil. I use a mix of 90% gesso and 10% raw umber, possibly with a bit more raw umber, to paint the white vermiculation lines. The gesso, which is opaque, is better for covering the black feathers than a transparent white such as titanium.

The cupped feather tips on the breast have many, many splits. I use a size 0 or size 1 Raphael #8408 brush loaded with the standard Hyplar black mix.

The sidepockets have a browner, warmer value, so after vermiculating I put on a wash or two of burnt umber with a one-inch Raphael #8250 brush.

The Legs and Feet

First, I apply gesso to cover any spilled paint, then I use a lining brush with thick gesso straight from the jar to create little scales on the legs. After the gesso dries, I paint the legs and feet with a mix of 90% raw sienna and 10% gesso. The webs are almost black — a mix of 50% burnt umber and 50% carbon black. The toes have faint black spots and black nails, which are painted with straight carbon black.

After painting the legs and feet, I put on a thin wash of burnt umber, which settles into the little crevices and gives good definition.

The legs and feet are finished with a couple of coats of matte medium-varnish diluted equally with water. The same mix is applied to the quills.

Photo 16

Photo 17

APPENDIX A:
Studying with Sprankle

Although Jim Sprankle has a room full of ribbons and trophies from bird-carving competitions around the country, he's perhaps as well known in wildfowl art circles for his teaching skills as he is for his bird sculptures. Jim is not only one of America's most gifted artists, he also is a dedicated teacher who has conducted seminars across the United States, Canada, and England.

At his studio on Eastern Bay near Annapolis, Maryland, Jim has constructed a permanent teaching facility, a place where carvers can spend an informal week or two studying bird art with Jim or with other gifted artists such as Bob Guge, Larry Barth, or Rich Smoker. The seminars cover all aspects of wildfowl art from carving to painting, and the subjects range from songbirds to waterfowl. The seminars are held in an informal setting, and participants range in skills from beginners to advanced carvers.

"I met Jim at the Ward World Championship in 1985," says Vern Jones of Westport, Washington, who was taking his seventh Sprankle seminar during the

summer of 1990. "I was ready to study with a top artist, and after talking with him I thought he'd be easy to learn from. Your skill level doesn't matter. He takes the time to work with you."

Dr. Charles Meckstroth, a retired heart-lung surgeon from Columbus, Ohio, has been carving since 1972 and enrolled in a seminar at Jim's studio after earlier taking a Sprankle class at the P. C. English Company. "Anyone can read a book and learn the technical aspects," he said, "but you can't beat hands-on instruction. Jim's personality is a large part of it. You're going to learn a lot while you're here. He doesn't cut corners."

Dr. Roger Kennedy, a neurosurgeon from North Dakota, attended a Sprankle seminar in Seattle, then traveled to Jim's Maryland studio last year. "Compared to bird carving, brain surgery is a piece of cake," joked Dr. Kennedy. "The things you do with your hands are similar. I watch Jim and he makes it look so easy."

Mike McInnis came from Canada during the summer of 1990 to take his fourth seminar with Jim. He

developed an interest in wildfowl art several years ago but didn't feel he had the artistic ability to create his own bird carvings. "Jim creates an atmosphere where you can learn," he says. "He sets a high standard and encourages you to improve your work. I get a great deal out of the courses. He has a thoroughly professional approach."

Ken Pangburn of Kingston, New York, met Jim at the Easton Wildfowl Festival in 1980 and has taken Sprankle seminars every summer since they began in 1982. "I had a serious illness, and while I was recuperating I wanted to do something with my hands," he says. "I came to Jim's first summer seminar and I've taken classes every year since. I like his commitment and his talent. Plus, it's a relaxing atmosphere and you meet a lot of nice people."

Rusty Sarini of Mesa, Arizona, has been carving for four years, and when he signed up for the Sprankle seminar in 1990 he convinced his wife, Harriett, to come along with him. "Jim's the best teacher I ever had in my life," says Rusty. "He's easygoing and presents the information so it will help people of all skill levels."

Harriett, a food stylist, was painting her first bird, a canvasback drake, and although she felt a little intimidated at first, she quickly got the hang of washes and blending. "Jim's a wonderful teacher," she said. "I think he could teach anything."

James Pearce came all the way from London to study with Sprankle. "In the U.K. the quality of bird carving is a lot lower than it is in the States," he said. "I wanted to learn from the best, so I signed up to study with Jim. I've read his books, but the experience of being in class with him is fantastic."

Dear Carver:

Starting in 1995, our seminars will be conducted at two new locations. One will be on Sanibel Island at Tarpon Bay, Florida, next to the world-renowned "Ding" Darling Wildlife Refuge. This teaching facility, which is leased to us under the auspices of the Sanibel-Captiva Conservation Foundation, sits on a tropical lagoon, is fully air-conditioned, and is next to a canoe/fishing-guide operation. Our northern location will be at the new Queen Anne's County Arts Council facility in Centreville, Maryland, very near our original site on Kent Island.

My carving sessions will explore use of research and reference material, laying out patterns and roughing out the bird, laying out feather groupings, texturing and stoning, positioning of eyes, and final preparation of birds for painting. My painting sessions will focus on use of acrylic paints, demonstration of blending and feather flicking, application of iridescents, and sequences in painting the bird.

All classes will begin with an introductory session on Sunday evening and may continue until Saturday noon, depending upon the size of the project. For those of you needing accommodations, we will send you a list of suggested motels—rates begin at about $35 per night, including tax. Both locations, Sanibel and Centreville, have RV and camper facilities nearby.

You will be responsible for your own breakfast and evening meals, and we will furnish you with lunch each day, as well as coffee and tea. Soft drinks are available at a nominal fee. Thursday evening we will conduct an open discussion group on class progress toward the week's goals. We will host your evening meal during this discussion, and your spouse is invited to join us at this time.

The closest airport to the Centreville, Maryland, location is Baltimore/Washington International at Baltimore; the closest airport to Sanibel is Regional

Southwest Airport in Ft. Myers. We will be glad to arrange for a pick-up *at these two airports only,* so please keep that in mind when making your travel arrangements.

To reserve a space during the week of your choice, contact us at our new address. Reservations are $50; after you have made a reservation, we will send you an invoice for the remainder of the tuition, which is due sixty days before the class starts. Excluding the deposit, all tuitions will be refunded if cancellations are made before thirty days prior to the beginning of the session. Other refunds are made on a case-by-case basis.

Upon receipt of the tuition, we will send you a list of carving/painting tools and materials needed for your specific class, directions to the class workshop, and the names and addresses of those attending your same session. A basic wood cutout will be supplied for carving, and in Jim's painting classes, a molded study bird will be furnished. We have carving and painting supplies, books, molded birds, and other supplies for sale here.

Because each class has only eleven students, we can accommodate any level of expertise, from beginner to advanced, but the downside is that classes may fill up quickly, so we urge you to send in your deposit as soon as you have made your choice. If there are any questions regarding these seminars, *please feel free to call or write us—Jim or Patty—we are always available.*

Many of our former students have expressed dismay and shock that we have moved from our original location on Kent Island, and while we have been contacted by eager learners in the Southeast section of the country, some alumni have shown a certain resistance to making the move with us. To those of you, I would like to say that we have deliberately selected our dates with lower off-season air rates in mind. As well, we have found accommodations similar in caliber to those we had used in the Kent Island area, *at similar prices.* And these motels on Sanibel are all on the Gulf of Mexico with swimming pools—no more traffic noise of Route 50! Sanibel is twenty to thirty minutes closer to the airport than our Maryland classroom was to BWI.

At Tarpon Bay the location of the classroom itself is so beautiful, in a secluded cove shaded by palm trees with a constant Gulf breeze, that you will wonder how you can return to civilization. For those accompanied by spouses, we will be happy to furnish you information on all the shopping, shelling, swimming, and cultural activities available on the Island. We could even take a class tour through the Wildlife Refuge. So, we hope that our former students will be receptive to our new location. We are excited about it, and believe that it is a good move for us and for Greenwing University. For those of you who think Florida is too hot, remember those mid-summer days on the Chesapeake! The National Weather Service is on record as saying that summers are hotter on the Chesapeake (Washington/Baltimore) than they are here.

So in our twelfth year of Greenwing University classes, we invite you to join us in the location of your choice. And we also encourage you to give us a try at our Sanibel location; after all, could life be so bad sitting by the pool, overlooking the Gulf of Mexico, with an ice-cold drink, watching the sun go down through the palm leaves after a challenging and exciting day of creating your own personal waterfowl sculpture?

Sincerely,
Jim Sprankle
1147 Golden Olive Court
Sanibel Island, FL 33957
813-472-8666

P.S.

Over the years our feedback has consistently told us that many people want to come, but are intimidated and held back by what they perceive to be their lack of ability. This should not be a concern. The format of our classes is specifically designed to accommodate both the novice and the more advanced student. Many people who have come for the first time have never even held a Foredom tool, let alone a high-speed grinder. To ease apprehensions, we will furnish you upon request with names of graduates (in your area if possible) so that you may contact them directly and discuss any apprehension you may have about your skill level. We know you will obtain the highest level of assurance that you will be receiving good value for your money, and that there is a place for each and every wildfowl carver/artist at Greenwing University.

APPENDIX B:
Sources for Supplies

Buck Run Carvings
781 Gully Rd.
Aurora, NY 13026
1-800-438-6807

Canadian Woodworker Ltd.
1391 St. James St.
Winnipeg, Manitoba R3H 0Z1
CANADA
204-786-3196

Carvers Corner
153 Passaic St.
Garfield, NJ 07026
201-472-7511

Carvers Cove
R.R. 1 Box 1211
Trenton, Ontario K8V 5P4
CANADA
613-394-2903

Albert Constantine & Sons, Inc.
2050 Eastchester Rd.
Bronx, NY 10461
718-792-1600
718-792-2110 (fax)

Craft Cove, Inc.
2315 W. Glen Ave.
Peoria, IL 61614
309-692-8365

Craftsman's Cove, Inc.
36103 Plymouth Rd.
Livonia, MI 48150
313-522-2708

CraftWoods
2101 Greenspring Dr.
Timonium, MD 21093
410-561-9469
410-560-0760 (fax)

Curt's Waterfowl Corner
P.O. Box 228
123 Le Boeuf St.
Montegut, LA 70377
504-594-3012
504-594-2328 (fax)
1-800-523-8474 (orders)

Decoy Carving Supplies
59 Woodcrest Ave.
St. Albert, Alberta T8N 3H8
403-458-7086 CANADA

The Decoy Gallery
Kingshill
Chewton Mendip
Somerset BA3 4PD
ENGLAND
076121 357

Electric Tool & Service Co.
19442 Conaut Ave.
Detroit, MI 48234
313-366-3830
313-366-1855 (fax)

P.C. English Enterprises
6201 Mallard Rd., Box 380
Thornburg, VA 22565
703-582-2200

Exotic Woods, Inc.
2483 Industrial Street
Burlington, Ontario
CANADA L7P 1A6
905-335-8066
905-335-7080 (fax)

The Foredom Electric Co.
16 Stony Hill Rd., Rt. 6
Bethel, CT 06801
203-792-8622
203-790-9832 (fax)

Forest Products
P.O. Box 12
Avon, OH 44011
216-937-5630

Garrett Wade
161 Avenue of the Americas
New York, NY 10013
1-800-212-2942

Christian J. Hummul Co.
P.O. Box 1093
Hunt Valley, MD 21030
1-800-762-0235

Jennings Decoy
601 Franklin Ave. NE
St. Cloud, MN 56304
612-253-2253/612-253-9537 (fax)

J.H. Kline Carving Shop
P.O. Box 445, Forge Hill Rd.
Manchester, PA 17345
717-266-3501

Lee Valley Tools Ltd.
1080 Morrisson Dr.
Ottawa, Ontario K2H 8K7
CANADA
613-596-0350
613-596-3073 (fax)

Lewis Tool and Supply Co.
912 West 8th St.
Loveland, CO 80537
303-663-4405

Little Mountain Supply Co.
Rt. 2, Box 1329
Front Royal, VA 22630
703-636-3125

George Nelson, Inc.
2680 S. McKenzie
Foley, AL 36535
1-800-44-DUCKS

Old Hall Decoys
Old Hall Farm
Scole, Diss,
Norfolk IP21 4ES
ENGLAND
0379 740911

Pintail Decoy Supplies
20 Sheppenhall Grove, Aston Heath
Nantwick, Cheshire CW5 8DF
ENGLAND
0270 780056

Ritter Carvers
1559 Dillon Rd.
Maple Glen, PA 19002
215-646-4896

Stuart's Woodcarvers Supply
R.R. 1
Kirkwood, IL 61447
309-768-2607

Susquehanna Decoy Shop
P.O. Box 492
Intercourse, PA 17534
717-768-3092

Tool Bin
10575 Clark Rd.
Davisburg, MI 48350
810-625-0390
810-546-1725 (fax)

Veasy Studios
182 Childs Rd.
Elkton, MD 21921
410-392-3850
410-392-2832 (fax)

Warren Tool Co.
2209-1 Rte 9G
Rhinebeck, NY 12572
914-876-7817

WASCO (Wildlife Artist Supply Co.)
1306 West Spring St.
P.O. Box 967
Monroe, GA 30655
1-800-334-8012
1-404-267-8970 (fax)

Waterfowl Study Bills, Inc.
P.O. Box 310
Evergreen, LA 71333
318-346-4814
318-346-7633 (fax)

Welbeck Sawmill Ltd.
R.R. 2
Durham, Ontario
CANADA N0H 2V0
519-369-2144
519-369-3372 (fax)

Wil-Cut Company
7113 Spicer Dr.
Citrus Heights, CA 95621
916-961-5400

Wood Carvers Store and School
3056 Excelsior Blvd.
Minneapolis, MN 55416
612-927-7491
612-927-0324 (fax)

Woodcarvers Supply, Inc.
P.O. Box 7500
Englewood, FL 34295-7500
1-800-284-6229
813-698-0329 (fax)

Woodchips Carving Supplies Ltd.
8521 Eastlake Dr.
Burnaby, B.C.
CANADA V54 4T7
604-421-1101
604-421-1052 (fax)

Woodcraft Supply Corp.
210 Wood County Industrial Park
Parkersburg, WV 26101
1-800-225-1153

Wood-N-Feathers
R.R. 3
Ashton, Ontario K0A 1B0
CANADA
613-257-2900
613-253-5014 (fax)

Wood N Things
601 E. 44th St., #3
Boise, ID 83714
208-375-9663

Wood'N Works
1901 Quebec Ave.
Saskatoon, Saskatchewan
S7K 1W3 CANADA
306-244-9663
306-244-1075 (fax)

BURNING TOOLS

Annex Mfg.
955 Blue Ball Rd.
Elkton, MD 21921

Chesterfield Craft Shop
20 Georgetown Rd.
Trenton, NJ 08620
609-298-2015

Colwood Electronics
15 Meridian Rd.
Eatontown, NJ 07724
908-544-1119
908-544-1118 (fax)

The Detail Master Burning Systems
2650 Davisson St.
River Grove, IL 60171
708-452-5400
708-453-7515 (fax)

Hot Tools, Inc.
24 Tioga Way
P.O. Box 615
Marblehead, MA 01945
617-639-1000
617-631-8887 (fax)

CARVING KNIVES

Lominack Knives
P.O. Box 1189
Abingdon, VA 24212-1189
703-628-6591

Jack Andrews, Knives
1482 Maple Ave.
Paoli, PA 19301
610-644-6318

CARVING WOOD

The Duck Butt Boys
327 Rosedown Way
Mandeville, LA 70448
504-626-8919

CAST FEET

See Chesterfield Craft Shop
under "Burning Tools" above.

Richard Delise
920 Springwood Dr.
West Chester, PA 19382
610-436-4377

Taylor Made Bird Feet
165 Terrianne Drive
Taunton, MA 02780
508-824-3337

CAST STUDY BILLS

Highwood Book Shop
P.O. Box 1246
Traverse City, MI 49685
616-271-3898

Oscar Johnston Wildlife Gallery
Rt. 2, Box 1224
Smith River, CA 95567
707-487-4401

GLASS EYES

Carver's Eye Company
P.O. Box 16692
Portland, OR 97216
503-666-5680 (fax same)

Eyes
9630 Dundalk
Spring, TX 77379
713-376-2897

G. Schoepfer Inc.
460 Cook Hill Rd.
Cheshire, CT 06410
1-800-875-6939
203-250-7794 (fax)

Robert J. Smith Glass Eyes
14900 W. 31st Ave.
Golden, CO 80401
303-278-1828
303-279-2538 (fax)

Tohickon Glass Eyes
P.O. Box 15
Erwinna, PA 18920
1-800-441-5983

MOLDED BIRDS

Greenwing Enterprises
1147 Golden Olive Court
Sanibel Island, FL 33957
813-472-8666

Bob Guge
8 Pine Cone Lane
Sleepy Hollow, IL 60118

Ernest Muehlmatt
700 Old Maple Rd.
Springfield, PA 19064
215-328-2946

PAINTS AND BRUSHES

Greenwing Enterprises
1147 Golden Olive Court
Sanibel Island, FL 33957
813-472-8666

Winsor & Newton Ltd.
London HA3 5RH
ENGLAND

RUBY CARVERS

Elkay Products Co.
1506 Sylvan Glade
Austin, TX 78745
512-441-1155

TAXIDERMISTS

Mike's Taxidermy Studio
5019 Lolly Lane
Perry Hall, MD 21128
301-256-0860

WILDFOWL PHOTOS

John E. Heintz Jr.
6609 S. River Rd.
Marine City, MI 48039
313-765-5059

Larry Stevens Photos
3005 Pine Springs Rd.
Falls Church, VA 22042
703-560-5771

WOODEN BASES

Thomas Art Bases
Ken Thomas
1909 Woodstream Dr.
York, PA 17402
717-757-2702